Art Anatomy of
ANIMALS

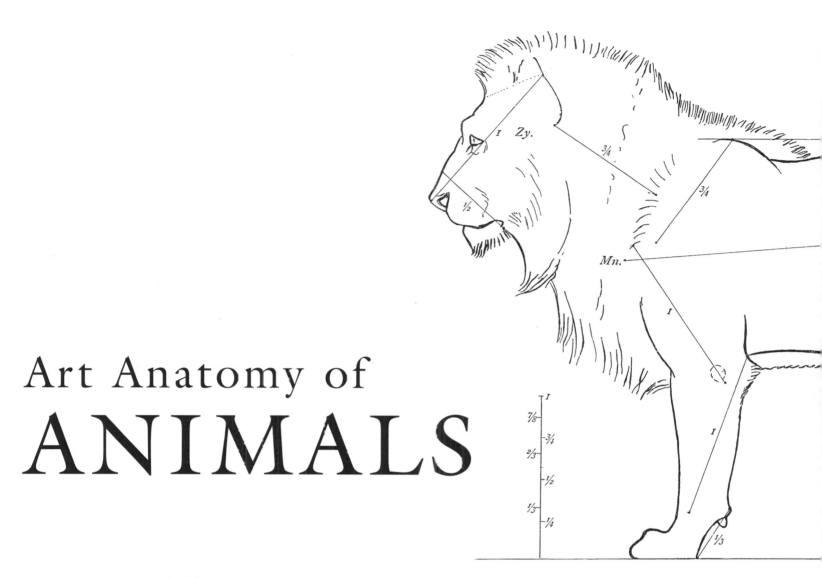

Art Anatomy of
ANIMALS

Ernest Thompson Seton

Dover Publications, Inc., Mineola, New York

Bibliographical Note

This Dover edition, first published in 2006, is an unabridged republication of the work originally published by Macmillan and Company, Ltd., London, in 1896 under the title *Studies in the Art Anatomy of Animals*.

Library of Congress Cataloging-in-Publication Data

Seton, Ernest Thompson, 1860–1946.
 [Studies in the art anatomy of animals]
 Art anatomy of animals / Ernest Thompson Seton. — Dover ed.
 p. cm.
 Originally published: Studies in the art anatomy of animals. London: Macmillan and Co., Ltd., 1896.
 Includes index.
 ISBN 0-486-44747-2 (pbk.)
 1. Animals in art. 2. Anatomy, Artistic. I. Title.

NC780.S5 2006
743.6—dc22

 2005046661

Manufactured in the United States of America
Dover Publications, Inc., 31 East 2nd Street, Mineola, N.Y. 11501

TO MY LIFE-LONG FRIEND

MRS. C. M. B. SCHREIBER,

WHO FIRST DIRECTED MY ATTENTION TO THE STUDY OF ART ANATOMY,

THIS VOLUME IS

Affectionately Dedicated.

PREFACE

There has hitherto been no general work on the Anatomy of Animals from the Art standpoint. There have been several treatises on the Anatomy of the Horse and one or two on others of the domesticated animals, but no work presenting the general principles of Comparative Anatomy applied to Art.

The various special works existent cannot be said to answer the present purpose even within their somewhat circumscribed limits. All are open to serious objection. Either they were written entirely from the surgical or zoological standpoint, and internal structure rather than external form made the chief object of study; or the subject is treated obviously with the dead animal only in view; or they are overburdened with text and in most cases poorly illustrated.

I have endeavoured to advance a step by treating primarily the *visible form* of the *living animal*; working always with the living subject before me as well as a dead one on the dissecting table. I have aimed to inculcate general principles by treating in detail a familiar and typical species, the Dog, comparing with it all animals commonly represented by the painter and sculptor and supplementing the anatomical studies of each by series of actual and proportional measurements.

I have made a careful study of Hair, or Fur, from the scientific as well as the artistic point of view. That this is the first attempt ever made to study the subject is surprising in view of its great importance to the artist, an importance which will scarcely be questioned after an examination of the works of the conscientious Japanese or the best modern masters of animal sculpture. The section on the Art Anatomy of Birds may also claim to be unique, for although antedated by the full and valuable papers from the pen of Mr. Goodchild, this is the first time that the subject has been treated in a publication designed expressly for artists.

The plates, which are the chief feature of this work, are from original drawings made from my own dissections or from nature.

The same anatomical names are used for all the species treated, as I cannot understand why anatomists should give a fresh set of names to the muscles for each new animal—surely it is better to retain throughout, as far as possible, the familiar nomenclature of the human subject. It is maintained that this results in occasional absurdities in view of the meaning of the terms, but it seems to me preferable to consider the names merely as handles to the facts, as abstract symbols; for if we admit the right to a fully descriptive name the nomenclature must continue to change as long as human opinion changes.

Among the books referred to, the most useful were Ellenberger and Baum's "Anatomie des Hundes," and the anatomical works of Chauveau, Mivart, and Cuyer and Alix. A list of the principal works consulted is appended.

My thanks are due to Dr. John Caven, of Toronto Medical School, and to Dr. A. Primrose, of Toronto Biological School, for assistance in making my dissections as well as for placing at my disposal the material and appliances in their laboratories; to Professor Filhol, of the Museum d'Histoire Naturelle, for putting at my service the skeletons in the Galerie d'Anatomie Comparée; and to Professor Ed. Cuyer for assisting me with the material in the Museum of the École des Beaux Arts in Paris.

I am also indebted in an especial degree to Mr. William Anderson, F.R.C.S., Professor of Anatomy at the Royal Academy of Arts, London, for assistance in matters bibliographical, and for a revision of the text, particularly of the chapters relating to the bones and muscles; and to Miss Grace Gallatin, of New York, for essential aid in the literary revision of the work, and for putting the manuscript in due form for the printer.

Ernest E. Thompson.

Paris,
August 1895.

TABLE OF CONTENTS

LIST OF PLATES

INTRODUCTION

We have not yet reached the point where it is no longer necessary to defend the study of Anatomy for artists. Art Anatomy of the human form has had many advocates; the argument that they have considered quite satisfactory being,—the artist *can* draw the human form without a knowledge of its bones and muscles, but he does it much better, and much more quickly and surely, when equipped with such knowledge.

The argument for the Art Anatomy of Animals is yet stronger,—the knowledge of it is absolutely indispensable. The figure-painter always can pose his models, and paint what he sees. The *animalier* must continually work from knowledge of the form, his models never pose, and, unlike those of the figure-painter, they are invariably *au naturel*.

There is no more convincing argument than the practice of the masters. The advocates of Human Anatomy point with pride to Michael Angelo, Leonardo da Vinci, and Raphael, who were profound students of surgical anatomy, as well as great lights of art. They were, in fact, pioneers in this field, entering it with a view to advancing their art.

In like manner the *animalier* may find guidance—and guidance even less equivocal—in the history of animal painters and sculptors. There have been great *genre* painters who did not study Anatomy, but there has never been a famous *animalier* who did not. Barye, Landseer, Gericault, Mêne, Cain, as well as the living men, with one voice send the student to the study of Anatomy. Some of them would carry the study farther than others, but all are agreed in carrying it far, in grasping the subject thoroughly and broadly, but exactly. And yet, contradictory as it may seem, they all unite in warning the artist, that he who endeavours to make a display of his anatomical knowledge is as surely lost as though he had none to display.

The following extract from the address delivered by M. Eug. Guillaume at the inauguration of the Barye monument, gives an excellent idea of the methods pursued by the great sculptor of animals, and shows how he made use of anatomy in a manner that was at once broad and of the utmost exactness :—

'The composition once decided upon, Barye, compass in hand, measured the skeletons of the animals which he was about to model, recording the dimensions with the most scrupulous care, and incorporating them in his work ; and, unless the bones, in their relative proportions, entered exactly into the frame of his *maquette*, he changed the latter, and never declared himself satisfied until he had made his work agree exactly with the proportions of the species he had undertaken to represent.

'It was thus that Barye arrived at perfection. His works give the lie direct to those theories which would make us believe that it is beneath the dignity of art to seek the aid of exact knowledge, or to have recourse to methods of precision ; they are at least a rebuke to those who say that to proceed in this way is to divest art of its spontaneity, its ideality, and its life.* * * *

'If one were to ask me now what is, in my opinion, the master trait of the great artist, I should say strength. This, with arrangement, is the quality that he never fails to emphasize. At a time when there are so many enervated minds, when we are tossed

about by changing aspirations, when by a sort of depraved dilettantism, one willingly styles oneself decadent, or again, to be more exactly in *fin de siècle* conditions, one is pleased, in the art world, by an affectation of languor and vapidity,—it is indeed good to exalt and do honour to vigour in an artist of incontestable renown, for this is the sovereign and incomparable quality of the works of Barye.'

To this Professor Ed. Cuyer adds :—

'In brief, these admirable embodiments of strength and suppleness were executed at the cost of a labour as scientific as it was incessant. The drawings as well as the casts that we possess at the Museum of Anatomy at the Ecole des Beaux Arts effectually establish this. They explain also why one of his biographers wrote,—"Barye simply turned on his heel when he heard it said that science is fatal to the imagination."'

Professor Anderson of the Royal Academy, in his address before the British Medical Association on Art in its relation to Anatomy, makes the following very apposite remarks :—

'It is not the knowledge but the misuse of the knowledge that is dangerous, and there is no doubt that the pride of Michael Angelo in his anatomical attainments led him to neglect that close study of the living model, which had given perfection to the work of Pheidias; hence it is that the critic who is dumb before the old Greek may feel compelled to temper his admiration of the Florentine with a regret that so great a mind should have stopped short of the highest goal.

'That Pheidias attained consummation in Art, without scientific education, proves only that there is no law for the highest genius ; the writings of Shakespeare do not tower above rivalry because he knew "small Latin and less Greek," but because with Pheidias, and, perhaps, a dozen other men in the world's history, he rose far above all theories of education. Setting apart such men as these, the greatest artist in art or literature will always express best what he best understands. The wise man is he who knows not merely a fact, but the meaning of the fact, and Science will not fail to stimulate and guide observation when not weakened by admixture with an over-weening pride in itself.'

The question has been raised as to whether the study of Anatomy is synonymous with dissection. Some writers consider that dissection is the sole means to a knowledge of the subject. I am inclined to the belief that the artist who works in the dissecting room, over ground already well known, is not using his time to the best advantage. He should rather avoid the dead animal and the surgical point of view. There is no doubt that one obtains a more thorough knowledge of the construction by dissecting, but it is unnecessarily thorough. It is of much greater importance that the student should model from the living animal, using as guides the best anatomical diagrams obtainable, bearing in mind however that Anatomy is like a virulent poison—when judiciously administered it is a powerful stimulant to art, but in an overdose it is death. This is especially true in painting; one sees but little of Anatomy in the living animal except in silhouette; and he who makes it of prime importance, produces mere diagrams, and loses sight of the greater essentials of light, colour, and movement.

ART ANATOMY OF ANIMALS

CHAPTER I.

GENERAL CONSIDERATIONS.

ART ANATOMY is a scientific explanation of the *visible living form*, or, in other words, it is the study of those parts of a living animal which influence its outward form or its expression. Besides the principal bones and muscles, this includes tendons, cartilages, sinew-sheaths, external veins and nerves, folds of skin, teeth, claws, beak, hoofs, horns, bristles, hair, feathers, &c.; and although it has been the custom of art anatomists to treat only of the first two mentioned, it will be seen that in many animals, the hair, and even the veins, are of far greater importance than many of the muscles or minor bones.

In depicting Birds also, a knowledge of the feathering is, generally speaking, of more value to the artist than familiarity with the separate muscles and bones. But a sound knowledge of the form of Mammals must be founded on an acquaintance with the bony skeleton and muscular system.

All Mammals are built on the same general plan; even the human form is but a slight variation of the same. All however are not equally good for study; some are poorly developed, some have the form obscured by wool, or by fat, some are too unwieldy or too minute, and others are not obtainable for study, through their rarity. But the Greyhound will be found well adapted to the requirements of the art anatomist, in his initial study of bones and muscles. It is superbly developed and the relation of its parts is admirably displayed through the fine skin and thin coat. It is neither too large nor too small, it is readily obtained almost anywhere, and when alive is perhaps easier to study than any other animal.

Natural sequence requires that the hairy coat be first treated or dissected. And it will be seen that this course is not entirely without justification in the importance of the subject.

Before proceeding further it will be well to give a word of warning regarding individual variation. In all departments of anatomy great allowance must be made for this, but especially in the muscles and the hair. It is probable, indeed, that the variations between a typical Dog and a typical Cat, Fox, Wolf, or Lion, &c., are not greater than those which will be found existing between different Dogs.

CHAPTER II.

THE HAIR.

Plates I., II., III., IV.

It is remarkable that the study of the Hair should have been so long and so entirely ignored. In all animals that bear it, it is of interest and value, in most it is of equal importance with the muscles, in many it is of much more consequence than these, ranking in value next to the bones as an element of form.

In the Horse, or the Greyhound, we see the hairy coat at a minimum, and yet in these the Hair has much to do with their appearance. In a Wolf the hair-masses are at least of equal importance with the muscles, and in a Grizzly, or Brown Bear, in its winter coat, the hair-masses and the bones give the clue to nearly all the visible form. In a Barye statue of a bear now before me it is impossible to detect the form of a single muscle, except on the arm. All the rest of the detail is worked out in hair-masses.

In very small Mammals the turn of the Hair is almost the only clue to the form, and the peculiar rounding and cracking on ham and on shoulder are the only indications of the complicated machinery of bones and muscles which lies far beneath.

The Greyhound has too scanty a covering to be a good subject for an initial study of Hair, so the Common Wolf (*Canis lupus*) will be used instead. This animal, practically the same throughout North America, Europe, and Northern Asia, is really a Wild Dog, with the best possible development of a Dog's powers. Its coat illustrates admirably all the essential features of furry covering, features which, though discoverable in the Greyhound, are in that animal so reduced as to be difficult of study.

The Hair of the Wolf and of most Mammals is of two kinds; a fine wool next the skin, and an outer covering of long, nearly straight hairs growing through this. The first retains the heat, and the second repels the rain. The first predominates on the lower and the second on the upper parts of the body.

The wool is also better than the hair for such parts as are very supple and change much in form, consequently we see a predominance of wool in those areas of loose or sliding skin under which the body has great play.

This may be due to the wearing off of the longer, brittler hair. The wool on these sliding areas is seen to crack open when the skin is extended. These peculiar tracts are so much more the result of arrangement than of actual change in the fur, that it is impossible to distinguish them in the animal after it is skinned or long dead; but no one can look at the living, moving creature and doubt their importance from a picturesque point of view.

These areas are limited in the Wolf, but in the Puma, or American Panther, we see them at a maximum, and the wonderful suppleness of this animal is aptly illustrated by the fact that its body is almost everywhere clad in this particular kind of covering.

The legs, shoulders, and face of the Wolf are covered by a variety of hair which is short, close and very hard. This is well calculated to give to the limbs and the senses perfect freedom of action, and at the same time is readily kept clear of mud, remnants of food, &c.

In general, the direction of the Hair is determined by two laws. First, the necessity of offering the least possible resistance to the air, and to grass, brushwood and other obstacles, while the animal is in motion. (This may be illustrated by the well-known fact that the hunter can readily drag, nose first, a dead deer which, heels first, he could scarcely move, for the obvious reason that it would be 'against the grain.') Second, the necessity for running off the rain, especially while the animal is lying at rest. The first law gives a backward, and the second a downward direction to the Hair.

But these rules are much broken by local requirements of more force, as will be seen in the Wolf. The first important exception is the curious radiation of the hair about the eye, with the object of clearing the way for the sight. This divergence is well shown in the American Buffalo; and among the feathered tribes, a notable parallel case is seen in the Owls. The hair of this radiation, meeting the counter-current of hair on the nose, produces the little ridge which is such a marked feature on the face of all hairy animals. (See Plates I., II., and III.)

On the side of the throat is a patch of reversed hair; it lies between the great thatch of the neck and the softer covering of the throat; it also covers the triangle between the upper and lower maxillary veins where they join the jugular.

This may be clearly seen in the Greyhound. (See Plate III.) After discussing with Dr. Caven the probable cause of this disturbance, we concluded that its history was briefly as follows :—

The early aquatic ancestor of living Mammals breathed by means of gills, which were gradually discarded as the creature became a land animal, and breathed by means of the elaborated air bladder, which we now call lungs. But with that conservatism so well known in organic bodies, the gill-cleft in the side of the neck persisted for long afterwards, and with it the accompanying circumvolution of the veins. This may be detected in the mammalian fœtus, and when finally the old scar heals up, the disturbance in the surrounding hair is still to be seen, and in not a few cases the blood vessels preserve traces of the now useless circumvolutions.

There is a centre of divergence on the inside of each arm, as shown in Plate II., and the meeting of these radiations with the descending hair of the chest causes the ridges that are such a marked feature of the front view. (See Plate III.)

To explain these arrangements, I can suggest only the following theory.

The skin is formed from centres of pellification, just as the bone is formed from centres of ossification. At these centres the lowest layers are first formed, and in them the hair bulbs. The minute structures of the upper layer, having a tendency to push farther from the centre, would naturally give to the hair which traverses them, but which is fixed at its lower end, a tendency to diverge from the centre. The ridges of hair which appear as lines of convergence are the natural corollaries of the centres of divergence, they are the points where meet the two areas of independently formed skin, and may be styled Structural Scars.

The reversion of the hair on the back of the fore-legs may perhaps be explained in another way. The protection accorded by its position frees it from the operation of the first law; and the fact that the leg is horizontal when the animal is lying down would give the second law full force and reasonably account for its direction.

On the ischiatic bones we have radiating centres like those on the fore-arms, and on the inside of the hind-legs are reversed parts of the coat, as on the fore-legs. In Cows this area of reversed hair is called the 'milk-mirror,' as its extent is known to correspond with the amount of milk given by the animal. This has been explained on the ground that the direction of the Hair is determined by the main veins, and the amount of milk has, of course, a direct connection with the blood supply. This explanation, however, is not complete or satisfactory, even though one finds in other parts of the animal a remarkable coincidence

between the presence of superficial blood vessels and of disturbance in the Hair-arrangement. These radiations are all remarkably clear in the Greyhound.

Plate I. shows how the Wolf illustrates the foregoing principles. The drawing is understood to be diagrammatic, as the disposition of fur therein shown, though more or less discernible in all Wolves, will but rarely be found as clear and sharp as in the drawing.

The chief masses are :—

> The ruff, beginning before the ears, and passing over the back of the jaw and under the throat ; this is much better developed in the Lynx and the Lion (Plate IV.).
>
> The curious little cushion under each ear, a sort of central point or whorl of the several hair currents of the region.
>
> The great thatch or mane of coarse hair ; much developed in the Lion.
>
> The soft woolly part under the throat meeting the mane ; these two coincide nearly with the two parts of the *Panniculus cervicis*.
>
> The mane along the shoulders, and the smaller crest on the top or dorsal edge of each scapula.
>
> The patch of sliding fur behind each shoulder, and the corresponding patch on each flank, before the hind-leg, showing the great play of the limbs.
>
> The two areas of reversed hair on the breast.
>
> The fringe of reversed hair on the back of each fore-leg.
>
> The great cushion of wool on each of the buttocks.
>
> The tail, clad entirely in the sliding fur, except the slight thatch on the base above.
>
> The ridges on the chest and on the belly, apparently structural scars as already defined.

The correlation of colour with this arrangement is striking.

The heavy thatches are much mixed with black hair ; the thatch on the base of the tail is usually ended in a dark spot ; the ruff on the cheeks is always paler in colour than the hair on the crown and neck ; the sliding fur is always paler than the hair about it ; while the close fur on the limbs and face is usually darker than elsewhere.

This arrangement both of form and of colour will be seen in all Dogs, Wolves, Jackals, and Foxes, and in a general sense is common to all the Carnivora ; the leading features are to be found in all hairy quadrupeds, as well as in man himself. From this it will be seen that, excepting on the shoulder, the fore-leg, and the hind-leg below the knee, these anatomical details of the hairy coat are in the Wolf, as well as in many other animals, of more importance than the anatomy of the muscles.

CHAPTER III.

THE SKIN FOLDS.

Plate VII.

IN many animals the Folds of Skin are of consequence. In the Rhinoceros for instance they are of much more importance than any of the individual muscles. In the present example, the Greyhound, we find several of these loose flaps, which though greatly reduced are still of value in picturesque effect.

First, the fold from the back of the arm to the ribs, that is, the roof of the armpit formed in part of the muscular fibres of the Flyshaker or *Panniculus carnosus.*

Second, the fold from the knee to the belly, forming the groin-flap or loose-flank.

Nearly all quadrupeds have this and the first well marked, and usually they are distinguished by a peculiar arrangement of hair.

Third, two loose folds on the throat arising one from each ramus of the lower jaw, uniting on the front of the neck. These are excessive in the Bloodhound and kindred races, as well as in Bulls and several Pachyderms. Their object apparently is to give free play to the neck and protection to the throat.

CHAPTER IV.

THE NERVES.

Plate XII.

ALMOST the only Nerves we need to observe are those whose terminations are enlarged bosses on the skin in which are long specialised bristles, feelers or whiskers.

In the Dog we find these in four places on each side of the head, and in two places on the lower jaw :—

Ends of the Infraorbital Nerves, or Whisker-bed. This is the great nerve-bed at each side of the muzzle, out of which, in the Dog, grow the whiskers in four rows.

Malar, a small boss with four or five bristles.

Zygomatic, a smaller boss on the cheek above and behind the preceding—in the Greyhound with but few bristles.

Frontal, over the inner corner of each eye.

The Mental, on the lower surface of the end of the Lower Jaw; more or less provided with bristles.

Mylo-hyoid, a conspicuous boss with long bristles; it is situated on the inter-ramal space beneath the lower jaw.

There is also a noticeable cord crossing the hough space; this is formed by a nerve and a vein lying side by side, and is strongly marked in the Greyhound.

Some animals, as the Squirrels, have nerve-endings and bristles on the inner surface of the fore-legs.

These organs act as feelers of exquisite sensibility. They are usually most developed in the strictly nocturnal quadrupeds, and in those whose mode of life necessitates an absolutely silent course through the woods, when their eyes can avail but little. In such the bristles usually project the width of the body on each side of the head.

CHAPTER V.

THE GLANDS.

Plates VIII., XII.

Lymph and Salivary Glands appear as rounded bosses in several parts of the Dog. Those claiming notice are the following :—

Salivary.

> Parotid.
> Submaxillary.
> Buccalis.

Lymph.

> Pre-auricular.
> Cervical or superficial lymphatic glands of the throat, in three pairs.
> Thyroid, a deep set of glands showing between the jugular vein and the trachea.
> Suprascapular, in three parts under the cephalo-humeral and angularis muscles.

There are many other larger glands, but they are too deep-set to influence the visible form. In other animals, such as the Goats and Deer, the glands are more numerous and important than in the Dog.

CHAPTER VI.

THE VEINS.

Plates VIII., XII., XIII., XVI., XX.

THE Veins are in many instances more important than the muscles. They are largest and most marked when the animal is alive and in action. In the dead animal they are inconspicuous, and in the skinned subject they must be sought for. This no doubt accounts for their having been ignored so long. Yet the great *facial* and *angular* veins are among the most marked features of the face in the Dog, Horse, Deer, &c. They are discernible even in the human face when the individual is thin or aged. Contrary to the usual rule, the overlying skin, instead of hiding the large external veins, seems rather to add to their prominence.

The important Veins of the Dog are as follows:—

Facial with its tributaries,

Coronary,

Angularis,

Dorso-nasal.

Temporal with its facial tributaries, not visible in the living Dog,

Internal Maxillary, uniting with the temporal and maxillary to form on the neck

The Jugular, a very large vein, though not always visible.

Brachial, uniting in the front of the arm with the

Subcutaneous Basilic Vein to form the

Cephalic.

Ulnar, a tributary of the brachial.

Great Saphenous, this is the conspicuous vein that crosses the hough; its branches are seen on the back, front, and inner side of the hinder limb.

CHAPTER VII.

THE FASCIÆ, LIGAMENTS AND TENDONS.

Plates VIII., XIX., XXI.

THE whole body is more or less covered with a thin fibrous expansion called Fascia. This is allied to tendon in its structure, but forms broad planes ensheathing the muscles and tendons and often giving attachment to muscular fibres. Its direct influence on the visible form is not very perceptible, although it is anatomically very important.

The only Fasciæ we need note are as follows :—

> Lumbo-dorsal, covering the loins.
> Ventral, on the belly.
> Fascia Lata, one of the most important, covering the outer side of the thigh, also called the Vagina Femoris.
> Femoral, on the inside of the thigh.
> Tibial or Crural, enveloping the leg. It is the chief insertion of the biceps.

In their nature Ligaments are similar to Fasciæ, but are thicker and narrower, with more definite boundaries and purposes. While every joint has its ligaments we need mention only the following :—

> Ligamentum nuchæ, a very powerful and elastic structure connecting the occiput and cervical vertebræ; it supports the head.
> Greater and Lesser Sacro-sciatic Ligaments, between the sacrum and the ischium.
> Ligamentum patellæ from the lower part of the patella to the crest of the tibia,—really the tendon of the quadriceps extensor, and not a ligament.
> Annular Ligaments, to retain the tendons at the lower joints of the limbs as shown on plates.

Tendons or Sinews are composed of thick cords of material similar to that of the ligaments but appearing as parts of a muscle, in which connection the important ones are considered.

CHAPTER VIII.

THE BONES.

Plates V., VI., IX., X., XXI.

IT is not necessary to describe in detail each of the Bones. The plates give a sufficient idea of their individual characters as well as their general relations. A few remarks on special points and on the skeleton as a whole will be of most service.

While some fair-sized Bones, such as the Vomer, Palatine, Ethmoid, &c., are of little or no importance to the artist, some of the smallest, as the Pisiform and Calcaneum, are of cardinal interest. This of course is due to the latter being next the skin, through which they form prominent points of the visible anatomy.

It is necessary to know these places of Bone contact with the skin, as they are fixed points whose position is mathematically ascertainable and from which all the rest of the anatomy may be accurately determined and drawn.

The following is a classified list of the bony prominences of the Dog :—

THE HEAD.

Plates VI., XI.

Occipital Tuberosity, Lambdoid Crest, and the Superior Curved Lines or Occipital Crest across the back of the head.

Sagittal or Interparietal Crest—at right angles to the lambdoid.

Internal Angular, or Orbital Process of the Frontal Bone, making the prominent ridge on the inner corner of the eye.

Orbital Process of Malar Bone, much less prominent, but readily discernible at the outer corner of the eye.

Nasal Bones. These present a large rounded surface rather than a point.

Alveolar Ridge of the Premolars, on the upper jaw or maxillary.

Alveolar Ridge or Eminence of the Canines, on the upper jaw or maxillary, much hidden by the whisker-bed.

Zygomatic Arch—from the orbit to the ear.

The Superciliary Frontal or Semilunar Ridges, over the eyes meeting in V shape on the forehead.

THE NECK.

Plates VI., VII., X.

The Wings of the Atlas or First Cervical Vertebra, though not quite reaching the skin, are sufficiently prominent to make marked external protuberances.

THE BODY.

Plates V., VII., IX., X.

The Neural Spines of all the (13) Dorsal Vertebræ, especially where clear of the trapezius.

Neural Spines of all the (7) Lumbar Vertebræ.

Neural Spines of the Caudal Vertebræ, the first or that next the sacrum being the most prominent, and the rest less so in regular succession.

Curves or Bends of seven or more Ribs.

Lower Ends of seven or more Ribs, that is, the slight projections where the ribs unite with the costal cartilages.

Manubrium or Presternum, the prominent point of the breast bone or sternum; it forms a leading feature of the front view.

Tuberosities of the Ischium, one on each buttock.

Crest of the Ilium, or Hip Bone, a very important projection.

Keel of Sacrum, at the back upper part of the pelvis.

THE FORE-LEG.

Plates V., VI., IX., X., XIX.

Dorsal Edge of Scapula.

Spine of Scapula, showing as a groove in the living animal.

Acromion, the prominent outward point of the shoulder.

Coracoid Process, discernible but not prominent over the head of the humerus.

Head of Humerus, the prominent forward point of the shoulder.

Olecranon Process, or Point of Elbow, one of the most important bony projections.

External Epicondyle of Humerus, at the exterior of the elbow joint.

Capitellum or Head of Radius, just below the preceding.

Internal Epicondyle of Humerus, a prominent point on the inner side of the elbow joint, the only one in that region, as the head of the radius does not show on the inner side.

Pisiform, or Supercarpal, a small bone projecting from the back of the wrist. It is of cardinal importance.

Internal Malleolus of Radius, the prominent feature of the inner side of the wrist joint.

Tuberosity of Radius, in front, not very important.

Scapho-lunar, below the preceding, sometimes appearing also as a second slight boss in front below the radius.

Trapezium, below the preceding.

Head of the First Metacarpal, the lowest prominence on the inner side of the wrist.

Pyramidal, the prominent boss on the outside of the wrist joint.

Unciform, before and nearly on a level with the preceding—not very prominent.

Head of the Fifth Metacarpal, the strongest feature on the outer side of the wrist.

Heads of the Fourth and Third Metacarpals, forming protuberances in front below the carpus.

Sesamoids, small bones set in pairs, one pair under the end of each metacarpal.
The Knuckles or Joints of the Phalanges.

THE HIND-LEG.

Plates V., VI., IX., X., XXI.

Great Trochanter of Femur, a very strong feature.

External Tuberosity or Epicondyle of Femur, on the outside of the knee.

Head of the Fibula, below the preceding.

Patella or Knee-cap, the small bone that lies in front of the femur at the knee-joint.

Internal Tuberosity or Epicondyle of Femur, on inner side of knee.

Internal Tuberosity of Tibia, below the preceding.

Tuberosity or Crest of Tibia, projecting from the fore part of the tibial head. It is the prominent feature of the knee in profile.

External Malleolus, the tuberosity on the lower end of the fibula.

Internal Malleolus, the lower tuberosity of the tibia on the inner side of the hough.

Os calcis or Calcaneum, the heel bone, the great feature of the hough.

External Process of Calcaneum, a prominence on the outer side of the hough.

Cuboid, under the preceding, very variable.

Head or Tuberosity of External Metatarsal, the strongest feature of the lower and outer side of the hough.

Navicular or Scaphoid, the tuberosity of this bone is prominent on the inner side of the hough just below the internal malleolus.

Head or Tuberosity of the Internal Metatarsal, the most pronounced projection on the inner side of the joint.

Tuberosities of the Two Internal Metatarsals show in front.

Sesamoids, minute bones corresponding with those of the carpus.

The Knuckles or Joints of the Phalanges are the remaining bony protuberances.

CHAPTER IX.

THE MUSCLES OF THE DOG.

NOTE.—In the following descriptive catalogue, those muscles which influence visibly and individually the form, and are perceptible in the living Greyhound, are in heavy-faced type.

THE MUSCLES OF THE SKIN.

Plate VII.

Immediately underlying the skin, and adhering to it strongly, are two very thin sheets of muscle that envelop nearly the whole surface of the trunk. They have but little influence on the visible form, and must be carefully removed before a clear view of the important muscles can be obtained. These are :—

PANNICULUS CARNOSUS, or Flyshaker. A great thin sheet of muscular fibres covering the body under the skin. Its action is to move the skin, and its attachments are chiefly to it. But its fibres, which run obliquely downwards and forwards, leave the trunk at two places, and become definite elements of form, at the groin where they are the muscular basis of the loose flank, and behind the shoulder where this muscle, at its thickest, forms the roof of the arm-pit, and uniting with the latissimus it becomes apparently an auxiliary of that great muscle. Excepting at these two places it is of little consequence to the artist.

PANNICULUS CERVICIS (*Platysma myoides*). In two parts, upper and lower, the upper covering the neck and uniting on the face and throat with the lower. Its action is to draw back the lips, shake the skin and move the ears. It is no thicker than a sheet of paper, and is of no consequence to the artist. A small slip of this is attached to the front of the ear; as it draws the ear forward it has been called the 'Watching Muscle.'

THE MUSCLES OF THE HEAD.

There are about forty muscles in a Dog's head, but not more than a fourth of these are important, or need be studied individually, for it is only as a mass that they influence the visible form. The following is a classified list of these muscles. Those on the muzzle, lower jaw and hyoid region are briefly described, as some of them are distinguishable in the living animal.

The Muscles of the Mouth and Cheek.

Plates VII., VIII., X., XII.

I have failed to detect the individual form of any but four of these in the living Dog, but the complex mass surrounding the mouth is peculiar in shape and is important.

RISORIUS (*Risorius Santorini*).

ZYGOMATICUS MAJOR, running from the malar bone to the angle of the mouth.

Levator labii superioris alæque nasi (*Maxillaris*). This may be detected in the living animal on careful examination.

MALARIS OR ZYGOMATICUS MINOR, an unimportant auxiliary of the preceding. It is closely related to the *lachrymalis* of Hoofed Animals.

Levator labii superioris proprius (*Nasalis longus*), discernible on careful examination. This and the preceding are parts of the *Quadratus labii superioris*.

Levator anguli oris (*Caninus*). This may be discovered on careful examination.

INCISIVI, minute fibres connecting the orbicularis with the gums.

BUCCINATOR. This is divided into two parts, the *molaris* and the *buccalis*.

Orbicularis oris (*Sphincter oris, Labialis*), surrounding the mouth.

DEPRESSOR LABII INFERIORIS (*Quadratus labii inferioris, Maxillo-labial*).

The Muscles of the Eyelids.

Plate XII.

None but the first of these is individually discernible in the living animal, but the corrugations of the skin that they cause are very marked.

Orbicularis palpebrarum, surrounding the opening of the eye.

LEVATOR PALPEBRÆ SUPERIORIS, a minute and deep-lying muscle that raises the upper eyelid.

CORRUGATOR SUPERCILIARIS MEDIALIS, or inner frowning muscle.

CORRUGATOR SUPERCILIARIS LATERALIS, or outer frowning muscle.

The eyeball itself is held in place and moved by seven unimportant small muscles within the socket; four *Recti*, two *Obliqui*, and a *Choanoid* or *Retractor*.

The Auricular Sheet or the Muscles of the Outer Ear and Scalp.

Plates VII., VIII., X., XII.

Authorities differ greatly in their treatment of the thin but complex sheet of fibres that surrounds the base of the ear and causes the movements of that organ. None of the divisions or recognised muscles are discernible in the living animal, and in the dead they readily escape the notice of the dissector.

SCUTULARIS, subdivided into three parts, *intermedius, frontalis,* and *cervicalis*.

ATTOLLENS (*Auricularis superior, Levator auris medius*).

ATTRAHENS (*Auricularis anterior*). This muscle is divided into three parts, *superior, median* and *inferior*.

RETRAHENS (*Auricularis posterior, Cervico-auricularis, Occipito-auricularis*). This is subdivided into *longus, brevis* and *levator*.

PAROTIDEUS (*Depressor conchæ, Parotideo-auricularis*).

ROTATOR (*Scutulo-auricularis inferior,* or *internus*).

There are also several minute unimportant muscles connected with the cartilage of the ear; these are *Transversus*, *Helicis*, *Antitragicus*, *Tragicus major*, and *Tragicus minor*.

EPICRANIUS (*Occipitalis*). This is a thin sheet of fibre that moves the scalp.

THE MUSCLES OF THE LOWER JAW.

Plates VIII., XII.

Masseter. This is a very prominent muscle : it is divided into three layers or parts, which however need not be considered separately. Origin : zygomatic arch and malar bone. Insertion : into the concave outer surface of the ascending ramus of the lower jaw. Action : to raise the lower jaw and close the mouth.

Temporalis. Origin : on the side of the skull and from the bony crest bounding the temporal fossa or great space between the temporal bone and the zygoma; it fills this fossa. Insertion : the coronoid process and anterior border of ramus of lower jaw. Action : to close the mouth by raising the lower jaw.

Pterygoideus internus and **externus.** This is within the jaws; it is in two parts, the internal and external. Origin : the first, on the inside of the pterygoid bone which is in the back of the palate behind the palatine bone. Insertion : the hollow or inner face of ramus of lower jaw. Origin of the external part: on the outer side of pterygoid and surrounding bones. Insertion : the neck of the mandibular condyle. Action : to raise the jaw.

THE MUSCLES OF THE TONGUE AND THROAT.

Plates VIII., IX., X., XII., XVI., XXIII.

Digastricus (*Biventer maxillæ inferioris*). Origin : styloid process of the occipital bone. Insertion : one part into the posterior border of lower jaw, the other part into the internal face of same. Action : to depress the lower jaw and to open the mouth.

STYLO-HYOID. Origin : styloid process of the temporal bone and auditory bulla. Insertion : the base of the lesser cornu of the hyoid bone. Action : to draw the hyoid bones backward and upward.

MYLO-HYOID. Origin : on the inner side of the mandible. Insertion : the body of the hyoid. Action : to support or raise the tongue and the hyoid bone.

GENIO-HYOID. Origin : inside the lower mandible at the symphysis or chin suture. Insertion : the body of the hyoid. Action : to draw the hyoid forward.

STERNO-THYROID. Origin : inner surface of presternum or manubrium. Insertion : thyroid cartilage of larynx. May be perceived in some dogs while alive.

THYRO-HYOID. This is a sort of continuation of the last. Origin : thyroid cartilage. Insertion: the greater cornu of the hyoid bone.

STERNO-HYOID. Origin: inner surface of manubrium anterior to the sterno-thyroid. Insertion: the body of hyoid bone. Action: this, with the foregoing two, draws back the hyoid, &c.

STYLO-GLOSSUS. A large muscle arising from the styloid process of temporal bone, and passing into the tongue. It is the edge of the tongue. This and the following two are obviously of little importance.

HYO-GLOSSUS (*Basio-glossus*). A flat muscle from the body and cornua of the hyoid bone to the side of the tongue.

GENIO-GLOSSUS. A flat muscle from the under side of the tongue to the thyro-hyal.

Lingualis, longitudinal fibres, extending the length of the tongue, divided into *superficial* and *deep*. This forms the body of the tongue.

Closely related to the foregoing are seven pairs of very small deep-lying muscles that act upon the pharynx and soft palate, and yet other seven pairs which move the larynx.

CHAPTER X.

THE MUSCLES OF THE DOG (*continued*).

THE DEEP-LYING MUSCLES OF THE NECK.

Plates XIII , XIV., XV., XXIII.

THE following twelve muscles influence the form as a mass only, and therefore need not be studied in detail. In the subject they are very complicated and subject to much variation. The first four may be grouped together as parts of the *Prevertebral Mass,* and the remaining eight as parts of the *Erector colli* or *Postvertebral Mass.* Omitting the last two, the whole group has been styled the *Capital Muscles.*

LONGUS COLLI. Origin : from the first six dorsal vertebræ under the neck to all the cervical vertebræ but the first two or three. Insertion: the under side of atlas. Action: to curve the whole neck downwards.

COMPLEXUS MINOR (*Longissimus capitis, Trachelo-mastoideus, Transversalis capitis*). Origin: first four dorsal and last three or four cervical vertebræ. Insertion : mastoid process. A separate slip on the under side of this is attached to the wing of the atlas, and has been called the *Longus atlantis.* Action : to incline or bend the head.

RECTUS CAPITIS ANTICUS MAJOR (*Longus capitis*). Origin : transverse processes of all but the first and last cervical vertebræ. Insertion: under side of occipital bone. Action: to bend the head down or to one side.

RECTUS CAPITIS ANTICUS MINOR. Origin: the atlas. Insertion : under side of occipital bone. Action: to aid the foregoing.

RECTUS CAPITIS POSTICUS MAJOR. Origin : neural spine of axis. Insertion : occiput. Action : to raise the head.

RECTUS CAPITIS POSTICUS MINOR. Origin : the atlas. Insertion : occiput below preceding. Action: to lift the head.

RECTUS CAPITIS POSTICUS MEDIUS, closely related to the two foregoing.

RECTUS LATERALIS. Origin : wing of the atlas. Insertion : styloid process and surrounding portion of skull. Action: to turn the head.

OBLIQUUS INFERIORIS, a large muscle. Origin : neural spine of axis. Insertion : wings of the atlas. Action: to turn the atlas on the axis.

OBLIQUUS SUPERIORIS, a small muscle. Origin: transverse process of atlas. Insertion: the mastoid region. Action : to turn the head.

TRANSVERSO-SPINALIS CERVICIS, a continuation on the neck of the multifidus.

INTERTRANSVERSALIS, small muscles between the transverse processes of the vertebræ of the neck. Action : to incline the neck to one side.

THE MUSCLES OF THE NECK.

Plates VIII., XIII., XIV., XV., XXIII.

The following, though really belonging to the foregoing group, are more superficial, and are visible in the living animal. The first belongs to the Prevertebral group, and the other two to the Erector group.

Splenius (*Spino-transversalis*). This large muscle, with the preceding, has an important influence on the form of the neck. It is in two parts, *S. capitis* and *S. colli*. Origin : all along the neck and as far as fifth dorsal vertebra from the neural spines. Insertion : with the little complexus into the mastoid, and into the transverse processes of the upper cervical vertebræ. Action : to extend or incline the head.

Complexus major, a large and important muscle. Its upper part is sometimes treated separately as the *Semispinalis*. Origin: the last six cervical vertebræ, and the dorsal vertebræ as far as fourth. Insertion: occiput. Action : to extend the head or bend it to one side.

Longissimus cervicis (*Cervicalis descendens, Transversus cervicis*). Origin : on the spines of the first four or five thoracic vertebræ and on the longissimus dorsi, of which it is a continuation. Insertion : the transverse processes of the four or five last cervical vertebræ. Action : to raise the head and neck.

THE MUSCLES OF THE TRUNK.

Erector spinæ. This very large and complex mass of fibres involves the dorsal surface of the whole spinal column. If we consider it as one muscle, the following three must be looked on as parts of it. I have, however, treated them separately because they appear on the surface and as well-marked separate forms. Most of the authorities treat it as a number of closely related muscles, of which the most important parts, in addition to these three, are :—*Semispinalis, Multifidus spinæ, Rotatores spinæ Interspinales, Intertransversales*. But as the whole mass of these latter is so deeply seated as to have no influence on the external form, excepting as a mass, it may be well for the sake of simplicity to reckon them as one muscle under the above name. (Plates X., XIII., XIV., XV., XXIII.)

Longissimus dorsi (*Long Dorsal, Ilio-spinalis*). This large and important muscle is a part of the erector spinæ, it is especially noticeable in the loins, where, with the ilio-costalis and spinalis, it forms the long horizontal mass above the hollow of the flank. Origin: anterior margin of ilium and sacrum. Insertion : the seventh cervical vertebra, and also to all the thoracic and lumbar vertebræ by their transverse processes, and to the ribs. Action : to extend the spine or bend it to one side. (Plates X., XIII., XIV., XV., XXIII.)

Spinalis (*Spinalis dorsi et cervicis* or *colli*). This is but the inner part of the longissimus dorsi, and is therefore part of the erector spinæ. Origin : chiefly in the last dorsal and the lumbar vertebræ and from the sacrum. Insertion : the spinous processes of all the thoracic and cervical vertebræ except the atlas. Action : the same as that of the longissimus. (Plates XIII., XIV., XV.)

Ilio-costalis (*Sacro-lumbalis*). This is part of the erector spinæ. Origin: ilium and sacrum and the longissimus dorsi. Insertion: the seventh cervical vertebra and by a tendon to each rib. Action : to assist the two preceding and to aid in expiration. (Plates XIII., XIV., XV., XXIII.)

SERRATUS ANTICUS (*Serratus posticus superior*). Origin: by fascia from the spinal column. Insertion: by muscular digitations into each rib from second to tenth. Action : to lift the rib in inspiration. (Plates XIII., XIV., XXIII.)

SERRATUS POSTICUS (*Serratus posticus inferior*). Origin : by fascia from the foremost lumbar vertebræ. Insertion : into thirteenth, twelfth, eleventh, and tenth ribs. Action : to draw down these ribs in expiration. (Plate XIII.)

Serratus magnus (*Serratus anticus major*). This, though not a superficial muscle, is of great importance, as its large and peculiar form is always well marked on the living animal, but much more so

in the Cat tribe than in Dogs or Hoofed animals. Its cervical part is sometimes described separately as the *Levator anguli scapulæ*. Origin : by digitations from the first seven ribs and the last five cervical vertebræ. Insertion : the vertebral margin of the scapula. Action : to raise the trunk between the shoulders and the ribs in inspiration. (Plates XIII., XIV., XXIII.)

LEVATORES COSTARUM, small groups of fibres. Origin : dorsal transverse processes, passing obliquely backward to their insertion in the ribs. Action : to raise the ribs in inspiration. (Plate XXIII.)

Intercostales. These are fibres in two layers, *external* and *internal*, connecting the ribs, one, the outer, directed downwards and backwards ; the other, the inner, the reverse way. Action : in breathing. (Plates VIII., XIII., XIV., XV., XXIII.)

STERNALIS (*Transversus costarum*). Origin : anterior end of rectus abdominis close to the sternum at the third and fourth costal cartilages. Insertion : first rib just below insertion of scalenus. Action : an inspirator. (Plates XIII., XIV., XXIII.)

TRIANGULARIS STERNI. Origin : inside of sternum. Insertion : cartilages of the ribs. Action : an expirator. It is within the chest, and therefore not important to the artist.

Rectus abdominis. Origin : on the pubic bone. Insertion : into the xiphoid cartilage by muscular fibres and into the cartilages of the first five or six ribs by a tendon ; its muscle fibre ceases at the ninth rib, in front of this it is a narrow, ribbon-like tendon. Action : it is the principal flexor of the spine. (Plates VIII., XIII., XIV., XV., XVI., XXIII.)

Obliquus abdominis externus (*Great Oblique*). The lower edge of the fleshy part of this muscle forms the prominent ridge along the side of the hound. Origin : from the eight or nine hindermost ribs and the lumbar fascia. Insertion : the ilium, pubic bone and the fascia of the loin and groin. Action : in expiration or to flex the spine, or incline it laterally. (Plates VIII., XVI., XXIII.)

OBLIQUUS ABDOMINIS INTERNUS (*Small Oblique*). Origin : this lies under the preceding, and its fibres cross those of the great oblique nearly at right angles : it arises from the lumbar fascia and the ventral margin of the ilium and the pubic bone. Insertion : on the back end of the last rib and cartilages of the hindmost ribs. Action : to assist the preceding. (Plates XIII., XXIII.)

TRANSVERSALIS ABDOMINIS. Origin : this is the deepest of the abdominal muscles, its fibres are nearly perpendicular ; it arises from the cartilages of the ribs behind the diaphragm, and from the lumbar transverse processes. Insertion : the fibres extend downwards into an aponeurosis which unites with the rectus. Action : it forms a kind of elastic and contractile belt to support or compress the bowels. (Plates XIV., XXIII.)

The *Diaphragm*, and the minute muscles styled the *Inguinal* and *Preputial*, are omitted here, the first being entirely internal, and the others quite insignificant.

QUADRATUS LUMBORUM. This is within the abdominal cavity, and therefore not important. Origin : the inner face of two or three last ribs and most of the processes of the lumbar vertebræ on their under side. Insertion: chiefly on the ilium. Action : a flexor of the spine. (Plates XXII., XXIII.)

SCALENUS in two or sometimes three distinct parts, *anticus, medius,* and *posticus.* Origin : cervical vertebræ, chiefly the fifth. Insertion : on the ribs as far as the sixth near the sternum and by a tendon reaching as far as the ninth rib. Action : to draw the ribs forward and so expand the chest. This muscle is more important in the Cat than in the Dog, because in the former it is seen on the ribs farther behind the shoulder. (Plates VIII., XIII., XIV., XXIII.)

Trapezius. An important sheet of muscle in two parts. *Fore part*, origin : fascia in the middle of the neck and back as far as the middle of the scapula. Insertion : the spine of the scapula. *Hind part*, origin : spines of the dorsal vertebræ. Insertion : upper third of spine of scapula. Action : to raise the shoulder, or to carry it forward or backward. (Plates VIII., IX., X., XXIII.)

Angularis (*Levator scapulæ ventralis*). This has been called a ribbon of the trapezius. Origin : the atlas. Insertion : the acromion. Action : to lift the lower end of the scapula. (Plates VIII., IX., XXIII.)

Rʜᴏᴍʙᴏɪᴅᴇᴜs, in two parts, *dorsal* and *nuchal*. Origin: neural spines of six hinder cervical, and six or seven anterior dorsal vertebræ: a thin separate ribbon of this is inserted into the lambdoid ridge, and has been described as the *Levator scapulæ dorsalis*. Insertion of both parts, the vertebral margin of scapula. Action: to draw the shoulder upwards or backwards. (Plate XIII.)

Cephalo-humeral, consisting of two parts, a great thin variable sheet originating in the fascia behind the head; and a thick band of muscle under the first, originating on the mastoid process by a tendon. These two unite near the shoulder, on what is known as the clavicular tendon, because it marks the place where the clavicle bone ought to be, and are inserted into the lower end of the humerus around the fascia of the shoulder joint. Action: to advance the limb or to draw the limb and the head together. (Plates VIII., IX., X., XVI., XXIII.)

Mastoideus, or **Sterno-Mastoid.** This is more or less united with the preceding, sometimes they are described together as the *Sterno-cleido-mastoid,* or *Mastoido-humeralis*. Origin: the manubrium. Insertion: the mastoid process and also by fibres to the fascia of the occiput. Action: to depress the head. (Plates VIII., IX., X., XVI., XXIII.)

Latissimus dorsi (*Great Dorsal*), a large and important muscle. Origin: neural spines of vertebræ from the sixth dorsal, the fascia investing the loins and the last two or three ribs. Insertion: its tendon blending with that of the teres major and with the panniculus inserted into the humerus inside below the tuberosity, and also into the fascia enveloping the arm. Action: supports the arm and carries the trunk forward, &c. (Plates VIII., X., XXIII.)

.**Pectoralis superficialis** or **major.** A large and important muscle in two layers, a forward and a transverse. Origin: the manubrium and attachments of first four costal cartilages. Insertion: on and under the lesser tuberosity half-way down the humerus. Action: to adduct, flex and rotate inwards the fore-limb. (Plates VIII., IX., XIII., XVI., XXIII.)

Pectoralis profundus or **minor,** a large and important muscle, much disposed to split up into bundles, one for each part of the sternum. Origin: on the sternum from the xiphoid cartilage to the second rib. Insertion: to the inner tuberosity of the humerus. Action: to draw the shoulder downwards and backwards, and move the arm backward. (Plates VIII., IX., XIII., XVI., XXIII.)

CHAPTER XI.

THE MUSCLES OF THE DOG (*continued*).

THE MUSCLES OF THE SHOULDER.

Plates VII., VIII., IX., X., XIII., XVI., XXIII.

MOST muscles have more than one function. Many of the foregoing, though classed as muscles of the trunk, bear also on the limbs, &c.; the last nine should perhaps be considered as muscles of the fore-limb rather than of the trunk. The following are strictly muscles of the fore-limb.

Deltoid (*Abductor brachii*), in two portions. *Scapular part*, origin: spine of the scapula and surrounding aponeurosis. *Acromion part*, origin: acromion and adjacent parts of scapula. Insertion of both: the deltoid ridge on the outside of humerus. Action: to flex the shoulder joint and rotate the humerus outwards.

Supraspinatus. Origin: the whole surface of the front part of the scapula and its spine. Insertion: by a tendon to the inside of the great tuberosity of the humerus. Action: extends the humerus.

Infraspinatus. Origin: the whole extent of the infraspinatus fossa. Insertion: by a tendon to the external face of the great humeral tuberosity. Action: to abduct the humerus and rotate it outward.

TERES MINOR. Origin: posterior (axillary or caudal) border of scapula and by a small tendon from the external side of margin of glenoid cavity. Insertion: on the humerus near the top of the deltoid ridge. Action: to flex the shoulder joint.

TERES MAJOR. Origin: dorsal surface of scapula near the angle, and the posterior border of the subscapular muscle. Insertion: chiefly by its tendon to the internal tuberosity of the humerus. Action: to flex the shoulder joint and draw the arm back.

SUBSCAPULARIS. Origin: the whole under surface of scapula. Insertion: by thick tendon to the internal tuberosity of the humerus. Action: to extend the shoulder joint and push the arm forward.

THE MUSCLES OF THE ARM.

Plates VII., VIII., IX., X., XIII., XVI., XVII., XVIII., XXIII.

Biceps (*Biceps brachii, Coraco-radialis, Long Flexor of Arm*). Origin: by a thick tendon at base inside of the coracoid process. Insertion: by one tendon to the bicipital tuberosity of the radius and by a smaller tendon to the tuberosity of the ulna. Action: to flex the fore-arm.

Brachialis anticus (*Humeralis obliquus, Humeralis externalis*, or *Short Flexor of Arm*). Origin:

on the deltoid ridge of the humerus. Insertion: by a small tendon which forks and unites with the tendons of the biceps. Action: to flex the fore-arm.

CORACO-BRACHIALIS. Origin: the beak of the coracoid. Insertion: by a flat muscular band to the humerus by the internal tuberosity. Action: to advance the arm, and rotate it inwards, and extend the shoulder joint.

EPITROCHLEARIS (*External Dorso-epitrochlear, Extensor antibrachii longus, Tensor fasciæ antibrachii*), a muscle of but slight importance though superficial. I fail to detect it in the living Dog or Cat, though Mivart gives it great prominence in the latter. Origin: of its principal head in the fascia of the latissimus dorsi, of which it seems to be a mere slip; it is also attached to the spine of the scapula. Insertion: inner side of olecranon. Action: to draw the arm backwards and aid the triceps.

Triceps (*Anconeus longus, A. vastus,* or *Caput longus*). A very important and prominent muscle in four well-marked parts or heads—the *long,* the *outer,* the *inner,* and the *posterior heads.* Some authorities treat the four divisions of the triceps as one muscle, with four different origins and one insertion. Others treat them as four distinct muscles. As the divisions are quite well marked, it will be better for us to treat them separately. Nevertheless, in the living animal, the fossa between the long head and its tendon is much more pronounced than the depression between any two of the divisions of the triceps.

> Long Head. Origin: nearly the whole axillary or caudal border of scapula. Insertion: the top of the olecranon. Action: to extend the fore-arm.
>
> Outer Head (*Anconeus externus, A. brevis,* or *A. lateralis*). Origin: on the deltoid ridge or spine of the humerus. Insertion: the olecranon. Action: to extend the fore-arm.
>
> Inner Head (*Anconeus internus, A. medialis*). Origin: along the inner side of humerus below the lesser tuberosity. Insertion: chiefly by a tendon, to the inner side of the olecranon. Action: to extend the fore-arm.
>
> POSTERIOR or DEEP HEAD (*Anconeus posticus*). Situated behind the inner head and uniting with it near the olecranon. Origin: the under edge of the head of the humerus. Insertion: the olecranon fossa. Action: to extend the fore-arm.

Anconeus (*A. parvus* or *quintus*). Origin: the back of the external condylar process of humerus. Insertion: capsule of the elbow joint. Action: to raise the articular capsule that it covers and prevent it being pinched between the two bony surfaces, and to aid the triceps.

THE MUSCLES OF THE FORE-ARM.

Plates VIII., IX., XIII., XVI., XVII., XVIII., XIX., XXIII.

The muscles that belong strictly to the fore-arm group themselves as follows :—

> Six Extensors on the outer side and fore part of limb.
> Seven Flexors on the inner side and hind part of limb.
> Two Supinators.
> Two Pronators.

Extensor carpi radialis (*Extensor magnus, Radialis lateralis, R. externus* or *Anterior Extensor of the Metacarpus*), an important muscle. Origin: chiefly from the supracondylar ridge on the outer side of the humerus. Insertion: by two tendons to the upper ends of second and third metacarpals. Action: it extends the metacarpus on the fore-arm.

Extensor digitorum communis (*Ext. pedis, Anterior Ext. of Phalanges*). Origin: chiefly on the epicondyle. Insertion: by a four-forked tendon one branch into each of the digits except the first. Action: to extend these fingers and to help to extend the hand.

Extensor digitorum brevis (*Ext. digitorum lateralis, Ext. dig. tertii, quarti, quinti proprius, Ext. suffraginis* or *Lateral Extensor of Phalanges.*) Origin: chiefly from the external epicondyle.

Insertion: by a three-forked tendon to the three outer digits. Action: to extend these three digits and to help to extend the hand.

EXTENSOR POLLICIS LONGUS ET INDICIS PROPRIUS, a very small and unimportant muscle. Origin: with the oblique extensor on the outer border in the middle of the ulna. Insertion: the thumb and index by a two-forked tendon. Action: to extend the thumb and index.

Extensor carpi ulnaris. This muscle is one of the most striking features of the side of the arm. Origin: from the external epicondyle by a short strong tendon. Insertion: after forking it is inserted by a short wide posterior tendon into the pisiform, and by its long round tendon into the external metacarpal. Action: to extend the carpus with slight outward rotation.

EXTENSOR OBLIQUUS (*Extensor ossis metacarpi pollicis, Abductor longus pollicis,* or *Oblique Extensor of Metacarpus*). Origin: outer edge of ulna and radius. Insertion: head of the internal metacarpal. Action: to extend the first toe.

Flexor digitorum sublimis, or **Perforatus** (*Sublimis, Superficial Flexor of the Fingers, Outer Flexor*). Origin: the inner epicondyle. Insertion: by a tendon passing through the carpal sheath and in four branches to the second phalanx of each of the four main digits. Action: to flex the toes and the whole foot on the fore-arm.

Flexor digitorum profundus, or **Perforans** (*Deep Flexor of the Fingers*). The three parts of this complicated muscle have been described separately as *deep flexor, radial palmar,* and *ulnar palmar.* The deep flexor or humeral portion takes origin on the inner epicondyle; it is in three separate bundles of fibres. The radial palmar rises on the inner edge of the radius. The ulnar palmar rises on the back edge of the ulna. Insertion: these three parts unite in a tendon which passes through the carpal sheath and divides into five branches—one for each digit. Action: to flex the toes and foot.

PALMARIS LONGUS, a very small and unimportant muscle on the back of the perforans, and inserted by a two-forked tendon into the perforatus tendons near the toes. Action: to bend the hand.

Flexor carpi radialis (*Palmaris magnus, Radialis internus, R. medialis,* or *Internal Flexor of Metacarpus.* Origin: on the inner epicondyle. Insertion: by a two-forked tendon to the second and third metacarpals. Action: to flex the carpus on the fore-arm.

Flexor carpi ulnaris (*Ulnaris internus or medialis, Supercarpeus*). This, especially at its lower and tendinous end, is of prime importance in the form of the limb. Origin: in two parts—one from the inner epicondyle of the humerus, and the other from under side of the olecranon. Insertion: the two parts unite and are inserted into the pisiform and fifth metacarpal. Action: to flex the carpus and fore-foot or hand.

SUPINATOR LONGUS (*Brachio-radialis*). This muscle, so well developed in the Cat, is rudimentary or wanting in the Dog. Origin: with the extensor carpi radialis on the epicondyloid crest of the humerus. Insertion: on the inner face of the radius. Action: to turn the radius laterally outwards, *i.e.* to supinate the arm.

Supinator brevis. Origin: on the epicondyle of humerus and surrounding fascia, and on the outer side of the radius. Insertion: by its fleshy fibres to the inner edge of radius. Action: to turn the arm so that the paw turns inwards and upwards.

Pronator radii teres (*Round Pronator*). A marked feature of the inner surface. Origin: the inner epicondyle of the humerus. Insertion: the internal side about the middle of the radius. Action: to turn the paw downward and outwards by rotating the radius.

PRONATOR QUADRATUS (*Square Pronator*). A thick quadrilateral muscle with transverse fibres extending from the ulna to the radius nearly their whole length. Action: to counteract the supinators.

THE MUSCLES OF THE PAW.

Plate XIX.

In the paw of the Dog, are a number of small muscles, which however have but little effect on the visible form, excepting as a fleshy mass, under the flexor tendons of the fingers or fore-toes. They may be grouped together as the *Plantar Flexors*. According to Messrs. Ellenberger and Baum they are as follows:—

PALMARIS BREVIS.

LUMBRICALES.

INTEROSSEI.

ABDUCTOR POLLICIS BREVIS ET OPPONENS POLLICIS.

FLEXOR POLLICIS BREVIS.

ADDUCTOR POLLICIS.

ADDUCTOR MINIMI DIGITI.

FLEXOR BREVIS MINIMI DIGITI.

ABDUCTOR MINIMI DIGITI.

ADDUCTOR INDICIS.

CHAPTER XII.

THE MUSCLES OF THE DOG (*continued*).

THE MUSCLES OF THE HAUNCH.

Plates VIII., IX., X., XIII., XIV., XV., XX., XXII., XXIII.

PSOAS MAGNUS. It is within the abdominal cavity. Origin: on the under side of the last three or four lumbar vertebræ and on the edge of the ilium. Insertion: the internal or lesser trochanter of the femur. Action: to flex and rotate the thigh or flex and incline the lumbar region laterally when the thigh is fixed.

PSOAS PARVUS. Also within the abdominal cavity, and it is more properly a muscle of the trunk. Origin: the last three or four dorsal and the first one or two lumbar vertebræ. Insertion: the ilio-pectineal crest on the edge of the pelvic basin. Action: to flex the pelvis on the spine.

OBTURATOR INTERNUS. Origin : around the obturator foramen inside the pelvis. Insertion : by a tendon which passes out behind the sciatic or ischiatic ridge, and ends in the hollow behind the great trochanter. Action : to rotate the thigh outwards.

OBTURATOR EXTERNUS. Origin : on the under or outer side of the ischium and pubic bone opposite the preceding. Insertion : by a tendon into the hollow behind the great trochanter, near the preceding. Action : to rotate outwards and adduct the thigh.

Tensor vaginæ femoris (*Tensor fasciæ latæ*), in two parts, a *long* and a *short*. Origin : external angle of ilium. Insertion : into the fascia lata, vagina femoris, or sheath which envelops the side of the thigh and to some extent the underlying muscles individually. Action : to flex the thigh and make tense its sheath, the vagina femoris.

Gluteus maximus (*Superficial Gluteus*). Origin : arises by fascia from the membrane covering the sacrum, coccyx, and surrounding region. Insertion : into the great trochanter and into the fascia lata. Action : to abduct the thigh ; or it acts as an extensor, when the sacrum is fixed, and rotates the knee outward.

Gluteus medius. Origin : entire crest of ilium and surrounding fascia. Insertion : by a large tendon to the outer surface of the great trochanter. Action : to extend, rotate, or abduct the thigh, when the pelvis is fixed, but when the femur is fixed it causes the pelvis to rock, as in rearing.

GLUTEUS MINIMUS (*Deep Gluteus*). Origin: neck of ilium and sciatic spine. Insertion: low on the great trochanter. Action : to abduct the thigh and rotate the femur inwards.

PYRIFORMIS (*Pyramidalis*). Origin : chiefly on the ventral surface of sacrum, passing out by the sciatic notch. Insertion : the great trochanter with the gluteus medius. Action : to rotate the hind limb outwards and assist the glutei generally.

QUADRATUS FEMORIS. Origin: inferior surface of the ischium. Insertion: the back upper end of the femur. Action: to extend and adduct the femur.

GEMELLUS. In two parts, *anterior* or *superior*, and *posterior* or *inferior*. Origin: spine and tuberosity of ischium. Insertion: by a tendon that ends in the hollow behind the great trochanter. Action: to rotate the thigh outwards or carry it forward.

THE MUSCLES OF THE THIGH.

Plates VIII., IX., X., XIII., XIV., XX., XXII., XXIII.

Biceps femoris. This is the muscle whose sharp ridge is the prominent feature of the outside of the thigh at its under half. The ridge not only varies in different individuals, but often is quite different on the two sides of the same animal. Origin: on the ischiatic tuberosity and the ligaments which stretch between the ischium and the sacrum. Insertion: by a great aponeurosis which spreads over the tibial muscles, and is inserted into the knee, the tibial crest, the fascia lata, and by a tendon into the calcaneum. Action: it flexes the leg, renders tense the tibial fascia. When the leg is fixed it extends, rotates, or lateralises the pelvis on the femur.

A very thin, deep-lying, unimportant ribbon of the biceps has been described as the *Tenuissimus*. It arises in the sacro-sciatic ligament, and is inserted into the biceps down near the bottom of the femur.

Semitendinosus, in two parts. Origin: on the ischiatic tuberosity. Insertion: by a tendon passing over the internal surface of the tibia into its crest, and into the surrounding fascia. Action: to flex the knee and make tense its tibial aponeurosis, also it draws back the thigh and pushes the body forward.

Semimembranosus, in two very distinct parts, appearing like two separate muscles. Origin: ischiatic tuberosity and inferior face of ischium. Insertion: by two heads, one into the fascia about the inner epicondyle of the femur, and the other into the internal tuberosity of the tibia. Action: to adduct the limb, to extend the thigh, and to flex the knee.

Sartorius, in two very distinct parts. Origin: the external angle and ventral border of the ilium. Insertion: of one part the ligament of the patella, and of the other the internal head and neck of the tibia and surrounding fascia. Action: to adduct the leg and carry the thigh forward.

Quadriceps extensor cruris. This is the great extensor of the leg. It corresponds to the triceps of the arm. It arises by three heads in three separate parts as below. These have been treated as separate muscles, but all unite and have a common insertion into the tendon of the patella, and through it into the tuberosity of the tibia, and a common purpose of extending the knee joint.

The small deep-lying bundle of fibres that represents the *Crural* muscle of human anatomy, and constitutes the fourth head of the quadriceps, is in the Dog more or less fused with the adjoining parts of that great extensor.

 Rectus femoris. Origin: on part of the ventral margin of ilium and margin of acetabulum. This is the middle and superficial part of the quadriceps.

 Vastus externus. This is the muscle which chiefly gives form to the fore outer side of the thigh, though it is overlaid by the fascia lata. Origin: on the upper outer surface of the femur and on the great trochanter.

 Vastus internus. Origin: on the inner side of front of the femur under the great trochanter. This is the largest part of the quadriceps.

CAPSULARIS. This small muscle is considered by some writers as a deep portion of the quadriceps. Origin: from the front of the femur near the head. Insertion: into the capsule of the joint in front. Action: to draw the thigh forward.

Gracilis. Origin: by tendinous fascia from the symphysis of the pubes. Insertion: into the inner side of the tibia. Action: to adduct the thigh.

Pectineus. Origin: anterior part of pubic bone and brim of pelvis. Insertion: the back of the femur near its lower end. Action: to flex, adduct, and rotate inwards the femur.

Adductor magnus. Origin: on the pubic rami, from the symphysis to the tuberosity of the ischium. Insertion: the linea aspera at the back of the femur. Action: to adduct and rotate outwards the thigh and push the body forward.

The Muscles of the Lower Leg.

Plates VIII., IX., XIII., XX., XXI., XXIII.

Tibialis anticus. Origin: the external head of the tibia and surrounding fascia. Insertion: by a strong tendon into the rudimentary first metatarsal (apparently the head of the second). Action: to bend the foot forward and upwards on the leg.

Extensor pedis. Origin: by a strong tendon outside the outer epicondyle of the femur; it becomes a tendon passing through a loop on the ankle. Insertion: it forks in four tendons, one of which goes to each toe. Action: to extend the toes and draw the foot forward.

EXTENSOR POLLICIS LONGUS (*Long Extensor of the Great Toe*). A minute muscle intimately connected with the extensor pedis, and of no consequence to the artist.

Peroneus longus (*P. lateralis*). Origin: on the external tuberosity of the tibia. Insertion: its tendon passes down in front of the external malleolus, in front of fibula, and behind the foot, when it is apparently lost in the deep fascia, but it is really inserted near the head of first or rudimentary metatarsal. Action: to turn outwards the lower end of the limb.

PERONEUS BREVIS, an unimportant muscle. Origin: outer lower part of fibula and tibia. Insertion: into upper or proximal end of fifth metatarsal by a tendon which passes behind the external malleolus and under the tendon of the peroneus longus. Action: to flex the foot.

Gastrocnemius. Origin: chiefly by two principal heads, from the back of the femur above the two tuberosities on the sesamoid bones which develop in the tendons. Insertion: the summit of the calcaneum. Action: to extend the foot on the tibia.

Perforatus, or **Flexor digitorum sublimis** (*Superficial Flexor of Phalanges*). Origin: with the outer head of the gastrocnemius in the hollow behind the femur at the lower end. Insertion: by a tendon which passes over the calcaneum and forking in four tendons inserts one into each of the main digits. Action: to flex the toes, draw back the foot, and bend the knee.

Perforans (*Deep Flexor of the Phalanges, Flexor pedis*). Origin: In two distinct parts, a *large* or *outer* and a *small inner* or *auxiliary*, on the hinder surface of tibia, of fibula, and adjoining fascia forming two tendons, which unite after passing behind the internal malleolus, and in the plantar region again divide into four tendons which are inserted into the distal phalanges of the digits after perforating the tendons of the perforatus; it also gives off another thin tendon which forks and is inserted into the plantar pad. Action: to flex the toes and draw the foot backwards.

TIBIALIS POSTICUS, or FLEXOR ACCESSORIUS (*Oblique Flexor of Phalanges*), a very minute and unimportant muscle. Origin: on the hinder surface of head of fibula. Insertion: its tendon passes with the inner head of the deep flexor through a special groove in the internal malleolus, and is inserted into the fascia of the tarsus. Action: to flex or rotate the foot.

Popliteus. Origin: by a thick tendon on the external tuberosity of the femur. Insertion: posterior surface of the upper portion of the tibia. Action: to rotate the tibia sideways and outwards.

The Hind-Foot.

Plates XX., XXI.

Extensor brevis digitorum. Origin : in front of tarsus on calcaneum and cuboid. Insertion : by a tendon into each of the digits except the fifth. Action : to extend the toes.

Plantar flexors. Under this name I enter the mass of minute muscles in the sole of the foot. Several of them are like those already noted in the sole of the fore-paw or hand. The following is the list :—

Lumbricales.
Interossei.
Square fleshy flexor—related to the Perforans.
Adductor quinti digiti.
Adductor indicis.

CHAPTER XIII.

THE MUSCLES OF THE DOG (*continued*).

THE MUSCLES OF THE TAIL.

Plates VIII., IX., X., XIII., XIV., XV., XXII.

Erector (*Extensor coccygis*). This is in two parts, a *long* part, which is really a caudal continuation of the longissimus dorsi, and a *short*, next the spine and which is really a continuation of the spinalis. Origin : the processes of the lumbar and sacral vertebræ. Insertion : the caudal vertebræ. Action : to raise the tail.

Curvator, a small muscle outside of the preceding. It draws the tail sideways and upwards.

Coccygeus. Origin : inner side of ilium. Insertion : caudal vertebræ. Action : to depress the tail and draw it sideways.

Depressor (*Flexor coccygis*), in two distinct parts, an *outer* or *long,* and an *inner* or *short.* Origin : on each side of sacrum and coccyx. Insertion : on caudal vertebræ. Action : to depress the tail.

The INTERTRANSVERSALES are minute muscles between the processes of the caudal vetebræ. In some animals these are very well developed, but in the Dog they are too small to need description.

THE MUSCLES OF THE ANUS.

Plates XIV., XXII.

LEVATOR ANI, attached to the inner face of the pelvic bones, to the caudal vertebræ and to the anus. Action: to constrict the anus.

SPHINCTER ANI, in three parts, *outer*, *inner*, and *mediator.* Action : to close the anus.

TRANSVERSUS PERINEI, an unimportant muscle, attached to the bulbo-cavernosus.

BULBO-CAVERNOSUS, a somewhat prominent muscle in the male ; it envelops the bulb of the urethra, and is a constrictor of the same.

ISCHIO-CAVERNOSUS, a small muscle connected with the foregoing.

CHAPTER XIV.

THE SIZE AND PROPORTIONS OF THE DOG.

Plate XXIV.

THE Great Dane, the Irish Wolfhound, and the Mastiff are the largest of the Dogs. They range from 30 to 34 inches at the shoulder, and specimens as high as 35 inches are on record; such animals attain a weight of 200 lbs.

St. Bernards are nearly as large; indeed the celebrated Sir Bedivere was $33\frac{1}{2}$ inches at the shoulder, with a weight of 212 lbs.

Greyhounds are from 24 to 27 inches at the shoulder, and weigh 60 or 70 lbs.

The dimensions of a large Dog of unknown breed will be found in the table of bone measurements.

There are many reasons for believing that the Dog is a thoroughly domesticated Yellow Wolf, a smaller animal than the true Wolf (*Canis lupus*). For although we see enormous Dogs far surpassing in size the ordinary Wolf, it is not hard to find in these giants visible and constitutional defects which stamp them clearly as mere giantisms, cases of over-development. The following illustrates this point:—A child is about 5 heads in height, a man about $7\frac{1}{2}$, and a giant 10 or 11. Thus it may be readily discerned that the size of the head in man is the least variable of the dimensions. The same rule applies in the other species. A Tiger but 2 heads in height at the shoulder would be a cub or a dwarf, and a Tiger 3 heads high a giant. A Dog of any large thoroughbred race is 3 heads high; his wild kinsman, the Wolf, is but $2\frac{1}{2}$. But if we let any kind or number of breeds of Dog revert to their ancestral type, so as to re-establish their original size and form, we shall infallibly get a yellowish, wolfish, prick-eared animal about 23 inches high at the shoulder—*i.e.*, smaller than a Wolf but of like proportions, its body going in a square of $2\frac{1}{2}$ heads. (See Plate XXIV.)

The fifth toe or ' dew-claw,' which frequently appears on the hind feet of large Dogs, is a blemish, a reversion to some five-toed ancestral form, another proof that these Dogs are physically over-developed. An examination of some scores of Gray Wolves and over a hundred Coyotés has failed to discover a single instance of this malformation.

In the Dog and all carnivores, the lower canines are in front of the upper when the jaws are closed. This is an important element of expression.

In all carnivores, perhaps in all true quadrupeds, the fore feet are larger than the hind feet.

The above remarks on proportion apply as as well to the Greyhound; for although it gives the impression of being very long and thin, it is in fact of much the same proportions as a Foxhound, Great Dane, Newfoundland, &c. The difference is chiefly in the loose integuments and fur which in this animal are greatly reduced.

It is worthy of notice that all swift-footed animals go in a square, or else are higher than long. There are however exceptions to this rule: for example, the Elephant is $2\frac{1}{2}$ heads in height by 2 in length, and is

a slow, clumsy animal beside the Rhinoceros, which is 2 heads in height by 3 heads in length, and is remarkable for its activity and speed.

In nearly every case the proportional measurements given are bone measurements. The head however, not the skull, is the standard; it is measured from the point of the occipital tuberosity to the point of the nose. When it is the skeleton that is being measured, add one-tenth to the length of the skull to give the length of the head. Sometimes it is not possible to see the point of the occiput in the living animal on account of the fur or ears obscuring the region; it will be found on a line with the back edge of the ear when the latter is directed forward, or with the back edge of the opening of the ear when it is in a normal position.

The square that includes the body is drawn just before the head of the humerus to the height of the shoulder, thence to the top of the hip-bone or ilium, and back of the ischiatic tuberosity to the base line.

Although on Plate XXIV. the proportions of the Dog are clearly set forth, they will be given categorically, so that the more important ones may be emphasised:—

1. **The body goes in a square whose side** equals 3 heads
2. **At half the height of the sides of the square are the knee and elbow joints E, F.**
3. Through the deepest part of the chest „ $1\frac{1}{3}$ head
4. The neck above, from the occiput A to the end of the neck-thatch or mane G „ 1 „
5. The neck below „ 1 „
6. **The length of the neck vertebræ, i.e., the interior line of the neck, C D** ... „ 1 „
7. The depth of the neck at base „ 1 „
8. **The length of the humerus** „ 1 „
9. „ „ „ „ **radius** „ 1 „
10. „ „ „ „ **femur** „ 1 „
11. „ „ „ „ **tibia** „ 1 „
12. The width of the body through the biceps of the thigh, i.e., the widest point N ... „ 1 „
13. **The length of the scapula** „ $\frac{3}{4}$ „
14. The width of the chest at at its widest point O „ $\frac{3}{4}$ „
15. „ „ „ **shoulder through the acromions** „ $\frac{3}{4}$ „
16. The depth of the loins „ $\frac{3}{4}$ „
17. The width of the thigh at H I „ $\frac{3}{4}$ „
18. **The length of the foot L M** „ $\frac{3}{4}$ „
19. The depth of the head from throat to front „ $\frac{1}{2}$ „
20. „ „ „ „ neck at throat „ $\frac{1}{2}$ „
21. **The length of the fore-foot from P to the ground** „ $\frac{1}{2}$ „

CHAPTER XV.

THE ANATOMY, SIZE, AND PROPORTIONS OF THE WOLF.

(*Canis lupus*).

Plates I., XXIV.

ACCORDING to the best authorities there is no constant or reliable difference between the Wolves of Europe, Northern Asia, and North America. The various terms—Russian Wolf, Common Wolf of Europe, White Wolf, Timber Wolf, Buffalo Wolf, Gray Wolf, etc., are then to be understood either as synonyms or as names of local varieties of *Canis lupus*.

The Wolf is simply a large wild Dog, and differs from the domesticated species more in appearance than in anatomical details.

An ordinary male wolf is from 27 to 28 inches in height at the shoulder, and about 3 feet 9 inches in length of the head and body. When in good condition he weighs from 90 to 100 lbs. The females are smaller.

The following are the dimensions of a fair-sized American Gray Wolf, a male ; they were taken immediately after death :—

	Feet.	Inches.
Length from top of nose to end of bone in tail	5	2
Tail bones	1	4
Height at shoulder	2	3
Girth of fore-arm	—	$8\frac{1}{4}$
Girth of neck...	1	6
Girth of chest	2	$4\frac{1}{2}$

Weight, 102 lbs.

This species, however, seems to be subject to great variation, and specimens weighing as much as 150 lbs. are on record.

Sir John Richardson gives the following dimensions of a Gray Wolf that was starved to death at Fort Franklin, April 1821 :

	Feet.	Inches.
Length of head and body	4	2
Tail	1	7
Height at shoulder	2	8

Franklin mentions a large White Wolf that measured as follows :

		Feet.	Inches.
Length of head and body	4	4
Tail	I	7
Height at shoulder	2	10
Girth behind fore-legs	2	6

Audubon and Bachman give the following measurements of an American Gray Wolf in winter pelage.

		Feet.	Inches.
Length from point of nose to root of tail	4	—
„ of tail (vertebræ)	I	I
„ to end of hair	I	5
Height of ear	—	4
Breadth of ear	—	3
From point of nose to end of skull	—	$11\frac{1}{2}$
From eye to point of nose	—	5
From shoulders to longest nail	2	4
Longest upper canine tooth	—	$1\frac{1}{2}$
Length of the hair on the back	—	3 to 4

The proportions of the bone lengths of the Wolf are the same as those of the Greyhound, if we add one quarter to the head and neck after constructing on the plan of the Dog. Or in other words, if we take the humerus as the unit or standard, the head $=1\frac{1}{4}$, the neck $=1\frac{1}{4}$, and the other proportions are as in the Greyhound (see Plate XXIV.). The Wolf, however, has the forequarters more robustly made, to correspond with the heavier head and neck ; his loins are heavier, and his coat of fur is well developed.

The Coyoté or Prairie Wolf (*Canis latrans*) might well be styled the American Jackal. It is a small Wolf standing about 20 inches high at the shoulder with a weight of about 25 lbs.

CHAPTER XVI.

THE FOX.

THE Fox resembles the Dog and Wolf in its general anatomy and proportions; its chief visible differences being the smaller, lighter form, the sharper nose, larger ears, bushier tail, and the linear pupil of the eye. The arrangements of hair, described in Chapter I. are largely lost sight of in the Fox.

The following measurements of the European Red Fox are given by Bell (*Brit. Quad.*) :—

															Feet.	Inches.
Length of the head and body	2	$3\frac{1}{2}$
,, ,, ,, head		—	6	
,, ,, ,, ears		—	$3\frac{3}{4}$	
,, ,, ,, tail			I	4	
Medium height at the shoulders				I	$2\frac{1}{4}$	

Audubon and Bachman give the following measurements of the American Red Fox :—

														Feet.	Inches.
From point of nose to root of tail			2	6
Tail (vertebræ)			I	I
Tail to end of hair			I	5
Height at shoulder			I	I
Height of ear posteriorly			—	$2\frac{3}{4}$

Mivart (*Monog. Canidæ*), after weighing the claims to separation of the American and European Red Foxes, says, 'We cannot hesitate to unite them under one title, *Canis vulpes.*'

The Red Fox of Europe, the Common Fox of America, and the Jackal of Central Africa (*Canis adusta*) invariably have the tail terminated in a white tip. The Gray Wolf and the Prairie Wolf, on the other hand, have the tail tip black. And the Dog, notwithstanding its kinship to the Wolf, if it has any pure white on the body, always has a white tip, or at least a few white hairs, in the end of the tail.

CHAPTER XVII.

THE ANATOMY, SIZE AND PROPORTIONS OF THE CAT.

Plate XXV.

THE anatomy of the Cat bears a general resemblance to that of the Dog. The differences are chiefly matters of degree, as will be seen on comparing Plates VIII. and XXV. There are, however, some positive differences which should be kept in mind,—thus, all Cats have a clavicle, or collar-bone, in each shoulder, it is small but morphologically important; on the spine of the scapula is a process, called the metacromion, that is like a second acromion; and the claws with their sheaths, as well as the muscles which govern them, are highly developed so as to be sharp, recurved, and eminently retractile weapons. The whole skeleton is more elastic and better jointed, although the rest of the bones are similar to those of the Dog.

The Cat has also more and better developed muscles. Thus, in the fore-leg the supinator longus is far from being rudimentary; in the hind-leg it has the soleus ; and according to Mivart, it has on the breast a second sternalis.

The shoulder has so much play that the scapula may touch the jaw, or slide back as far as the eighth or tenth rib ; while the muscles regulating these movements are greatly developed, endowing the Cat with remarkable power for climbing and for striking blows.

But these differences, it will be seen, are secondary matters, and would not impair the truth of the broad statement, that in their Art Anatomy the Dog and the Cat are identical.

An average female of the ordinary House Cat measured as follows :—

	Feet.	Inches.
Length of head ...	—	$3\frac{9}{16}$
Length of neck from occiput to point of scapula ...	—	$3\frac{9}{16}$
Length of body from point of manubrium to point of ischium ...	—	$11\frac{5}{8}$
Total length from point of nose to point of ischium ...	I	$5\frac{3}{4}$
Height at shoulder ...	—	$8\frac{7}{8}$
Length of tail ...	—	$8\frac{7}{8}$

Males are, of course, larger and heavier, but the relative bone lengths are the same.
The proportions are, as will be seen in the above :—

Total length of head and body ...	equals	5	heads
Height at shoulder equals half the total length	,,	$2\frac{1}{2}$,,
Length of tail equals half the total length ...	,,	$2\frac{1}{2}$,,
Length of body from manubrium to ischium ...	,,	$3\frac{1}{4}$,,

The proportions of the limb bones will be found to agree exactly with those of the Lion indicated on Plate XXVII., although the relative length and height of the body are not the same. The Cat and its kind are thus too low and long to fill a square, as do the Dog, Horse, Deer, &c.

It is worthy of note that, whatever be the figure that includes the animal's body, the same figure of but half the dimensions usually appears in the space that is comprised by the belly, legs, and ground.

In the Cat family, add $\frac{1}{16}$th to the length of the skull to find the length of the head in life.

CHAPTER XVIII.

THE ANATOMY, SIZE AND PROPORTIONS OF THE LION.

Plates IV., XXVI.

IT is now generally conceded that there is only one species of Lion, though there are, perhaps, four varieties:—the Indian Lion, with very little mane; the Babylonian Lion, with the shoulder covered with mane; the North African Lion, with the mane usually black; and the South African Lion, with the mane usually yellow. The Lion in its muscular and bony anatomy closely resembles the Cat. The chief differences are the slightly dissimilar proportions; the mane and other hairy developments. On Plate IV. is given a plan of the Lion's mane; it will be found to agree in general disposition with the plan of hair arrangement indicated in Chapter I. and Plate I. But on the shoulder is a curious centre of divergence that is seen only in the large Cats; it is of course well marked in the Lioness. There is another centre of this sort in the middle of the pelvic region of the spine. These various radiations of hair have been used to great advantage by Barye in his different Lion groups.

Lions vary greatly in the extent, length, and arrangement of the mane. In some it covers the entire shoulder. But the naked-shouldered Lion is the sculptor's favourite; it has all the picturesque effect of the mane about its great head and throat, and yet on the shoulder exhibits the powerful muscles that are capable of such surprising feats. The hair-tufts that grow on the elbow, on the belly, and on the end of the tail, conform to the general rules in Chapter I., but are subject to extreme individual variation. It is well to remember also that the wild Lion never has a mane as long as that of the Lion in captivity, the combing and teasing of the brush and grass through which the animal crawls having the effect of keeping the mane very short.

According to Mr. R. A. Sterndale (*Mammals of India*), an Asiatic Lion is from 6 to $6\frac{1}{2}$ feet from nose to insertion of tail; the tail itself is from $2\frac{1}{2}$ to 3 feet long; the height at the shoulder is $3\frac{1}{2}$ feet. The same author mentions that the weight of a Lion which was 8 feet $9\frac{1}{2}$ inches in total length, was 490 lbs. after the entrails were removed.

Mr. W. T. Blanford (*Fauna of India*) records a Lion that was 8 feet $9\frac{1}{2}$ inches long, and 3 feet 6 inches at the shoulder.

According to Vogt, a Lion reaches a weight of 200 kilos, or about 441 lbs.

The following measurements from living specimens in the Jardin des Plantes were taken by the writer in 1895:—

	Feet.	Inches.
Lion, height at top of scapula ...	2	$10\frac{3}{4}$
„ „ „ „ „ „ ...	3	$0\frac{1}{4}$
„ „ „ „ „ „ ...	3	$1\frac{3}{4}$
Lioness „ „ „ „ „ ...	2	8
„ „ „ „ „ „ ...	2	$10\frac{1}{4}$

The average length of three Lions, measured in skeleton, was 5 feet 5⅓ inches from the nose to the ischium. The average height at shoulder of nine Lions was 33½ inches. A large skeleton, known as 'Cuvier's Lion,' measured by De Blainville, gives an approximate height at the shoulder when alive of 39½ inches.

In estimating the height of the animal from the skeleton, take five-sixths of the sum of length of scapula, length of humerus, length of radius, and distance from wrist-joint to the ground.

In its proportions the Lion differs from the true Cats, and approximates rather to the Dog form, as will be seen on comparing the Plates XXIV. and XXVII. In brief :—

 A Dog goes in a square of 3 heads.
 A Lion goes in a rectangle of 2½ heads in height by 3 heads in length.
 A Cat goes in a rectangle of 2½ heads in height by 3¼ heads in length.

The Lioness presents no striking proportional differences. In the table (Chapter L.) are given measurements of a Lion and of a Lioness.

CHAPTER XIX.

THE ANATOMY, SIZE AND PROPORTIONS OF THE TIGER.

ALTHOUGH the Lion is popularly called the king of beasts, most sportsmen agree that the Tiger is a larger, stronger, and more formidable animal.

Mr. Sterndale says in this connection : 'I should say that the Tiger was the more formidable of the two, as he is, I believe, superior in size. . . . I usually found the Tiger the larger of the two.'

Mr. Blanford says : 'Of the two, the Tiger, though standing lower, is heavier in the body and, I think, the more powerful animal.'

Colonel G. A. Sweny, a sportsman of some African and many years' Indian experience, writes me that he agrees with Mr. Blanford in the foregoing, and adds : 'The average full-grown male Tiger, in the Central Provinces of India, will weigh, when in good condition, about 400 lbs., but the female not more than 330 lbs. Average height at shoulder of male about 3 feet 4 inches; females considerably smaller. Assuming that my estimate of 400 lbs. is a reasonable average for the full-grown male, I have certainly seen a dead Tiger which weighed over 500 lbs., but only one.'

According to Colonel Percy (Badminton Library), 'The Lion is a less active animal than the Tiger, and apparently not so powerful; in every case of a fight between the two occurring in a menagerie, the Tiger has invariably killed his opponent.'

According to Jerdon : 'An average Tiger is 9 to 9½ feet in total length, or occasionally 10 feet.'

Sterndale gives the following :—

Measurements of two very large Tigers.

Length.	Girth of Chest.	Girth of Head.	Tail.	Girth of Fore-arm.	Height.
11 ft. 0 in.	4 ft. 6 in.	2 ft. 10 in.	3 ft. 4 in.	2 ft. 2 in.	3 ft. 7 in.
10 „ 2 „	6 „ 1 „	3 „ 5 „	3 „ 1 „	2 „ 10 „	3 „ 9 „

Measurements of the largest Tigress among seventy or eighty that came under his notice :—

	Feet.	Inches.
Length of Head and body	5	2
„ „ „ „ tail	3	2
Total	8	4

He gives a medium-sized Tiger at 9 feet 8¾ inches, of which the tail was 3 feet; and adds these measurements of a male :—

	Feet.	Inches.
Length	9	5
Tail	2	10
Heel to shoulder	3	2

											Feet.	Inches.
Shoulder to point of toe...	3	11
Elbow to point of toe	2	—
Girth behind shoulder	5	3
Girth of fore-arm	2	7
Girth of neck	3	—
Circumference of head	3	3

According to Blanford, 'Sanderson found a bulky, well-fed male Tiger to weigh 25 stone (350 lbs.), and Elliot gives the weight of two large male Tigers as 360 and 380 lbs., and of a large Tigress 240 lbs.'

The following measurements from living specimens in the Jardin des Plantes were taken by the writer in 1895:—

									Feet.	Inches.
Tiger, adult, height at top of scapula	2	$11\frac{1}{16}$
,, ,, ,, ,, ,, ,, ,,	2	$10\frac{1}{4}$
,, young, ,, ,, ,, ,, ,,	2	$6\frac{15}{16}$
Tigress, adult ,, ,, ,, ,, ,,	2	$9\frac{1}{8}$
,, ,, ,, ,, ,, ,, ,,	2	$7\frac{1}{2}$
,, ,, ,, ,, ,, ,, ,,	2	$5\frac{1}{2}$

The average of seven measurements of head and body is 6 feet $2\frac{2}{7}$ inches; and the average of nine measurements of height at shoulder is a trifle over $35\frac{1}{2}$ inches. These figures show that the Tiger is proportionately longer, as well as a somewhat larger animal than the Lion.

On the Tiger's shoulder is found the centre of hair divergence that becomes so prominent in the Lion on account of its effect on the mane. This centre is seen also in the Jaguar and Leopard.

The Tiger is identical with the Cat in all other details of anatomy and proportions.

In the table (Chapter L.) is given a series of bone measurements.

CHAPTER XX.

THE JAGUAR.

(*Felis onça.*)

THE Jaguar of South America is in effect a large Leopard. It is extremely variable in size; the specimen now living in the Jardin des Plantes is but 24 inches high at the shoulder; and yet Azara speaks of one that was 2 feet 9 inches high, its measurements being :—

			Feet.	Inches.
Length			6	9
Tail			2	2
Circumference of root of the tail			—	8
„ „ neck			2	1½
„ „ fore-leg at the middle			1	2¼
„ „ ankle			—	8½
„ „ head close to the ears			2	2½
„ „ chest			3	11½
„ „ hind part of body			2	11
Height at shoulder			2	9
Length of head as far as occiput			1	0½
Height of ear			—	2⅓
Width „ „			—	2¾

There is, in the Museum of the Jardin des Plantes, the skeleton of a male which is even larger, it fairly rivals the Lion in size.

Its measurements are :—

			Feet.	Inches.
Length of skull			1	1½
„ „ head in life, about			1	2¼
„ „ cervical vertebræ			—	10
„ „ dorsal vertebræ to point of ilium			2	10
From front of ilium to back of sacrum			—	6
„ nose to sacrum			5	4
Height at shoulder			2	9½
From manubrium to ischium			3	8½

These, however, are exceptionally large individuals. Audubon gives an average specimen thus :—

			Feet.	Inches.
Nose to root of tail			4	1
Length of tail			2	1
Height of ear			—	2¾
Shoulder to end of claw			2	—
Length of largest claw			—	2
Around the wrist			—	7½
Around the chest			3	—
Around the head			1	9¾
Breadth between eyes			—	3

The proportions of the Jaguar are like those of the Cat.

CHAPTER XXI.

THE LEOPARD.

(*Felis pardus.*)

NATURALISTS now recognise but one species of true Leopard. It is spread over Africa and Southern Asia, and varies in colour with the climate, being reddish, yellowish, grayish, and even black, according to the region.

Sterndale states that it ranges

from 3 to $5\frac{1}{2}$ feet in length of body
„ $2\frac{1}{2}$ to 3 feet 2 inches in length of tail
„ $1\frac{1}{2}$ to 2 feet „ height

The largest one measured in Ceylon by Dr. Kelaart was :—

	Feet.	Inches.
Head and body	3	4
Tail	3	2
Height at shoulder	2	4

The following living specimens were measured by the writer in the Jardin des Plantes in 1895 :—

	Feet.	Inches.
Leopard male from the Congo, height at shoulder	2	$1\frac{5}{8}$
„ „ „ „ „ „ „ „	2	$1\frac{5}{8}$
„ „ „ „ India „ „ „	2	1
„ female „ „ ? „ „ „	1	$9\frac{1}{8}$

The skeleton of a small male measured as follows :—Skull, $7\frac{3}{4}$ inches; head, in life, $8\frac{1}{4}$ inches; shoulder to ischium, 24 inches; height at shoulder, 20 inches.

The proportions of the Leopard are similar to those of the Cat.

It may be considered as a small Tiger, and two-thirds of the dimensions given for the bones of the Tiger in Chapter L. will fairly represent the Leopard.

CHAPTER XXII.

THE COUGAR, PUMA, PANTHER, OR MOUNTAIN LION.

(*Felis concolor.*)

THIS is simply a large Cat of extraordinary agility and suppleness. In all its proportions and anatomy, it agrees with the Cat.

When young it is variegated, like most of the Felidæ, with black spots on the body, and rings on the tail. But these markings disappear as it matures, in order, it is supposed, to make it more like the Deer upon which it preys.

Audubon and Bachman give the following measurements :—

Male shot by J. W. Audubon, at Castroville, Texas, January 28th, 1846.

	Feet.	Inches.
From point of nose to root of tail	5	1
Tail	3	1
Height of ear posteriorly	—	3
Length of canine teeth from gums	—	$1\frac{3}{4}$

Female, killed January 26th, 1846.

	Feet.	Inches.
Length of head and body	4	11
„ „ tail	2	8
Height of ear	—	3
Length of canine teeth	—	$1\frac{1}{2}$

Weight 149 lbs.

Dr. C. H. Merriam says :—

'In the Adirondacks it is an uncommonly large Panther that measures 8 feet from the end of its nose to the tip of its tail, and an unusually heavy one that weighs 150 lbs. * * * * Shot a male on Seventh Lake Mountain, that weighed about 200 lbs. This is the heaviest Panther concerning which I have been able to procure trustworthy information. * * * * An adult Panther stands about $2\frac{1}{2}$ feet high at the shoulders.'

Mr. Rowley gives me the following measurements :—Panther, male, from Central Park Menagerie, New York : total length, 82 inches ; tail, 29 inches ; hind-foot, from point of calcaneum to point of longest toe, 11 inches.

Also another male from Barnum and Bailey's circus : total length, 84 inches ; tail, 30 inches ; hind-foot, 11 inches.

CHAPTER XXIII.

THE CHEETAH, CHITA, OR HUNTING LEOPARD.

(*Cynailurus jubatus.*)

THIS remarkable animal, although classed with the Cats, has somewhat of the Dog in its form, anatomy, habits, and proportions. It is long-legged, going in a square of three heads; its paws are but little prehensile, its claws are blunt and non-retractile, and it cannot climb. It is the species which properly bears the name 'Leopard,' as it was supposed by the ancients to be a hybrid between a Lion and a Pard or Panther; but the present allotment of names is according to modern usage.

Mr. Blanford says, 'It is probable that for a short distance the Hunting Leopard is the swiftest of all mammals.'

According to Jerdon :—

	Feet.	Inches.		Feet.	Inches.
Length of head and body about	—	—	...	4	6
Tail	—	—	...	2	6
Height	2	6	to	2	9
Basilar length of a skull...	—	5·35
Width across zygomatic arches	—	4·55

CHAPTER XXIV.

THE BEAR FAMILY.

In the Anatomy of the Bears the most important external difference from the Dogs and Cats is the plantigrade hind-foot, which is like the foot of man in being relatively short and so formed that the whole surface, from the heel or calcaneum to the toes, is set on the ground. The Bears also have on each foot five fully developed toes, with long non-retractile claws; the first toe on the fore-foot is on a level with the rest. The pointed muzzle, the small, close-set eyes, the rounded ears, the in-toeing of the fore-paws, the shaggy coat, the high arching of the back, the diminutive tail, and the lowness of its position are the other important peculiarities.

As in the Cats the edge of the scapula rises above the line of the dorsal spines, causing the shoulder hump—and the limbs are so articulated as to give them remarkable flexibility and play. But they resemble the Dogs in having no trace of a clavicle.

The Grizzly, Brown, and Black Bears go in a square of two heads.[1] The neck is three-quarters of a head long, the width at the shoulders one head, and at the trochanters three-quarters of a head.

[1] The arch of the back, however, rises considerably above the line ; but for the shortening of the body by this arch, it would be too long to form a square, as is seen in the table of measurements.

CHAPTER XXV.

THE GRIZZLY BEAR.

A GRIZZLY BEAR killed by Lewis and Clark near the Porcupine River, measured as follows :—

	Feet.	Inches.
Length from the nose to the extremity of the hind-foot	8	7½
Circumference near the fore-legs	5	10½
„ of the neck	3	11
„ „ „ middle of the fore-leg	1	11
Length of the talons	—	4⅜

To this Ord adds, 'His weight on conjecture was between 500 and 600 lbs. But this was not the largest Bear killed by the party. They give an account of one which measured 9 feet from the nose to the extremity of the tail; and the talons of another were 6¼ inches in length.'

Audubon and Bachman give the following :—Male, killed by J. J. Audubon and party on the Missouri River, in 1843, not full grown.

	Feet.	Inches.
From point of nose to root of tail	5	6
Tail (vertebræ)	—	3
„ (including hair)	—	4
From point of nose to ear	1	4
Width of ear	—	3½
Length of eye	—	1
Height at shoulder	3	5
„ „ rump	4	7
Length of palm of fore-foot	—	8
Breadth „ „ „ „	—	6
Length of sole of hind-foot	—	9½
Breadth „ „ „ „	—	5½
Girth around the body behind the shoulders	4	1
Width between the ears on the skull	—	7½

The following are the principal measurements of the Grizzly Bear skeleton, of which the full details are given in the table, Chapter L.

	Feet.	Inches.
Length of head in life	1	5½
„ „ neck	—	11½
Manubrium to ischium	3	10
Height at shoulder in life	3	2
Width between acromions	1	6
„ „ trochanters	1	1

CHAPTER XXVI.

THE BROWN BEAR OF EUROPE.

THIS animal closely resembles the Grizzly in its anatomical details; some old authorities have considered them as identical.

The following are the principal measurements of the Brown Bear skeleton, of which the full details are given in the table, Chapter L.

It is a small individual.

	Feet.	Inches.
Length of head in life	I	3
„ „ neck	—	10
Manubrium to ischium	3	2¼
Height at shoulder	3	0
Width at acromions	I	0⅝
„ „ trochanters	—	10¾

CHAPTER XXVII.

THE AMERICAN BLACK BEAR.

THE measurements of the commonest animals have proved the most difficult to get. No one seems to have thought it worth while to measure fully the Common Deer of America and of Europe or the commonest of the American Bears.

The skeleton in the Galerie d'Anatomie Comparée is as follows :—

	Feet.	Inches.
Length of skull	—	11¾
„ „ head in life, estimated	1	1½
„ „ cervical vertebræ	—	10
Manubrium to ischium	2	11
Height at shoulder	2	3
From elbow to ground	1	3
Width at acromions	—	10½
„ „ trochanters	—	9

Audubon and Bachman give the following measurements of a 'very large' Black Bear:—'From nose to root of tail, 6 feet 5 inches; height to top of shoulder, 3 feet 1 inch.

'A larger Bear than the above may sometimes be captured, but the general size is considerably less.'

CHAPTER XXVIII.

THE POLAR OR WHITE BEAR.

ONE measured by order of Lord Mulgrave was as follows :—

	Feet.	Inches.
Length from the snout to the tail	7	1
„ „ „ „ „ „ shoulder bone	2	3
Height at the shoulder	4	3
Circumference near the fore-legs	7	0
„ of the neck near the ear...	2	0
Breadth of the fore-paw	—	7

Weight of the carcass without the head, skin, or entrails, 610 lbs (*Ord*).

Dimensions of a Polar Bear, killed July 17, 1821, near Jan Mayen (see Manby's Journal).

	Feet.	Inches.
Length from snout to tail	7	6
Height of the shoulder	4	6
Circumference at the shoulder	6	$11\frac{1}{2}$
Breadth of fore-paw	—	$11\frac{1}{2}$
„ „ hind-paw	—	$9\frac{1}{2}$
Length of fore-claws	—	$2\frac{3}{4}$
„ „ hind „	—	$2\frac{1}{4}$
„ tusks in upper jaw	—	$2\frac{1}{8}$

CHAPTER XXIX.

THE ANATOMY OF THE HORSE.

Plates XXVIII., XXIX., XXX., XXXI., XXXII., XXXIII.

IF the domestic quadrupeds were ranged in a line according to their anatomical affinity, the Cat would probably be found at one end, and the Horse at the other. The Cat with eighteen toes, the Horse with but four; the Cat with its supple form, its manifold muscles, and its infinity of complex movements and positions, the Horse with its muscles and bones greatly reduced in number and its movements and positions almost limited to those required for mere locomotion.

The Horse's characteristic external features are so well known that they need not here be enlarged upon.

The skeletal differences on comparison with the Carnivores are sufficiently set forth by the Plates V., IX., XXVIII., XXX., and XXXI. It will be noticed on these that in the Horse the orbit of the eye is usually more prominent than the zygomatic arch; the male has canine teeth; the species has eighteen dorsal vertebræ, eighteen pairs of ribs, and but six lumbar vertebræ; the wings of the atlas are much developed, and form marked protuberances on each side of the neck; the scapula has little or no acromion, but at its upper end is a broad, strong cartilage, called the cartilage of prolongation, which virtually lengthens the scapula; it has no clavicle; its ulna and radius are fused, so that such acts as pronation or supination are impossible; its fibula is a mere rudiment; it has but one developed and two rudimentary metacarpals in each fore foot, and metatarsals in each hind foot; and each of its limbs is terminated in a single toe.

The muscles, with few exceptions, partake of the common tendency towards simplification. The panniculus is highly developed, in the living Horse the upper edge of its fleshy body forms a ridge which crosses the middle of the ribs obliquely backward and downward; the muscles for controlling the nostrils, the lips and the ears are more highly specialised than in the Dog; the zygomaticus does not reach the ear; the sterno-hyoid and sterno-thyroid are united; the superficial pectoral is divided into two distinct parts, the sterno-humeralis or anticus, and the aponeuroticus or transversus; the deep pectoral is divided in two parts, the sterno-trochineus and the sterno-prescapularis, the latter being attached to the fore part of the scapula; the deltoid and the flexor carpi ulnaris are divided in a peculiar manner; the extensor carpi ulnaris, and the special muscles of pronation and supination are absent.

On the hind-quarters, the gluteus medius is reduced, and the gluteus maximus greatly enlarged; the semitendinosus arises on the sacrum. There is a new large muscle called the vastus longus; this has been treated as the back part of the gluteus maximus, and also as the fore part of the biceps, it being formed of fibres derived from each, but most authorities separate it under the above name, as it has independent action; it arises on the sacrum and is inserted into the outside of the knee. The sartorius is small and inserted far back on the inside of the knee; the adductor magnus appears in two

separate parts, magnus and parvus ; there is but one peroneus on the leg ; the soleus is present ; the tendons of the perforans and perforatus are so close together as to appear like one mass or cord on each limb below the pisiform or the hough ; immediately next to the bone is the suspensory ligament of the fetlock—a flat, strap-shaped ligament which arises on the carpus (or tarsus) and passing downwards behind the bone is inserted into the summit of the sesamoid and into the toe. The point of the splint or rudimentary metacarpal (or metatarsal) bone forms the ridge that appears on each side of the lower part of each leg.

The chestnuts or warts on the insides of the limbs are no doubt relics derived from some remote ancestor that was provided with pads similar to those of the Camel.

The veins which show everywhere on the body of a thoroughbred Horse need not be treated in detail, excepting those large ones which are reasonably constant as features of the visible form. These are the angularis and facialis, of which the simplest types are represented in the plates ; the spur vein ; subcutaneus ; and the inner saphenous. The outer saphenous, so important in the Carnivores and Ruminants, is too minute in the Horse to need notice.

The ligamentum nuchæ becomes a structure of great size and importance, in the whole of the Horse family.

CHAPTER XXX.

THE SIZE AND PROPORTIONS OF THE HORSE.

Plate XXXIV.

ACCORDING to MM. Cuyer and Alix, Horses vary in height at the withers from 0·96 m. (about 37¾ inches) to 2·10 m. (about 6 feet 10¾ inches).

French Cavalry Horses are selected between 1·48 m. and 1·60 m. (about 4 feet 10⅓ inches to 5 feet 3 inches).

English Hunters vary from 1·55 m. to 1·62 m. (about 5 feet 1 inch to 5 feet 3⅜ inches).

Racers about the same or taller by 1 inch.

Heavy draught Horses from 1·65 m. to 1·75 m. (about 5 feet 5 inches to 5 feet 9 inches).

The following life-measurements were taken by the writer from an ordinary carriage horse, a gelding, of good form :—

	Feet.	Inches.
Length of head ...	2	0½
Thickness of head through zygomatic arches	—	9⅛
,, ,, ,, ,, orbits	—	9½
Depth of head ...	—	11⅞
Length of neck when erect ...	2	5½
Neck and body from occiput to insertion of tail ...	7	0
Ditto to point of ischium	7	4
Length of tail bones ...	1	8⅞
Total length from point of nose to point of ischium	9	4¼
Height at shoulder ...	5	1
Length of ear ...	—	7½
,, ,, ,, opening...	—	6
Width through external points of the iliac crests ...	1	8⅞
Width through at heads of humeri ...	1	3½
Girth of muzzle just behind the mouth ...	1	8⅞
,, ,, head ,, ,, ,, eyes ...	3	1½
,, ,, neck at throat ...	2	6¾
,, ,, ,, ,, base ...	3	7¾
,, ,, chest just behind shoulder ...	5	8⅞
,, ,, belly at deepest point ...	6	0
,, ,, loins just before ilium ...	5	7
,, ,, arm at middle of radius ...	1	2⅛
,, ,, metacarpus at middle ...	—	8⅛
,, ,, leg at middle of tibia ...	1	4½
,, ,, metatarsus at middle ...	—	9½

The following are the life measurements of 'Sunlight,' a nearly thoroughbred English hunter of

admirable form.　This may be considered a typical modern war-horse, as his size and build are those required for the heavy cavalry service.

His only defect, perhaps, is the size of the head, which should have been 1 inch shorter, and proportionately narrower.

		Feet.	Inches.
Length of head		2	2
Width of „ at widest point, *i.e.*, through upper eyelids		—	10
„ „ „ just above the orbits		—	9
Length of ear		—	8
„ „ neck, in ordinary position from occiput to point of first dorsal spine, *i.e.*, end of mane		3	1
„ „ body from first dorsal spine to point of ischium		4	5
„ from back point of ischium to front of iliac crest		1	10
Height at shoulders		5	$2\frac{1}{4}$
„ of belly from the ground...		2	9
„ from point of olecranon to ground		3	$1\frac{1}{2}$
„ „ „ „ calcaneum „ „		2	2
Depth of neck at throat		1	$0\frac{1}{2}$
„ „ „ „ base		1	$9\frac{1}{2}$
„ „ belly		2	$2\frac{1}{2}$
Width of neck at base		—	9
„ „ body from point to point of shoulders		1	$3\frac{3}{4}$
„ „ belly		2	$0\frac{1}{4}$
„ „ body through iliac crests		1	$10\frac{1}{4}$
„ „ „ „ trochanters		1	$9\frac{1}{2}$
„ „ „ „ extreme points of ischium		1	$3\frac{1}{4}$
Girth of head just above the eyes		3	$1\frac{1}{2}$
„ „ chest		6	1
„ „ belly		6	8
„ „ fore-arm in middle		1	$4\frac{1}{2}$
„ „ metacarpus		—	$8\frac{1}{16}$
„ „ leg in middle of tibia		1	$5\frac{3}{4}$
„ „ metatarsus in middle		—	$8\frac{3}{4}$
Length of fore-hoof from point to extreme of hairy heel		—	$6\frac{1}{2}$
„ „ hind-hoof „ „ „ „ „ „ „		—	$6\frac{1}{2}$
Width of fore-hoof		—	$5\frac{1}{2}$
„ „ hind-hoof		—	$5\frac{1}{4}$

The measurements of a Horse skeleton are given in the table, Chapter L.

The following proportional measurements will be found of service in determining the contour of a typical Horse.　The most important are put in heavy faced type.　Nos. 1, 4, 5, 6, 7, 8, 9, 14, 15, 28, 29, 30, 32, were indicated by Bourgelat, Duhousset, Cuyer, and other authorities.

The length of the head, A B, is the accepted unit of measurement.

1. **The body goes in a square whose side** equals $2\frac{1}{2}$ heads
2. The belly, legs and ground form a square whose side is about $1\frac{3}{7}$ head
　　(At half the height of this square is the pisiform bone Z.)
3. The length of the neck above, A H, in the position shown equals $1\frac{1}{6}$ „
4. **The depth of the body** „ 1 „
5. The distance from H on the withers to the lower part of the humeral head, on the
　　flat drawing „ 1 „
6. **From the point Cal. to the ground** „ 1 „
7. From the point P on the loose flank to the point Cal. „ 1 „
8. **From the back angle of the Scapula L to the foremost highest point of**
　　the crest of the ilium „ 1 „
9. From P, on the loose flank to the highest point of the croup, Cr., in nature but not in
　　the flat drawing „ 1 „

10. **From point to point of the crests at the widest part of the ilium through the body, that is, just below O** equals 1 head

11. **Through the widest part of the chest from side to side, that is, about the middle of the line M N** „ 1 „

12. **Through the thickest part of the thighs, that is, about the middle of the line R S** „ 1 „

13. The Crupper line O Q, that is, from the crest of the ilium to the ischiatic tuberosity ... „ $1\frac{3}{16}$ of a head

14. From P to Q „ $1\frac{3}{16}$ „ „

15. The bridle line A F „ $1\frac{3}{16}$ „ „

16. The depth of the neck at its base H I... „ $\frac{3}{4}$ „ „

17. The line of the under jaw D G „ $\frac{3}{4}$ „ „

18. The line of the throat D to the tip of the ear „ $\frac{3}{4}$ „ „

19. The line from the scapular angle to the front of the shoulder L J. „ $\frac{3}{4}$ „ „

20. The length of the front of the neck D Pc. „ $\frac{3}{4}$ „ „

21. **On the forelimb the length of the scapula,** *i.e.*, **from D S to G C** „ $\frac{3}{4}$ „ „

22. „ „ „ „ „ „ „ **upper leg** *i.e.*, **from V to M C** „ $\frac{2}{3}$ „ „

23. „ „ **hindlimb** „ „ „ „ „ **ilium** „ „ **O to R** „ $\frac{2}{3}$ „ „

24. „ „ „ „ „ „ „ „ **femur** „ „ **R to S** „ $\frac{2}{3}$ „ „

25. „ „ „ „ „ „ „ „ **leg** „ „ **S to A st.** „ $\frac{2}{3}$ „ „

26. „ „ „ „ „ „ „ „ **lower** „ „ „ **A st. to Ph** „ $\frac{2}{3}$ „ „

27. **From the outside point of the humeral head on one side through the body to the corresponding point on the other** „ $\frac{2}{3}$ „ „

28. **The depth of the head D C** „ $\frac{1}{2}$ „ „

29. „ „ „ „ **neck D E** „ $\frac{1}{2}$ „ „

30. **The length** „ „ **humerus J to Epi.** „ $\frac{1}{2}$ „ „

31. „ „ „ „ lower fore-leg M C to M P „ $\frac{1}{2}$ „ „

32. „ „ „ „ **hind canon Cub. to X** „ $\frac{1}{2}$ „ „

33. The thickness of each thigh is as a corollary of No. 12 „ $\frac{1}{2}$ „ „

34. **The thickest part of the head is from eye to eye, outside these rather more than** „ $\frac{1}{3}$ „ „

35. The length of the ear „ $\frac{1}{3}$ „ „

36. **The thickness of the neck at its thickest point T N** „ $\frac{1}{3}$ „ „

37. The width of the foreleg, V W „ $\frac{1}{3}$ „ „

38. **The distance from the fore fetlock to the ground Y Gr.** „ $\frac{1}{4}$ „ „

39. **The distance from the hind fetlock to the ground, X Gr.** „ $\frac{1}{4}$ „ „

40. The width of the hind-leg B T to F T „ $\frac{1}{4}$ „ „

41. The distance from the point of the calcaneum Cal. to the point of the cuboid „ $\frac{1}{4}$ „ „

42. From H, the 'axe cut,' to the end of the body Z Z „ 2 heads

M. Gustave Debrie, to whom I am indebted for a critical revision of the plates relating to the Horse, points out that since the typical Horse head is ·60 metre or $23\frac{5}{8}$ inches in length, the Horse which is only $2\frac{1}{2}$ heads at the withers is but 1·50 metre (about 59 inches) in actual height. This is a small Horse.

A specimen that is 1·60 metre (about 63 inches) would be $2\frac{2}{3}$ heads high, for the size of the head is the least variable of the dimensions. Similarly, a large Horse 1·75 metre (about 69 inches) at the withers would be nearly 3 heads in height.

To construct one of these large animals by the table of proportions, it would be necessary only to fix on a convenient standard of length, calling t a "head," but make the length of the real head $\frac{11}{12}$ of this for medium-sized horses, or $\frac{5}{6}$ of this for very large animals.

According to Colonel Duhousset, the head of a typical Horse is as follows :—·60 metre (about $23\frac{5}{8}$ inches) long, ·30 m. (about $11\frac{13}{16}$ inches) deep from throat to forehead ; ·22 m. (about $8\frac{11}{16}$ inches) wide from point to point outside the orbital arc.

These measurements are exactly the proportions of the Horse of Silene in the pediment of the Parthenon.

CHAPTER XXXI.

THE ASS OR DONKEY.

THIS animal agrees closely with the Horse in all essential features of its anatomy.

In its proportions it differs somewhat, especially in the size of its head.

All specimens examined by the writer go in a square of 2 heads. From the point of the occiput to the point of the withers is 1 head; the line of the breast just divides the height, *i.e.* it is 1 head from the ground; depth and greatest width of the belly, each 1 head; when the animal is standing the figure included between the fore-leg, breast, knee, and ground is a square of 1 head; the ear is half a head long.

In height, the Ass varies from 3 to 4 feet at the shoulder, although specimens of much greater size are occasionally seen. It is probable that the very large, thoroughbred Asses go in a square of 2½ heads, for, as elsewhere remarked, the head is the least variable part of the anatomy.

Life Measurements of a Female Ass of Medium Size.

	Feet.	Inches.
Length of head ...	1	9½
Depth ,, ,, just before the eye	—	10½
Width ,, ,, at the orbits, the widest point ...	—	8
Length of ear ...	—	10½
From tip to tip of ears ...	1	10
From occiput to neural spine of first dorsal vertebra ...	1	10
,, ,, ,, ischium ...	5	2
Total length from point of upper lip to ischium	6	11½
Length of tail (bone only) ...	1	2
Distance from manubrium to ischium ...	3	7½
Height at shoulder ...	3	6½
Depth of neck at throat...	—	10½
,, ,, ,, ,, base ...	1	2½
Width of belly, at thickest part ...	1	7
Depth of belly ...	1	9
Width between the points of the shoulders ...	—	10½
,, ,, crests of ilia ...	1	2
,, ,, ,, ,, ischia ...	—	9
Girth of chest ...	4	0
,, ,, belly ...	5	2½
Elbow to ground...	2	3
Calcaneum ,, ...	1	6
Belly ...	1	9
Knee to elbow (standing in ordinary position) ...	1	9½

CHAPTER XXXII.

THE ANATOMY, SIZE AND PROPORTIONS OF THE OX.

Plates XXXV., XXXVI.

In most of its bony and muscular anatomy the Ox may be considered intermediate between the Horse and the Dog. The Horse has one toe on each foot, the Ox two (fully developed), and the Dog four or five; the Horse has fifteen or sixteen bones in each foot; the Ox nineteen or twenty; the Dog thirty-two or thirty-six. The Ox resembles the Horse in having the ulna and radius united into what is practically one bone, and the fibula a mere rudiment; but it resembles the Dog in having thirteen pairs of ribs, whereas the Horse has eighteen; all three animals have twenty-eight bones in the head, seven in the neck, and lack the clavicle. The Horse has eighteen dorsal or thoracic vertebræ, six or five lumbar vertebræ, and about sixteen tail bones; the Ox has thirteen dorsal vertebræ, six lumbar vertebræ, and about twenty tail bones; the Dog resembles the Ox in the number of its vertebræ, except that it has seven in the lumbar region. Notwithstanding the increased number of ribs and dorsal vertebræ, the Horse has in all but 191 bones to the Ox's 196, and the Dog's 255.

The Ox is a typical ruminant, the digestive system being peculiar and complex; and the teeth are very different from those of either Horse or Dog. They consist of twenty-four molars, six on each side of each jaw, and eight incisors in the lower jaw. There are no upper incisors, i.e. front upper teeth, their place being taken by a sort of pad, against which the lower incisors work.

The horns of the Ox form a striking peculiarity; their radical difference from the antlers of the Deer is noted elsewhere. The rudimentary hoofs which appear on each foot are but little more than appendages of the skin; for although they are attached to minute bones, the rudiments of toes, these latter are not perfectly articulated with the limb, as in the Pig, and have no proper muscles or tendons.

There are no remarkable departures in the great muscles of the trunk. The well-known pronounced conformation of the region about the loins, for instance, is merely the result of increased weight and size, an exaggeration of the elements of form found in Dog and Horse, without any important change in the constituent bones and muscles.

But on the limbs the intermediate character of the muscles, corresponding with the intermediate number of toes, is very obvious. On the outer side of the fore-arm and on the hind-leg we find much the same muscles as in the Dog, but more united, and with less independent action; the extensor communis, however, is peculiar in being split in two parts. The supinators and pronators are absent as in the Horse. On the thigh, the Ox has the vastus longus, like that of the Horse, and on the leg the peroneus longus, as in the Dog. It also resembles the latter in having the semitendinosus arising on the ischium.

The prominent veins of the face and limbs are like those of the Dog; but it agrees with the Horse in having the great spur vein on the side of the chest and belly.

The following life measurements were taken from a half-bred Shorthorn Bull of good form, a three-year-old, and from a French milk Cow of somewhat fuller body than that depicted in the plate of proportions (XL.). The animals were standing in a normal position with the neck horizontal :—

	Bull Feet.	Bull Inches.	Cow Feet.	Cow Inches.
Length of head	1	10½	1	10¾
Length of body from top of head in a straight line to the point of ischium	7	7	7	1
Length of neck; from head to sharp point of the first dorsal vertebra (this varies greatly with the pose)	2	4	1	11¾
Length of tail to end of bone	2	8	2	1⅝
Height at shoulder	4	8	4	7½
Height of belly from ground	2	3	—	—
Width of head at widest part, i.e., through the upper eyelids	—	11	—	9⅞
„ „ „ just above orbits	—	10½	—	7½
„ „ body from shoulder point to shoulder point	1	11	1	6½
„ „ belly	2	5	2	7½
„ through body from outside points of crests of ilia	1	10	1	11⅝
„ „ „ „ extreme outer points of ischia	1	2½	1	3⅜
From back of ischium to front of iliac crest	1	11	1	11¼
Length of ear	—	8½	—	9⅞
Girth of head just behind eyes	3	8	3	5⅓
„ „ chest	7	2	6	5
„ „ belly	8	0	8	9
„ „ fore-arm in middle	1	11½	1	4½
„ „ metacarpus in middle	—	9	—	7⅞
„ „ leg in middle of tibia	1	9¼	1	9⅝
„ „ metacarpus in middle	—	9¼	—	9½

A larger Shorthorn Bull, five years old, measured :—head, 2 feet ; from top of head to ischium, 7 feet 8 inches ; height at shoulders, 4 feet 10 inches.

A smaller Cow of Swiss breed measured :—head, $22\frac{1}{16}$ inches ; height, 4 feet 5 inches. The head of another Cow of less than average size was $20\frac{7}{8}$ inches in length.

The proportions of the Ox are shown on Plate XXXVI.

CHAPTER XXXIII.

THE AMERICAN BUFFALO OR BISON.

Plate IV.

THE American Buffalo may be described as an Ox with the hind quarters somewhat reduced in size and the spines of the dorsal vertebræ elongated. This gives the animal a hump-backed appearance, especially in the case of the bulls in which the hump is usually much developed. The body is covered with wool, which is of great length on the head and the lower fore parts.

One frequently meets with allusions to the enormous size of the Buffalo's head, nevertheless apart trom the wool it is found to be of the usual proportions. For the present purpose the length of the head is measured from the lower part of the upper lip, to a central point on a line 2 inches above the upper side of the base of the horns.

The animal goes in a square of $2\frac{1}{2}$ heads, but its hip-bone does not reach the line by $\frac{1}{4}$ head. In some bulls the discrepancy is greater, and in most cows it is less.

Dr. George Vasey gives the following measurements of a large male Buffalo.

	Feet.	Inches.
From nose to the insertion of the tail	8	6
Height at the shoulder	6	0
„ „ „ croup	5	0
Length of head	2	1

According to Dr. J. A. Allen :—

' An adult male measures about 9 feet from the muzzle to the insertion of the tail, and $13\frac{1}{2}$ feet to the end of the tail, including the hairs, which extend about 15 inches beyond the vertebræ. The female measures about $6\frac{1}{2}$ feet from the muzzle to the insertion of the tail, and about 7 feet to the end of the tail, including the hairs, which extend about 10 inches beyond the vertebræ. The height of the male at the highest part of the hump is about $5\frac{1}{2}$ to 6 feet, of the female at the same point about 5 feet. The height of the male at the hips is about $4\frac{2}{3}$ feet, of the female at the same point about $4\frac{1}{2}$ feet. Audubon states the weight of old males to be nearly 2,000 lbs., that of the full grown fat females to be about 1,200 lbs.'

In chapter L. are given the bone measurements of a male Buffalo. The following additional measurements of the same skeleton will be found of service :—

	Feet.	Inches.
Length of skull	1	10
Estimated length of head in life	2	1
From top of head to point of longest (third) dorsal spine when the neck is horizontal	2	$10\frac{1}{2}$
From the point of the same dorsal spine to the end of the ischium	5	6
From a point on the spine opposite the iliac crests to the back of the ischium	1	$8\frac{3}{4}$
From manubrium to ischium	6	2
Total length from point of nose to end of body	10	$5\frac{1}{2}$

		Feet.	Inches.
Height at shoulder of skeleton		5	$3\frac{1}{2}$
„ „ „ when alive (estimated)		5	10
Height from ground of central line of last cervical vertebra, *i.e.* where it leaves the body		3	$6\frac{1}{2}$
Distance from the last point to top of head		2	$1\frac{1}{2}$
From top of olecranon to ground		2	$8\frac{1}{2}$
„ xiphoid „ 		2	1
„ calcaneum „ 		1	$9\frac{1}{2}$
Width across orbits		1	$1\frac{3}{8}$
„ through humeral heads		1	5
„ „ body at tenth rib		1	$10\frac{1}{2}$
„ „ external angles of ilia		1	10

The top of the scapula, even with the cartilage of prolongation, does not reach within six inches of the top of the longest dorsal spine.

CHAPTER XXXIV.

THE SHEEP.

Plate XXXVII.

In its muscular and bony anatomy the Sheep may be considered as a miniature Ox. Its external peculiarities, consisting as they do of the well-known differences in the coat, the form of the head, horns, and hoofs, are chiefly matters of degree, and need not to be enlarged upon. This animal goes in a square of $2\frac{1}{2}$ heads; its other proportions are sufficiently set forth in Plate XXXVII.

An ordinary male Sheep of French breed was 27 inches high at the shoulder. The females are smaller.

The following measurements in inches were taken from two-year old Sheep of Hampshire Down breed :—

	Male (wether)		Female.	
	Feet.	Inches.	Feet.	Inches.
Length of head	—	$11\frac{3}{4}$	—	$10\frac{1}{2}$
„ „ body, manubrium to ischium	2	$10\frac{1}{2}$	2	7
Total length	4	$7\frac{1}{4}$	3	$10\frac{1}{2}$
Height at shoulder	2	5	2	$1\frac{1}{2}$
Length of neck in ordinary horizontal position	1	1	—	$10\frac{1}{2}$
„ „ ear	—	$5\frac{1}{2}$	—	$5\frac{1}{2}$
„ from tip to tip of ears	1	3	1	$3\frac{1}{2}$
From point of upper lip to fore corner of eye	—	7	—	$6\frac{1}{2}$
Width of head through the eyes	—	6	—	$5\frac{1}{4}$
From calcaneum to ground	1	1	—	$10\frac{1}{2}$
„ elbow to ground	1	7	1	$3\frac{1}{2}$
Belly to ground	1	2	1	0
From elbow to knee while standing	1	7	1	$4\frac{1}{2}$
Girth of belly, measured over 2 months of wool	4	8	3	10
„ „ chest „ „ „ „ „ „	3	10	3	0

CHAPTER XXXV.

THE BIGHORN.

(*Ovis montana.*)

THIS animal, though clad in hair like that of a Deer, is a true Sheep in all anatomical essentials. Ord (*N. A. Zoology*) quotes from Mr. M'Gillivray the following measurements of a male :—

	Feet.	Inches.
Length from the nose to the root of tail	5	0
„ of the tail	—	4
„ „ „ horn	3	6
Circumference of the body	4	0
The stand	3	9

He adds, 'A pair of these horns have been known to weigh 25 lbs.'
Audubon and Bachman give the following :—

Male figure in our plate

	Feet.	Inches.
Length	6	0
Height at shoulder	3	5
Length of tail	—	5
Girth behind the shoulder	3	11
Height to rump	3	$10\frac{3}{4}$
Length of horn around the curve	2	$10\frac{1}{2}$
„ „ eye	—	$1\frac{3}{4}$

Weight 344 lbs., including horns.

Female figure in our plate.

	Feet.	Inches.
Nose to root of tail	4	7
Tail	—	5
Height of rump	3	$4\frac{1}{2}$
Girth back of shoulder	3	$4\frac{1}{2}$

Weight 240 lbs. (killed July 3rd, 1843).

CHAPTER XXXVI.

POLO'S OR THE PAMIR SHEEP.

(*Ovis polii.*)

THIS magnificent animal was originally described by Marco Polo in the thirteenth century. The account of this explorer was discredited however until the animal was rediscovered in 1840 by Major Blyth, who found that Polo had understated, rather than overstated, the facts.

Blanford gives the following :—

Dimensions of an adult male with 48-inch horns.

	Feet.	Inches
Height at shoulders	3	8
Length of head	1	1·25
From horns to tip of tail	5	2
Tail with hair	—	5·5
„ without	—	4
Length of ear in front	—	4·75
Girth round chest	4	3·5
		(Stoliczka).
Basilar length of a good skull	1	0·7
Breadth across orbits	—	7·5

Females are not much smaller than males. Good horns of rams measure 50 to 60 inches round the curve, and about 15 inches in girth at the base, the extreme recorded measurements being 75 and 16·75. Severtzoff estimates the weight of an old male at about 600 lbs., but he did not weigh one.

The large pair of horns mentioned would thus have a total length around the curves of 12½ feet. A pair described by Sterndale was 54 inches across the tips, and another was 5 feet from tip to tip. The same authority gives the weight of an adult Polo Sheep at 576 to 612 lbs., the head and horns weighing over 72 lbs.

It agrees with the common Sheep in going in a square. But the height of the figure is increased from 2½ to 3 heads, a change of proportion elsewhere noted as characteristic of giant races.

CHAPTER XXXVII.

THE GOAT.

THE ordinary Goat, though so unlike in appearance, is of the same proportions as a Sheep, nor does its bony and muscular anatomy present important differences.

The following are the life measurements of a male Goat a year and a half old :—

	Feet.	Inches.
Length of head	—	10
Width „ „ across orbits	—	5
From point of lip to corner of eye	—	5½
„ „ „ „ „ front basil line of horns	—	8½
Length of ear	—	5½
From tip to tip of extended ears	1	4
Length of body, manubrium to ischium...	2	4
Height at shoulders (exclusive of hair)	2	3½
Neck from occiput to point of scapula	—	10
Total length point of lip to ischium	4	7
Tail bones	—	6
Girth of belly	2	11
Height of belly from ground	1	2
Distance from point of elbow to ground	1	1
Length from point of calcaneum to ground	—	11

CHAPTER XXXVIII.

THE GIRAFFE.

THE three living Giraffes measured by the writer were each 4 heads in height at the shoulder, and 2 heads in length of the body; the croup [1] head lower than the withers; the neck 2 heads long. From the knee to the elbow was about 1 head; from the hough to the ground $1\frac{1}{2}$ heads; from the belly to the ground $2\frac{1}{2}$ heads.

The large male Giraffe in the Jardin d'Acclimatation is 21 feet high.

In the Galerie d'Anatomie Comparée is the skeleton of a male Giraffe which measures as follows:—

	Feet.	Inches.
Length of skull ...	2	$2\frac{1}{2}$
,, ,, head in life, estimated	2	4
,, ,, cervical vertebræ	5	$2\frac{1}{2}$
From manubrium to ischium	4	6
Height at shoulder	8	$7\frac{1}{2}$
,, ,, ,, in life, estimated	9	3
,, ,, iliac crest	7	0
From the highest point of the shoulders to the xiphoid	3	$9\frac{1}{2}$
,, xiphoid to ground	5	0
,, olecranon to ,,	5	6
,, calcaneum ,, ,,	3	6
,, ,, ,, patella	2	7
,, point of pisiform to ground	2	11
Width at humeral heads	1	$4\frac{1}{2}$
,, of chest at widest part	1	10
,, at trochanters	1	9
,, ,, iliac crests	2	$0\frac{1}{2}$

CHAPTER XXXIX.

THE PRONGHORNED ANTELOPE.

(*Antilocapra americana.*)

In its anatomy this unique animal bears a general resemblance to the Ox, Goat, and Deer tribes. One very evident difference is in the feet, the Antelope, like the Giraffe, having but two hoofs on each foot. Its horns are very remarkable, for although formed of true horn, as in the Ox, they are shed periodically as in the Deer.

A typical Antelope is 2½ heads high and but 2 long. Richardson gives the following dimensions of a male Antelope :—

	Feet.	Inches.
Length from the nose to the root of the tail	4	4
Height at the fore-shoulder	3	0
„ „ „ haunches	3	0
Girth behind the fore-legs	3	0
„ before „ hind-legs	2	10
Length of the tail with the hair	—	4½

According to this, the head of the animal would have been 14½ inches long.

Judge Caton gives the following as the dimensions of an ordinary Antelope :—

	Feet.	Inches.
Length from nose to end of tail...	4	10 to 5 feet
Height at shoulder	2	10
„ „ hips	3	1
Length of fore-legs	1	6
„ „ hind-leg	1	10
„ „ ear	—	5

CHAPTER XL.

THE DEER FAMILY.

THE anatomy of the Deer corresponds closely with that of the Ox. The most striking difference is, perhaps, the antlers, which are borne by the males, and in the Caribou and Reindeer species by the females as well. These remarkable structures are of solid bone, and are grown and shed each year. The number of points on them has but little relation to the age of the animal; the finest antlers are grown by the finest bucks when they are in their prime; a very young, a very old, or an unhealthy buck always produces a poorly developed antler.

The Deer are also distinguished by the presence of a number of glands which secrete an unctuous matter that is supposed to be a means of intercommunication. At least two pairs of these merit notice :—the lachrymal pit or fossa under the inner corner of each eye, and the tarsal gland on the outer side of each hind-leg below the hough. The former by its size, colour, and shape is a marked feature of the face, and the latter on account of the hair-tuft around it gives a peculiar character to the hind-leg.

All of the true Deer measured by the writer go in a square of $2\frac{1}{2}$ heads, with 1 head or less for the neck, $1\frac{1}{4}$ heads for depth of belly, and 1 to $1\frac{1}{4}$ heads from hough to ground.

Some of the smaller Deer have a habit of drawing the hind quarters under them, so as to make the body short and very high at the back. In this position they of course do not make a square, although the height at the shoulders remains unaltered.

CHAPTER XLI.

THE WAPITI, OR AMERICAN ELK.

(*Cervus canadensis.*)

AUDUBON and Bachman give the following measurements of Wapiti :—

Adult male (killed on the Upper Missouri River).

	Feet.	Inches.
From nose to root of tail...	7	$8\frac{3}{4}$
Length of tail	—	$1\frac{3}{4}$
„ „ eye	—	$1\frac{3}{4}$
From tip of nose to root of ear	I	8
Length of ear	—	$9\frac{1}{4}$
Height to shoulder	4	10
Rump	5	2
Girth back of fore-legs	5	$6\frac{1}{2}$

The females we measured were rather smaller than the above : one killed on the Yellow Stone River measured 7 feet $6\frac{1}{2}$ inches from nose to root of tail, and 4 feet 7 inches from top of shoulder to the ground.

The Wapiti skeleton in the Galerie d'Anatomie Comparée is that of a small male. It measures thus :—

	Feet.	Inches.
Length of skull	I	$5\frac{1}{8}$
„ „ head in life, estimated	I	$8\frac{1}{2}$
„ „ cervical vertebræ	I	6
From manubrium to ischium	4	I
Height at shoulder	4	O
From calcaneum to ground	I	$7\frac{1}{2}$
„ olecranon „ „	2	5
Width of chest at widest point	I	$0\frac{1}{4}$
„ „ skull at widest point, the orbits	—	$7\frac{5}{8}$
„ „ shoulders at humeral heads	I	$0\frac{1}{2}$
„ at trochanters	—	$10\frac{1}{2}$
„ „ iliac crests	—	$10\frac{3}{8}$

According to Judge Caton, the males of this species attain a height of 5 feet 4 inches at the shoulder, and a weight of 1,000 lbs. ; while, on the other hand, he has seen females that stood but $3\frac{1}{2}$ feet at the shoulder and weighed under 400 lbs.

A fine female in the Jardin des Plantes is 4 feet 4 inches at the shoulder.

CHAPTER XLII.

THE RED DEER OF EUROPE.

(*Cervus elephas.*)

THIS is the Stag rendered famous by Landseer's pictures; it is much like a Wapiti in miniature. According to Bell (*Br. Quad.*), 'A fine Stag stands about 4 feet or even more.'

A medium-sized Stag at the Jardin des Plantes is 3 feet 8 inches at the shoulder. The does with him are about 4 inches lower.

According to Rev. L. Jenyns (*Br. Vert. An.*), the dimensions of the Stag are :—Length of body, $6\frac{1}{2}$ feet ; of the horns, about 2 feet ; of the tail, 7 inches ; height, about 3 feet 8 inches.

In the Galerie d'Anatomie Comparée is the skeleton of a male, which measures :—

	Feet.	Inches.
Length of skull...	I	$4\frac{1}{8}$
,, ,, head in life, estimated	I	$7\frac{1}{2}$
Actual length of cervical vertebræ	I	$8\frac{1}{4}$
From manubrium to ischium	4	$0\frac{1}{2}$
Height at shoulder	3	6
,, ,, ,, in life, estimated	3	9
,, ,, top of inner angle of ilium	3	$4\frac{1}{4}$
From xiphoid to highest point of shoulder	I	$8\frac{1}{2}$
,, ,, ,, ground	I	II
,, humeral head to ground	2	$6\frac{1}{2}$
,, olecranon ,, ,,	2	$0\frac{1}{4}$
,, patella ,, ,,	2	$6\frac{1}{4}$
,, trochanter ,, ,,	2	II
,, calcaneum ,, ,,	I	7
,, ,, ,, patella...	I	$3\frac{1}{2}$
Width of skull at widest place, the posterior edge of the orbits	—	$6\frac{7}{8}$
,, ,, shoulder at humeral heads	—	$9\frac{3}{4}$
,, ,, chest at widest place, 11th rib	I	I
,, ,, pelvis through iliac crests	—	$11\frac{1}{8}$
,, ,, ,, ,, trochanters	—	$10\frac{3}{8}$

Another fine skeleton in the same collection is as follows :—

	Feet.	Inches.
Length of skull...	I	$3\frac{1}{4}$
,, ,, head in life, estimated	I	$7\frac{1}{2}$
,, ,, cervical vertebræ	I	6
From manubrium to ischium	3	$7\frac{3}{4}$
Height at shoulders	3	9
,, ,, ,, in life, estimated	4	0
,, ,, top of sacrum	3	8
From olecranon to ground	2	6
,, calcaneum ,, ,,	I	$9\frac{3}{4}$
,, xiphoid ,,	2	$2\frac{1}{2}$

CHAPTER XLIII.

THE VIRGINIAN DEER, OR COMMON DEER OF AMERICA.

(*Cariacus virginianus.*)

AUDUBON and Bachman give the following dimensions of this species :—

	Feet.	Inches.
Length from nose to root of tail	5	4
„ of tail (vertebræ)	—	6
„ „ „ including hair	I	I
Height of ear	—	$5\frac{1}{2}$

The male skeleton in the Galerie d'Anatomie Comparée measures :—

	Feet.	Inches.
Length of skull	—	$11\frac{7}{8}$
„ „ head in life, estimated	I	2
Actual length of cervical vertebræ	I	$3\frac{1}{2}$
From manubrium to ischium	3	5
Height at shoulder	3	$0\frac{1}{2}$
„ „ „ in life, estimated	3	5
„ „ top of inner angle of ilium	3	I
From xiphoid to highest point of shoulder	I	3
„ „ „ ground	I	9
„ humeral head to ground	2	2
„ olecranon „ „	I	II
„ patella „ „	2	I
„ trochanter „ „	2	8
„ calcaneum „ „	I	5
„ „ „ patella	I	$2\frac{1}{2}$
Width of skull at widest place, the orbits	—	$4\frac{5}{8}$
„ „ shoulder at humeral heads	—	$7\frac{1}{4}$
„ „ chest at 11th rib, widest place	—	10
„ „ pelvis through iliac crests	—	$7\frac{1}{4}$
„ „ „ „ trochanters	—	$8\frac{1}{2}$

CHAPTER XLIV.

THE MOOSE AND THE EUROPEAN ELK.

MANY good authorities consider the Moose of America and the Elk of Scandinavia as one species. They differ considerably from the true Deer in their proportions, as well as in many details of their anatomy. The body is 2 heads in length and 2¾ heads in height at the shoulder. The neck is about half a head long, and the body through the belly 1 head deep; from the point of the hough or calcaneum to the ground is 1 head or rather more; and the distance from elbow to knee, when standing, is 1 head.

A Moose is from 5 feet 8 inches to 6 feet 6 inches at the shoulder, exclusive of the mane; 6 feet may be considered about the average height of a bull Moose.

Mr. John Rowley has given me the following measurements of a large bull Moose, shot by himself in New Brunswick:—

	Feet.	Inches.
Total length, end of muzzle to end of tail 	8	2
Femur to humerus, *i.e.,* centre of head of humerus to centre of great trochanter 	4	0
Height at shoulder, *i.e.,* from top of skin at hump to flat of hoof, with leg placed in a natural position, not outstretched, thus giving approximate standing height at shoulder 	6	4
Height at rump, leg placed in natural position not outstretched, and measured from skin on rump to flat of hoof 	5	9
Depth of body behind shoulder, from skin of back just behind hump to bottom of brisket	2	8
Greatest distance across horns 	5	0

Measurements in all cases made with a tape in a straight line, not following the contour of the body.

According to Sir Henry Pottinger (*Badminton Library*):—

The average bodily measurements of a full grown Scandinavian Elk, let us say over seven years old, are as follows:—

	Feet.	Inches.
Length from tail to crest... 	9	5
Crest to nose 	2	5
Height at wither 	5	8 to 9
At quarters 	5	5 „ 6
From belly to ground 	3	4
Greatest girth 	6	11 „ 7 ft.
Round thigh 	3	0
Round fore-arm	1	11

The following are the measurements of a male Elk, from Sweden. They were taken from the skeleton in the Galerie d'Anatomie Comparée:—

	Feet.	Inches.
Length of skull	2	0
Estimated length of head in life... 	2	4
From top of head to point of longest (4th) dorsal spine, with neck horizontal 	2	0
From same spine to back of ischium 	4	1½

	Feet.	Inches.
Actual length of cervical vertebræ … … … … … … … … …	1	8
From manubrium to ischium … … … … … … … … … …	5	2
Height at shoulder … … … … … … … … … … …	5	7
„ „ „ in life … … … … … … … … … …	5	11
„ „ top of inner angle of ilium … … … … … … … …	5	2
From manubrium to highest point of shoulder … … … … … …	2	1½
„ xiphoid „ „ „ … … … … …	2	5½
„ manubrium to ground … … … … … … … … …	3	10
„ xiphoid „ … … … … … … … … …	3	1
„ humeral head „ … … … … … … … …	4	1
„ olecranon „ … … … … … … … …	3	5½
„ patella „ … … … … … … … …	3	8
„ trochanter „ … … … … … … … …	4	6
„ calcaneum „ … … … … … … … …	2	6
Width of skull at widest place, the orbits … … … … … … …	—	9
shoulder at humeral heads … … … … … … … …	1	1½
„ chest at 11th rib (widest place) … … … … … … …	1	10½
„ pelvis through iliac crests … … … … … … … …	1	1¼
„ „ trochanters … … … … … … … …	1	3

CHAPTER XLV.

THE REINDEER AND THE CARIBOU.

(*Rangifer tarandus.*)

MOST authorities agree that the Reindeer and the Caribou are geographical races of the same species. They resemble the true Deer in general proportions and anatomy, their bodies going in a square of 2½ heads, etc., but they differ in many details of form. The small ear and eye, the bovine character of the head and neck, the hairy muzzle and the great size of the hoofs and the horns are striking differences. But the fact that the great palmated antlers are also borne by the females, is one of the most notable distinctions between this and the other Deer.

The skeleton of a male Reindeer in the Galerie d'Anatomie Comparée, gave the following :—

	Feet.	Inches.
Length of skull ...	1	3
„ „ head in life, estimated	1	4
„ „ cervical vertebræ	1	1½
Manubrium to ischium ...	3	5
Height at shoulders ...	3	4
Width at humeral heads	—	8½
„ „ trochanters ...	—	8½
From calcaneum to ground	1	7
„ olecranon „ „	2	1

CHAPTER XLVI.

THE CAMEL AND THE DROMEDARY.

Plate XXXVIII.

THE Camel, while it resembles the Ox in the general arrangement of its bones and muscles, shows many wide anatomical differences, as well as the very obvious dissimilarity of general form.

The absence of horns and of accessory hoofs; the presence of tusks like canine teeth (three on each side of the upper and two on each side of the lower jaw) ; of callosities on the breast, elbow, and knee ; and of the hump of reserve fat on the back; the small ear; the woolly coat; the twelve instead of thirteen dorsal or thoracic vertebræ with the accompanying twelve instead of thirteen pairs of ribs; the seven instead of six lumbar vertebræ; and the great length of neck and limb, are the most striking characteristics.

The Dromedary is merely a lightly built, swift Camel, bred for saddle use. Its bone measurements and general proportions are very similar to those of the Camel.

For those who wish to study the subject further, the monograph by Elijah Walton will be found quite exhaustive. The following measurements are taken from that volume:—

The head of a full grown Camel is from 1 foot 11 inches to 2 feet in length, and 1 foot across in the widest part.
The ear is small, being only 4 inches in length by about 3 in width.

Camel :—

The head 2 feet long and 1 foot deep.

	Feet.	Inches.
Full length from shoulder to tail	5	8
Foreleg full length	4	4
Hindleg „ „	4	4
Full height from top of hump to sole of foot	7	0

Dromedary, male :—

Head, length, 1 foot 9 inches ; width, 1 foot 2 inches.

	Feet.	Inches.
From shoulder to tail	4	11
Foreleg	4	0
Hindleg	4	0
Full height	6	6

Dromedary, female :—

Head, length, 1 foot 8 inches ; width 1 foot

	Feet.	Inches.
From shoulder to tail	4	10
Foreleg	3	8
Hindleg	3	8
Full height	6	2

In addition to these, the same authority gives the following measurements of the large Two-humped or Bactrian Camel, in the Zoological Gardens at London:—

Bactrian Camel, female :—

	Feet.	Inches.
Head, full length	2	4
From shoulder to tail	6	1
Foreleg, equally divided at the wrist	3	2
Hindleg	3	2
From top of humps to the soles of the feet	7	5

The proportions of the Camel are indicated on Plate XXXVIII.

CHAPTER XLVII.

THE PIG.

IN the main features of its anatomy the common Pig agrees with the Ox tribe. It has, however, many more bones—about 270 to the Ox's 196; the greatest differences being in the limbs, where the Pig has four fully developed toes, with accompanying bones, to each foot, and the Ox but two. The muscular anatomy need not be studied in detail, as nothing but general masses are visible.

The large Pig skeleton at the Beaux Arts gives the following dimensions:—

	Feet.	Inches.
Skull	I	2¾
Head in life about	I	4
Manubrium to ischium ,	3	10
Height at shoulders	2	8

This would give, as the life proportions, 2 heads in height at the shoulder, and 3 heads in length of body from manubrium to ischium.

A medium-sized female Pig of Essex breed measured as follows:—

	Feet.	Inches.
Head	I	0¼
Length of ear	—	8½
Height at shoulder	2	1½
„ „ back	2	5
Body from manubrium to ischium	3	0½
Total length from occiput to ischium	3	9
Total length, nose „ „	4	9¼
From point of calcaneum to point of accessory hoof	—	10
From point of elbow to ground	I	I

CHAPTER XLVIII.

THE INDIAN ELEPHANT.

THE males are usually 9 feet, and the females 8 feet at the shoulder.
According to Sanderson:—

The Indian Elephant does not reach a vertical height of 10 feet at the shoulder; the largest male out of some hundreds observed was 9 feet 10 inches, and the largest female 8 feet 5 inches. The calves at birth are usually 3 feet high at the shoulders, and have a trunk but 10 inches long.

Sterndale gives as a unique, authentic measurement of a male:—10 feet 7 inches at the shoulder, and mentions as a curious fact that twice around an Elephant's foot equals its height at the shoulders.

If the length of the head be taken from the crown between the ears to the point of the lower lip or to the point where the tusk first appears, the Elephant is $2\frac{1}{2}$ heads high at the shoulder, and 2 heads long from the point of the shoulder to the ischium. The ear is half a head long; the trunk more than long enough to reach the ground; from the breast to the ground about 1 head; the tail 1 head in length.

In the British Museum is the skull of a very large rogue Elephant that was killed at Meerut. Its dimensions were:—

	Feet.	Inches.
Height	10	6
Circumference of forefoot	5	3
„ „ trunk...	4	$4\frac{1}{2}$
„ „ neck	13	6
Length from top of head to end of trunk	11	1

Measurements of the skeleton of the female Indian Elephant, in the Galerie d'Anatomie Comparée :-

	Feet.	Inches.
Length of skull from highest point of crown to extremity of bone of upper jaw	3	1
Estimated length of head in life, from crown to point of lower lip	4	2
Height at shoulder	8	6
„ to top of inner angle of ilium, the only prominent point in the sacral region...	7	6
Length from manubrium to ischium	6	7
„ of neck bones	1	4
From manubrium to highest point of shoulder, i.e., the 3rd dorsal spine	3	6
„ top of head to highest point of shoulder	3	$5\frac{1}{2}$
„ xiphoid „ „ „	4	3
„ highest point of shoulder to inner angle of ilium	4	3
Height of lower outer angle of ilium from ground	6	0

(N.B.—This angle is very important; it is the most prominent feature of the region, and disguises the trochanter.)

	Feet.	Inches.
Distance from same angle to line of ischiatic tuberosity	I	I
„ of same angle in advance of centre of trochanter	—	8
„ „ „ above the trochanter	—	8

(N.B.—The pelvis, as well as the limb bones, of the Elephant is remarkable for its perpendicularity.)

	Feet.	Inches.
From manubrium to ground	5	6
„ xiphoid „	4	5
„ shoulder-head „	5	I
„ point of olecranon to ground	2	11½
„ knee-cap „	2	7
„ trochanter „	5	3½
„ ischiatic tuberosity „	5	0
Width of skull at the widest point, viz., just above the opening of the ear	2	4
„ „ chest „ „ „ the 10th rib	2	4
„ between the metacromions, the prominent external points of the shoulders	2	11
„ „ „ heads of the humeri	2	7
„ through the pelvis at the external angles of ilium	3	8½

CHAPTER XLIX.

THE AFRICAN ELEPHANT.

THIS is a slightly larger animal than the Indian species, and, although quite distinct, of the same anatomy and nearly the same general proportions.

According to Sterndale:—

The African Elephant is of larger size as a rule, with enormously developed ears which quite overlap the withers. The forehead recedes and the trunk is more coarsely ringed, the tusks are larger.* * * Sir Samuel Baker had in his possession a tusk, measuring 10 feet 9 inches.* * * The African Elephant has only three nails on the hind foot, whereas the Asiatic has four.

Mr. Rowland Ward, referring to the large Elephant brought from Africa by H.R.H. the Duke of Edinburgh, says:—

This animal was undoubtedly one of the largest examples ever brought to this country, of the African species.

	Feet.	Inches.
His height at the withers was	10	0
From tip of trunk to tip of tail	23	5
Girth	16	6
From top of the head to the end of trunk	11	3
Circumference of head	10	0
From ear to ear	9	0
Length of ear	4	6

The skull and tusks weighed more than 3 cwt. * * * The weight of the entire Elephant in the flesh was 4 tons, 8 cwt., 4 lbs.

The ears of the African Elephant, it will be seen, are 1 head long instead of half a head, as in the Indian species.

CHAPTER L.

MEASUREMENTS OF CERTAIN SKELETONS.

ACTUAL measurements in inches of certain skeletons which are in the normal position of the animal standing at rest.

All are from extreme points. The mark ' ? ' means that the measurement, though taken as it stands, is not beyond question.

In the Herbivores given, the greatest width of the skull is at the orbits, not at the zygomatic arch as in the Carnivores, and the greatest width of the shoulders is at the humeral heads.

The Dog, Brown Bear, Horse, and Cow are in the museum of the École des Beaux-Arts at Paris. The Lion, Lioness, and Tiger, Grizzly Bear and Buffalo are in the Galerie d'Anatomie Comparée, Jardin des Plantes.

	SPECIES.	DOG.	LION.	LIONESS.	TIGER.	GRIZZLY BEAR.	BROWN BEAR.	HORSE.	COW.	AMERICAN BUFFALO.
	Remarks.	Large. Sex and breed unknown	Average specimen	Average specimen	Small specimen male	Sex ?	Sex ? Size, Medium.	Small male.	Above average size.	Large Male.
SKULL.	Length of skull from occipital tuberosity to alveolars of upper incisors	$10\frac{1}{8}$	$13\frac{5}{8}$	$11\frac{1}{2}$	$12\frac{5}{8}$	16	$14\frac{1}{8}$	$20\frac{1}{2}$	$21\frac{1}{2}$	22
	Length of head in life, *i.e.* allowing for nasal cartilages, &c.	$10\frac{5}{8}$	$14\frac{5}{8}$	$12\frac{1}{4}$	$13\frac{1}{2}$	$17\frac{1}{2}$	15	$21\frac{5}{8}$	$22\frac{7}{8}$	25
	Depth of skull at external orbital process of frontal bone at right angles to the long axis	$4\frac{1}{2}$	$6\frac{1}{4}$	$5\frac{3}{4}$	$5\frac{7}{8}$	$7\frac{3}{8}$	$6\frac{3}{4}$	10	$10\frac{5}{8}$	$11\frac{1}{4}$
	Width between alveolars of upper canines	$2\frac{1}{16}$	$3\frac{3}{4}$	$3\frac{3}{8}$	$3\frac{3}{4}$	$3\frac{1}{2}$	$3\frac{1}{8}$	$2\frac{1}{8}$	—	—
	Greatest width (at zygomatic arches)	$5\frac{1}{8}$	$9\frac{3}{8}$	$7\frac{3}{4}$	$9\frac{1}{16}$	9	$8\frac{5}{8}$	—	—	—
	,, ,, (at orbits)	—	—	—	—	—	—	$7\frac{7}{8}$	$9\frac{3}{4}$	$13\frac{1}{4}$
SPINAL COLUMN.	Length of cervical vertebræ	$9\frac{7}{8}$	11	$10\frac{3}{8}$	$10\frac{5}{8}$	$11\frac{1}{2}$	10	$19\frac{1}{2}$	$19\frac{3}{4}$	19
	Length of dorsal vertebræ from neck to a point opposite the front of the crest of the ilium	22	$33\frac{1}{8}$	$26\frac{3}{4}$	$31\frac{1}{2}$	31	$25\frac{5}{8}$	36	$49\frac{1}{2}$	54
	From level of iliac crest to back of ischium	$7\frac{7}{8}$	13	$10\frac{1}{2}$	12	15	12	$16\frac{1}{2}$	$21\frac{1}{4}$	$21\frac{1}{2}$
	From level of iliac crest to back point of sacrum	$3\frac{1}{2}$	$7\frac{1}{4}$	$5\frac{1}{2}$	6	10	$8\frac{3}{4}$	$10\frac{5}{8}$	$13\frac{3}{8}$	$13\frac{1}{2}$
	Length of sacrum	$2\frac{1}{8}$	$4\frac{1}{4}$	$3\frac{1}{2}$	$3\frac{3}{4}$	$6\frac{3}{4}$	$5\frac{7}{8}$	$8\frac{3}{4}$	$10\frac{3}{4}$	$9\frac{1}{2}$
	Length of caudal vertebræ	—	$40\frac{1}{2}$	$36\frac{1}{4}$?	38?	$6\frac{1}{2}$?	$4\frac{3}{4}$	$15\frac{3}{4}$	32	20
TRUNK.	Depth of chest at xiphoid cartilage or metasternum	$11\frac{3}{4}$	13	$12\frac{5}{8}$	$14\frac{1}{4}$	20?	$15\frac{5}{8}$	24	$29\frac{1}{2}$	$39\frac{1}{2}$
	From iliac crest to centre of great trochanter	$5\frac{1}{2}$	$8\frac{7}{8}$	$7\frac{1}{16}$	$7\frac{3}{4}$	10	$8\frac{1}{16}$	12	15	$14\frac{1}{2}$
	Width from crest to crest of ilium at its widest point, *i.e.* the inferior external angle	5	6	$6\frac{1}{4}$	$6\frac{1}{4}$	$14\frac{1}{2}$	$10\frac{3}{4}$	$18\frac{1}{4}$	$22\frac{3}{8}$	20
	Width between ischiatic tuberosities, external points	$5\frac{3}{4}$	$6\frac{1}{8}$	6	6	$8\frac{3}{4}$	$6\frac{7}{8}$	9	15	$12\frac{1}{2}$
	Width at widest part of chest, *i.e.* about tenth rib	$8\frac{3}{4}$	$10\frac{3}{4}$	$9\frac{7}{8}$	$10\frac{1}{2}$	18	$13\frac{3}{8}$	$18\frac{1}{2}$	$22\frac{3}{4}$	$22\frac{1}{2}$
	Width from acromion to acromion, the widest point of shoulder	$7\frac{7}{8}$	$10\frac{3}{4}$?	$9\frac{1}{4}$?	10?	18	14	—	—	—
	Width from head to head of humeri, the widest point of shoulder	—	—	—	—	—	—	$12\frac{3}{4}$	18	17
	Width from trochanter to trochanter	$7\frac{1}{8}$	$9\frac{1}{8}$	$9\frac{1}{8}$	$9\frac{1}{2}$	13	$10\frac{3}{4}$	15	$19\frac{3}{4}$	19
	Height at shoulder when alive (estimated)	$29\frac{1}{2}$	37	32	35	38	36	54	60	70
	From angle of scapula to crest of ilium	$17\frac{3}{4}$	$25\frac{5}{8}$	20?	$22\frac{7}{8}$	$19\frac{1}{2}$	$17\frac{1}{4}$	$25\frac{5}{8}$	36	36
	Length of body from manubrium to ischium (or from head of humerus to ischium)	30	$44\frac{1}{2}$	$41\frac{1}{8}$	$45\frac{3}{4}$	44?	$38\frac{1}{4}$	$51\frac{5}{8}$	$70\frac{7}{8}$	74

	SPECIES.	DOG.	LION.	LIONESS.	TIGER.	GRIZZLY BEAR	BROWN BEAR.	HORSE.	COW.	AMERICAN BUFFALO.
	REMARKS.	Large. Sex and breed unknown	Average specimen	Average specimen	Small specimen male	Sex ?	Sex ? Size, Medium.	Small male.	Above average size.	Large male.
FORE LIMB.	Length of scapula to tip of acromion process	$6\frac{7}{8}$	$10\frac{1}{4}$	$8\frac{5}{8}$	$9\frac{1}{16}$	12	$9\frac{7}{8}$	—	$17\frac{3}{4}$	$17\frac{1}{2}$
	Length of scapula to tip of coracoid process	$7\frac{3}{8}$	$10\frac{1}{2}$	$9\frac{1}{4}$	$9\frac{5}{8}$	$11\frac{1}{2}$	$9\frac{1}{4}$	$14\frac{5}{8}$	$19\frac{1}{4}$	$20\frac{3}{4}$
	Length of humerus on outer side	$8\frac{1}{2}$	13	$11\frac{1}{4}$	$12\frac{1}{8}$	15	$13\frac{3}{8}$	$11\frac{5}{8}$	$10\frac{3}{4}$	$14\frac{1}{4}$
	Length of humerus from centre of head to centre of external epicondyle	$7\frac{3}{4}$	$10\frac{5}{8}$	$9\frac{1}{2}$	$10\frac{1}{4}$	$12\frac{3}{4}$	$11\frac{1}{4}$	$9\frac{1}{2}$	$10\frac{1}{16}$	12
	Length of humerus inside from centre of the trochin to the centre of the tubercle ...	$7\frac{1}{2}$	$10\frac{1}{2}$	$9\frac{5}{8}$	$9\frac{7}{8}$	$12\frac{1}{2}$	$11\frac{1}{4}$	$9\frac{1}{2}$	$10\frac{1}{2}$	$11\frac{3}{4}$
	Length of ulna from top of olecranon to line of flexure of wrist	$10\frac{1}{2}$	$14\frac{1}{4}$	$12\frac{1}{4}$	$13\frac{3}{8}$	14	$13\frac{1}{4}$	$16\frac{1}{2}$	$16\frac{3}{4}$	$17\frac{1}{4}$
	From top of olecranon to point of pisiform bone	$11\frac{1}{4}$	$14\frac{3}{8}$	$12\frac{5}{8}$	$14\frac{1}{4}$	15	$13\frac{5}{8}$	$17\frac{1}{8}$	$17\frac{1}{4}$	17
	Length of radius inside	$8\frac{7}{8}$	11	$9\frac{5}{8}$	$10\frac{5}{8}$	$12\frac{1}{4}$	$11\frac{5}{8}$	$13\frac{5}{8}$	$12\frac{1}{2}$	$12\frac{7}{8}$
	From line of flexure of wrist to under side of outer sesamoid...	$4\frac{1}{8}$	$4\frac{3}{8}$	$4\frac{1}{2}$	$5\frac{1}{4}$	$4\frac{5}{8}$	$3\frac{3}{4}$	$10\frac{1}{4}$	11	$10\frac{3}{4}$
	From point of outer sesamoid to level of tip of longest toe without hoof or claw	$4\frac{1}{8}$	$4\frac{1}{2}$	$4\frac{1}{2}$	$5\frac{1}{4}$	6	$5\frac{3}{4}$	$7\frac{1}{4}$	7	$7\frac{3}{8}$
HIND LIMB.	Greatest length of femur	$9\frac{7}{8}$	$14\frac{3}{4}$	$12\frac{5}{8}$	$14\frac{1}{4}$	$17\frac{3}{4}$	$15\frac{3}{4}$	$15\frac{1}{4}$	$16\frac{1}{2}$	17
	From centre of great trochanter to centre of outer tuberosity or epicondyle of femur...	$8\frac{1}{2}$	13	$11\frac{1}{2}$	$12\frac{7}{8}$	15	$13\frac{3}{8}$	$12\frac{1}{4}$	$13\frac{3}{8}$	14
	Length of tibia to inner malleolus	$9\frac{7}{8}$	$12\frac{5}{8}$	$11\frac{1}{4}$	12	$12\frac{1}{4}$	$11\frac{1}{2}$	$13\frac{3}{4}$	$14\frac{3}{4}$	$15\frac{3}{4}$
	From centre of outer tuberosity of tibia to bottom of outer malleolus	$9\frac{7}{8}$	$12\frac{1}{4}$	$10\frac{1}{4}$	$11\frac{5}{8}$	12	11	$12\frac{5}{8}$	$13\frac{1}{4}$	$13\frac{1}{2}$
	Length of fibula	$9\frac{1}{2}$	$11\frac{1}{2}$	$10\frac{1}{2}$	$11\frac{1}{4}$	$11\frac{3}{4}$	$10\frac{5}{8}$	$1\frac{1}{4}$	$6\frac{1}{4}$	—
	Greatest length of calcaneum	$2\frac{1}{2}$	$4\frac{1}{8}$	$3\frac{3}{4}$	$4\frac{1}{8}$	$3\frac{3}{4}$	$3\frac{1}{8}$	$4\frac{1}{8}$	$6\frac{5}{8}$	$6\frac{1}{2}$
	From top of calcaneum to under side of outer sesamoid	$6\frac{3}{4}$	9	$8\frac{3}{4}$	$9\frac{1}{2}$	$7\frac{3}{4}$	$6\frac{3}{4}$	$15\frac{5}{8}$	$17\frac{1}{4}$	$17\frac{1}{4}$
	From point of outer sesamoid bone to the tip of the longest toe without hoof or claw...	$3\frac{7}{8}$	$4\frac{1}{4}$	4	$4\frac{1}{2}?$	5	$5\frac{3}{8}$	$7\frac{3}{4}$	$7\frac{1}{2}$	$7\frac{1}{4}$

CHAPTER LI.

THE HORSE IN MOTION.

Plates XXXIX., XL., XLI.

THE positions in which artists were wont to represent quadrupeds in rapid motion have long been known to be merely conventional attitudes, with but little foundation in nature. Many original observers, John Leech, for example, made attempts to replace the conventional positions with others more true, but finally relinquished the idea as hopeless. The conclusion ultimately accepted by such men, was briefly this :—In every case art is a conventional abstract from nature, and its appeal to the imagination must necessarily be influenced largely by education. These impossible attitudes are through education able to suggest to us the idea of motion, and therefore they must be accepted.

Many other artists made attempts to draw nearer to the truth, but it was not until the appearance of the well-known Muybridge photographs, in 1878, that the matter was forcibly brought to the notice of the public and the whole art world. At first these photographs were looked upon merely as amusing curiosities, but their educational influence has steadily grown, and to-day it is the exception when one sees a running Horse depicted in the 'hobby-horse' attitude.

Being instantaneous photographs, their truth is beyond impeachment, and yet it is perhaps needless to remark that all truth is not equally good ; and the artist who blindly and without judgment adheres to the attitudes shown is not likely to arrive at satisfactory results. The plates representing the walk, amble, trot, rack, canter, and gallop of the Horse are kindly loaned by Professor Eadweard Muybridge, whose definitions of these paces, as given in the Standard Dictionary, are reproduced by permission of Messrs. Funk and Wagnall of New York.

Walk. To move with the slowest pace, in which a quadruped has always two or more feet on the ground, and a biped always one foot. (Plate **XXXIX.**)

It is thus seen that when a Horse during a walk is on two feet, and the other two feet are suspended between the supporting legs, the suspended feet are laterals. On the other hand, when the suspended feet are severally in advance of and behind the supporting legs, they are diagonals. These invariable rules seem to be neglected or entirely ignored by many of the most eminent animal painters of modern times.

Amble. A method of progressive motion in quadrupeds, with the same sequence of foot-fallings as in the walk, but in which a hind foot or a fore foot is lifted from the ground before its fellow hind foot or fellow fore foot is placed thereon, the support of the body devolving alternately upon one foot and upon two feet, the single foot being alternately a fore foot and a hind foot and the intermedial supports the diagonal and lateral. (Plate **XXXIX.**)

The amble is natural to the Elephant, and, in some countries, to the Horse, the Mule and the Ass. The sequence of foot-fallings is the right hind, the right fore, the left hind, the left fore, beginning again with the right hind foot. At no time during the stride is the body of the animal unsupported.

The amble and the walk are the only regular progressive movements of the Horse wherein the body is never without the support of one or more legs ; in all others the weight is entirely off the ground for a longer or shorter period.

Trot. A progressive motion of a quadruped, in which each pair of diagonal legs is alternately lifted, thrust forward, and placed upon the ground with approximate synchrony, the body of the animal being entirely unsupported twice during each stride. (Plate XL.)

It appears somewhat remarkable that until quite recently many experienced horsemen were of the opinion that during the action of the trot one foot of a Horse was always in contact with the ground.

Rack. The rack differs from the trot in the nearly synchronous action of the laterals instead of the diagonals. (Plate XL.)

Canter. A system of quadrupedal locomotion in which the feet are landed on the ground in the same consecutive order as in the walk, but at shorter or quicker comparative intervals of time. (Plate XLI.)

The canter is usually regarded as a slow gallop, probably from the facility with which a change from one gait to the other can be effected ; an important difference will, however, be observed.

Gallop. The most rapid method of progressive quadrupedal motion (sometimes erroneously called the *run*), in which the animal springs into the air from a fore foot, and lands upon the diagonal hind foot. (Plate XLI.)

CHAPTER LII.

THE GALLOP OF THE DOG.

Plate XLII.

MANY of the attitudes assumed by a Dog at full speed, unlike those of the Horse, agree with the conventional attitudes which have been used indiscriminately to represent all quadrupeds when galloping.

The following is the definition in the Standard Dictionary :—

The gallop of the Dog differs from that of the Horse in that the sequence of foot-fallings is rotary instead of diagonal. The order is the left fore, the right fore, the right hind, the left hind, and then again the left fore; but this sequence is often reversed, so that the order becomes, the left fore, the left hind, the right hind, the right fore, and then again the left fore.

CHAPTER LIII.

THE ANATOMY OF BIRDS.

THERE is a widespread idea that the bodies of birds are everywhere and equally covered with feathers. This is far from being correct. All birds, with one or two exceptions, have large naked spaces on their bodies, covered however by the overlap of the feathers nearest, which would in many birds show an aggregate area nearly as great as that of the feathered tracts.

The first to call attention to this arrangement of feathered tracts, or Pterylæ, and bare tracts, or Apteria, was Nitsch.

In the general plan of pterylosis that he lays down we find the following feather-tracts named :—

1. The Spinal tract, extending on the back from the nape to the tail; extremely variable.
2. The Humeral „ narrow bands, one on each arm across the humerus.
3. The Femoral „ similar to No. 2, one across each thigh.
4. The Ventral „ begins at the head and passes along the under surface to the tail; extremely variable.
5. The Capital „ covering the head.
6. The Alar „ the rest of the wing feathers.
7. The Caudal „ the tail and its region.
8. The Crural „ the leg feathers.

The importance of these tracts to the artist lies in the fact that the series of feathers which emanate from them are separately visible in the plumage of the living bird. And when drawing is made with due reference to these anatomical considerations, it wears an air of truthfulness which all recognise, even though they do not know the reason for it. Hitherto no one seems to have considered these facts to be worthy of the artist's notice, excepting the sculptors and painters of ancient Egypt, ancient Assyria, and Japan. In the last country the love of nature and truthful rendering of it has continually kept alive the study of feathers, as is abundantly attested by the exquisitely artistic and truthful representations of the Shijo, or Naturalistic School. Mr. Goodchild, in his able paper on the Cubital coverts of Birds, points out the peculiar character of the wing feathering of the Hawk tribes, and adds :—

The wing of a Merlin well illustrates the whole of the normal Acciptrine forms. Mr. Wolf's beautiful figures of the Birds of Prey all afford excellent illustrations of the same point, while, from a part of the world where experience has led us to expect minute accuracy of detail, we have the Japanese figure in metal of a species of Spizäetus now among the choicest treasures at South Kensington Museum which affords a correct illustration of the Accipitrine style of cubital coverts.

This figure is the work of Miyôchin Munéharu, an artist of the sixteenth century. In the same room is a bronze incense-burner of nineteenth-century work, decorated with life-sized Peafowl and Pigeons, which also affords equal evidence of artistic feeling and scientific accuracy carried to the highest pitch.

In our own time and country the bird drawings of Wolf, Keulemans, and Thorburn are among the best studies extant in this field. Mr. Wolf, indeed, may be called the founder of the London School. As early as 1840 he made a series of Falcon studies which are among the classics of the subject.

While Wolf was treating artistically the study of feathers, Sundevall was making purely scientific

investigations in the same department, and in 1847 published a paper on the 'Wings of Birds,' from which the following extracts are taken :—

(1) *Wing-quills* (Pennæ alares, Remiges, Linn. and Ill.) are only a single row, which are seated in the posterior margin of the wing, and are the largest of all. All the others are usually named *coverts* (tectrices).

(2) *Large coverts* (Tectrices majores, Pteromata, Ill.), a series of feathers which lie immediately over the roots of the quill-feathers, inserted in the skin behind the muscular layer.

(3) *Second series of coverts*, which are also seated in the fold of skin behind the true arm or hand. They often show the peculiarity that they lie in a reverse position to the preceding, as to which more hereafter.

(4) *Small coverts* (Plumæ or Tectrices minores, brachiales, cubitales, digitales, so named according to the part upon which they are seated). They form from three to five series, and are placed upon those parts of the skin which enclose the bones and muscles of the limb. They are wanting upon the cubitus in all birds which possess singing muscles at the lower larynx, but occur in all other birds.

(5) *Arm-fold feathers*, or the anterior small feathers of the wing (Plumæ antecubitales, or Tectrices minimæ), are seated in several rows upon the fold of the skin in front of the arm itself.

1. *Remiges primores* ("lash-feathers"), which are seated upon the hand, constitute the most important part of the organ of flight. In numbers they are usually ten.

The number of the feathers varies but little; only between 9 and 11. There are 9 of them only in some Song-birds, and this because the first feather disappears (of which more hereafter); and 11 in the genera *Podiceps* (all the Swedish species, also *P. domini-censis* and *phillippensis*), *Phoenicopterus, Anastomus, Tantalus, Ciconia* (according to Nitsch, also *C. mycteria*, but not *C. argala*), *Musophaga* and *Corythaix*, but not in *Schizorhix*, Wagl.

The typical form seems to be that all the 10 feathers are of equal length; but in consequence of the way in which they are attached to the hand, the first feather projects beyond the following ones and thus seems to be the longest, while the following ones appear to get gradually shorter. The wing then is quite acute. This form of wing occurs generally among the lower birds, namely, in a great many of the Water-birds.

In those which fly with remarkable rapidity, the second feather is usually the longest.

In the Song-birds without exception, the first feather is abbreviated.*** It either remains as a small rudiment, or entirely disappears; and in this latter case there are only nine primaries. This reduction of the first feather is peculiar to Song-birds, but among them it is quite usual. We may indeed estimate that one fourth of the known species are destitute of the first quill-feather, one fourth have it rudimentary, one fourth have short rounded wings with ten primaries, and the remaining fourth have tolerably long wings, but with the first feather shorter than those that follow.

2. *Remiges cubitales*, or Pennæ cubitales (arm-feathers), are inserted in the fold of the skin along the posterior side of the ulna, so that the root-ends always rest against the outer side of that bone.*** Most of them are nearly of the same size and structure, so that when the wing is folded the inner ones usually extend gradually beyond the outer; but a few of the innermost, 2–5, are always gradually much diminished in size, and have frequently a different colour and structure from the rest. They are in this case softer, more pointed, &c., and both in form and colour resemble the feathers of the back.

In number the cubital quill-feathers vary very considerably, namely, between 6 (in *Trochilus*) and 36–40 (in *Diomedea exulans*).*** The number is in general greatest in Water-birds, some of the Waders (*Ardeæ, Ciconiæ*) and Raptorial birds (*Vulturinæ*). The average number in the other Raptorial birds, Gallinæ, and Waders is 15–16, which also occurs in many Water-birds; most of the Coccyges have 10–13, but in these, as in all the fore-named orders, the number varies, even in species of the same genus. Only the Song-birds have a nearly constant number, 9, which is the smallest number of general occurrence.

1. *Tectrices majores* (great wing-coverts, Pteromata, Ill.) form a single series, which is always situated immediately within upon the roots of the quill-feathers. They always retain much resemblance in form, texture, and colour to their corresponding quill-feathers, and are always, like the latter, destitute of accessory plumules. They should be named after their quill-feathers, so that those on the hand are called *Tectrices primores* or manus (great hand-coverts), and those on the fore-arm *cubitales* (great arm-coverts). The former are always inserted in the skin in the same tube with their corresponding quill-feathers, and so close upon the latter that the two seem to have grown together.

The greater hand-coverts (*T. majores primores*) are equal in number to the quill-feathers.

Of the *Tectrices cubitales* there are always one or two more than of the corresponding remiges; thus, externally, there is always one small supernumerary one. Properly, they ought to be of equal number, as the feathers here, as everywhere, are arranged in quincunx (rows of three different sets), which constitutes a continuation of their arrangement on the hand. The supernumerary coverts seem to me, therefore, to show that a quill-feather, which ought to have been placed in the middle of the wing-fold, is not developed.*** In the Song-birds they are so short that they do not attain half the length of the remiges, except inwardly in some genera; but in all other orders they are larger, so that they always reach beyond the half of their corresponding remiges.

2. *Tectrices secundæ seriei* (the coverts of the second row), which lie immediately upon the greater coverts, generally resemble the ordinary feathers of the body. Those which belong to the cubitus have usually the peculiarity of lying reversed with relation to the greater coverts and remiges, so that the inner margin of each feather (that turned toward the humerus) is free and covers the outer margin of the next one. But I have always found them unreversed in *Trochilus, Coracias, Cuculus, Columba, Gallus, Lestris, Sterna,* and *Uria*, as

well as in young Song-birds in their first dress.*** They are most visible in the Oscines, in consequence of the absence of the next series, and are quite short, soft, and usually distinguished by a peculiar colour-marking, *e.g.*, white at the apex in many so that they form a transverse band upon the wing. (A transverse band upon the wing is almost still more frequently produced by the apices of the greater covert feathers, which in the Song-birds, are often white, yellow, or of paler colour.)*** In the Song-birds, in which they alone are reversed, they may receive this name (*perversæ*).

3. The *Tectrices minores cubiti* vel *manus* (smaller wing coverts) in form do not differ at all, or but slightly, from the feathers of the body, and in position they agree with the next preceding series, inasmuch as their margins cover each other in a contrary way to those of the remiges. But they lie similarly reversed also in those birds in which those of the second series are not reversed (*Coracias*, *Cuculus*, &c.).

In the Song-birds these feathers should properly form three series on the cubitus, but they show the remarkable peculiarity that they are never fully developed. Only in the young in their first plumage, and in the winter plumage, a few of them, but never all, occur in the form of down, or of very small undeveloped feather rudiments covered up by the next following perfect feathers. In older birds in the summer plumage, scarcely a trace of them is usually visible.

This remarkable structure is so peculiar to those birds which have the inferior larynx furnished with five pairs of muscles, that I have been unable to find any other form except *Cypselus* which resembles them in this respect, but it occurs in the whole of them without a known exception, and, consequently, forms a certain external character for them. In every Song-bird, even when sitting with folded wings, and in stuffed specimens, we recognise this deficiency at the first glance : it causes the wing to exhibit only a small number of coverts, and these to occupy an inconsiderable space in comparison with those in the wings of species belonging to other orders.

On the hand these feathers are continuous in two or three series, which in no respect differ in structure from the second series of coverts, and exactly cover the small portion of the hand which is not clothed by the large coverts. They are usually concealed by the quill-feathers of the thumb, and always lie right, *i.e.*, not reversed as on the cubitus.

4. The *Tectrices minimæ* s. *antecubitales* (smallest or foremost covert-feathers), are seated in several series upon the fold of the skin in front of the cubitus. They are right-lying, not reversed like those on the cubitus itself. But we often find one of these series reversed, in agreement with the preceding ones, *e.g.*, in the Gallinæ, in the diurnal and nocturnal Birds of Prey, and many others.

On Plate XLIII. is shown the Common Sparrow, its ordinary appearance, and a chart of its feather arrangements. These are explained by the drawings on Plate XLIV., and will serve to illustrate the feathering of all the Passerine Birds.

Plates XLV. and XLVI. present the living appearance and anatomical details of a Kestrel, as a type of the Birds of Prey.

Plates XLVII. and XLVIII. give the natural appearance, abstract form, feather arrangement, and living details of the Common Quail (*Coturnix communis*).

CHAPTER LIV.

THE PEACOCK.

Plate XLIX.

COMMON opinion has awarded to the Peacock, above all birds, the palm of beauty. Many of the recently discovered Hummingbirds are exquisite, as are the rare Birds of Paradise and some of the Asiatic Pheasants brought to light by modern research, but, divested of their charm of novelty, it is found that none of the species mentioned can successfully compete with the Peacock. Probably there is nothing else as beautiful in the world of Zoology.

The train, or ' tail ' as it is commonly called, is the unique and splendid feature of this regal bird. The chromatic beauties are no less notable than the mathematical correctness with which they are displayed. It is almost unquestionably the most remarkable illustration extant of the regular arrangement of feathers. The perfect geometric design, indicated in the Plate, is not merely hypothetical, but will be seen in every Peacock's ' tail ' when in full plumage.

The explanation of this is very simple, as will be seen on reference to the drawing of the naked Sparrow (Plate XLIV.). The true tail of the Peacock, composed of eighteen ordinary feathers, is underneath the train and supports it when spread. The train consists of two hundred and fifty odd posterior feathers of the dorsal tract, which are set on in diamond pattern, as in the Sparrow, and the regular lengthening of which towards the back, together with the radiation when spread, completes the mathematical figure.

A slight variation is sometimes seen when the tail is newly grown. The ends of the three outer rows or Y feathers are close together and separated from the true eye feathers by an exceptionally wide interval. They are also supplied with an embryo eye, which however is soon worn off.

A LIST OF THE PRINCIPAL WORKS CONSULTED.

1683. SNAPE (ANDREW). The Anatomy of an Horse.
With copperplate illustrations. A careful description, afterwards translated into French by F. Garsault, 1732.

1766. STUBBS (GEO.). The Anatomy of the Horse.* In eighteen tables, all done from nature. London.
The plates were engraved by the artist himself, and are among the most accurate anatomical illustrations extant.

1769. BOURGELAT (CL.). Elémens de l'Art Vétérinaire. [Traité de la Conformation extérieure du cheval, &c.] Paris.
The anatomy of the Horse compared with that of the Ox and Sheep. 4th edition in 1807.

1779. GOIFFON ET VINCENT. Memoire artificielle des principes relatifs à la fidelle representation des Animaux, tant en Peinture, qu'en Sculpture. Alfort. Folio.
With 23 large copperplates showing accurately the action, anatomy, size, and proportions of the Horse.

[1799.] GIRARD (J.). Tableaux Comparatifs de l'Anatomie des animaux domestiques. VII. de la République.

1807. GIRARD (J.). Anatomie des animaux domestiques. 8vo, 2 vols. (4th ed., 1841.)
Translated into German by K. L. Schwab, 1810–11.

1822. GURLT. Handbuch der Vergleichenden Anatomie de Haussaugethiere.
With atlas of plates. 2nd edition 1832 ; 3rd edition 1844.

1832. PERCIVALL (WM., M.R.C.S.). The Anatomy of the Horse. London. 8vo.
No illustrations.

1843. SUNDEVALL (C. J.). On the Wings of Birds : The Ibis, fifth series, vol. iv., No. xvi. art. xxxix. pp. 389–457. Plates ix. and x. [Translated from the original Swedish of the Kongl. Vetensk.-Akad. Handlingar, 1843, by W. S. Dallas, F.L.S.] London, 1886.
Two plates, comprising 13 valuable illustrations. This is the first attempt to study the subject.

1844–53. SCHLEGEL (H.) et VERSTER DE WULVERHURST (A. H.). Traité de Fauconnerie. Leiden and Düsseldorf.
With 12 life-size plates by J. Wolf.

1845. STRAUS-DURCKHEIM (HERCULE). Anatomie descriptive et comparative du Chat. 2 vols. text, 4to, 1 atlas folio. Paris.
Atlas with 13 admirable plates, ⅔ life-size.

1847. NITSCH (C. L.). Systeme der Pterylographie.
The first edition was published in 1833. The English translation by Dr. P. L. Sclater, in 1867.

1850. LEYH (F. A.). Handbuch der Anatomie der Hausthiere. Stuttgart. 8vo. 2nd edition, 1859.
Excellent treatise on Anatomy of Horse, Cow, Pig, Cat, and Dog, with careful woodcuts.

1861. LEISERING (A. G. T., Dr.). Atlas der Anatomy des Pferdes und Übrigen Hausthiere. [Drawings by Moritz Krantz.]
Valuable lithographic plates of Horse, Cow, Dog, Cat, Birds, &c.

1865. WALTON (ELIJAH). The Camel : its Anatomy, Proportions, and Paces. London. Folio.
Ninety-four large lithographic plates by the author, many of them coloured. A most valuable work.

1870. FLOWER (W. H.). Introduction to the Osteology of the Mammalia.

1873. MAREY (E. J.). La machine animale. Locomotion terrestre et aërienne. Paris. 8vo.
 The locomotion of animals studied by mechanical apparatus; 117 figures in the text. Followed some years later by works with instantaneous photographs.

1880. REGAMEY (GUILLAUME). Atlas de l'Anatomie des formes du Cheval. Paris.
 With chromo-lithographic plates.

1881. MIVART (ST. GEORGE). The Cat. New York. 8vo.

1882. STILLMAN (Dr. J. D. B., A.M.). The Horse in motion.* Under the auspices of Leland Stanford. London.
 One hundred and seven plates, chiefly from photographs by Mr. Ead. Muybridge, illustrating the Horse, Ox, Dog, Pig, and Deer in motion.

1883. FRANCK (Dr. LUDV.). Handbuch der Anatomie der Hausthiere. Stuttgart. 8vo.

1884. GOUBAUX (A.) et BARRIER (G.). De l'extérieur du Cheval. Paris.
 A valuable work with 34 plates and 346 illustrations. A second edition appeared in 1890.

1885. LEISERING (A. G. T.) und MUELLER (C.). Handbuch der vergleichenden Anatomie der Haussaugethiere. Berlin. 8vo.
 A new edition of Leisering's work (1861).

1886. CUYER (E.) et ALIX (E.). Le Cheval. Paris.
 Sixteen large coloured plates, with superimposed parts and many woodcuts.

1886. GOODCHILD (J. G.). Obs. on the Cubital Coverts of Birds. P. Z. S. Pp. 184-203. London.
 Thirty-seven cuts.

1887. MUYBRIDGE (EADWEARD). Animal Locomotion.* Philadelphia, 1872–1885.
 Ten folio volumes, containing 781 plates, each representing a series of movements of Man, Birds, or Animals.

1890. BALLU (Roger). L'Œuvre de Barye. Précédé d'une introduction de M. Eugène Guillaume. Paris. Folio.
 An important work, with 25 large plates, including portrait of Antoine Louis Barye, and 51 wood-cuts.

1891. ELLENBERGER (Dr. W.) und BAUM (Dr. H.). Systematische und topographische Anatomie des Hundes. Berlin.
 An admirable monograph, with 208 cuts, 37 lithographs.
 A French translation by Dr. J. Deniker appeared in 1894, published by C. Reinwald and Co.

1891. CHAUVEAU (A.). The Comparative Anatomy of the Domesticated Animals. Revised by S. Arloing. Translated by Geo. Fleming. New York. 8vo.
 First edition (French) dated 1855. First English edition 1864.

1892. GOODCHILD (J. G.), H.M. Geol. Surv., F.Z.S., M.B.O.U. The Cubital coverts of the Euornithes in Relation to Taxonomy. Proc. Roy. Phys. Soc. Edinburgh, 1890–91. Vol. x. Plate xv., 17 pp. 317–333 pp.
 One plate with 26 figures of wings.

1892. (Idem). Notes on Crested Birds of Prey. Same publication, pp. 202-208. Plate x.
 One plate with 13 figures of heads.

1893. (Idem). Supplementary Observations on the Cubital Coverts of the Euornithes. Same publication. Vol. xii. (1892-3), pp. 171-181.

1894. SUSSDORFF (M.). Lehrbuch der vergleichenden Anatomie der Hausthiere. 2 vols.
 An important work, with very accurate illustrations.

*Available as a reprint edition from Dover Publications, Inc., www.doverpublications.com

INDEX

INDEX.

INDEX.

THE PLATES

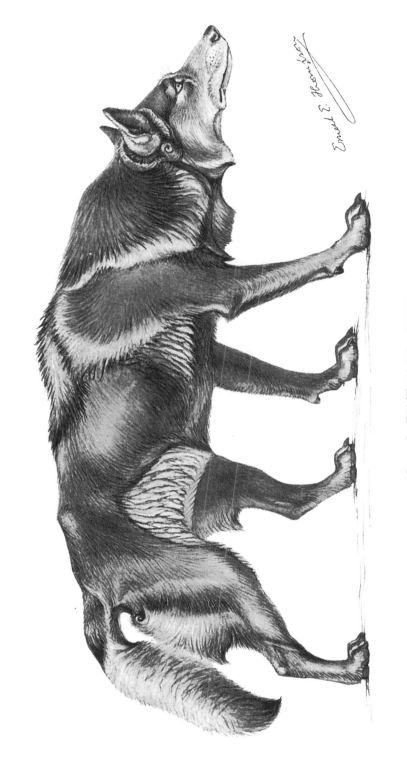

PLATE I.—DIAGRAM OF A WOLF.

To illustrate the Anatomy of the Hairy Coat. (*See* Chapter II.)

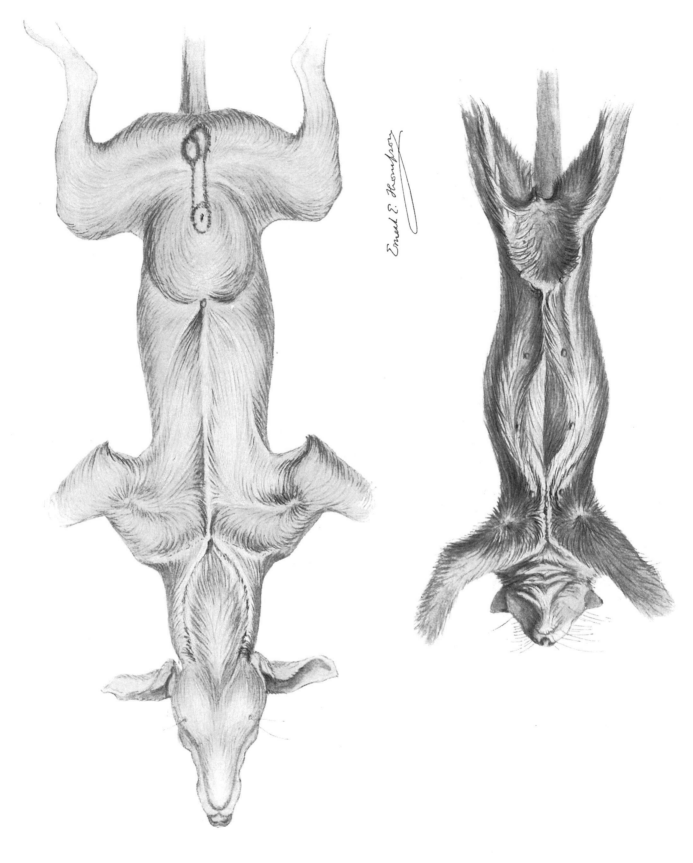

Ernest E. Thompson

PLATE II.—DIAGRAM OF THE HAIR ON THE BELLIES OF DOG AND CAT.
To illustrate the plan prevailing throughout the Mammalia. (*See* Chapter II.)

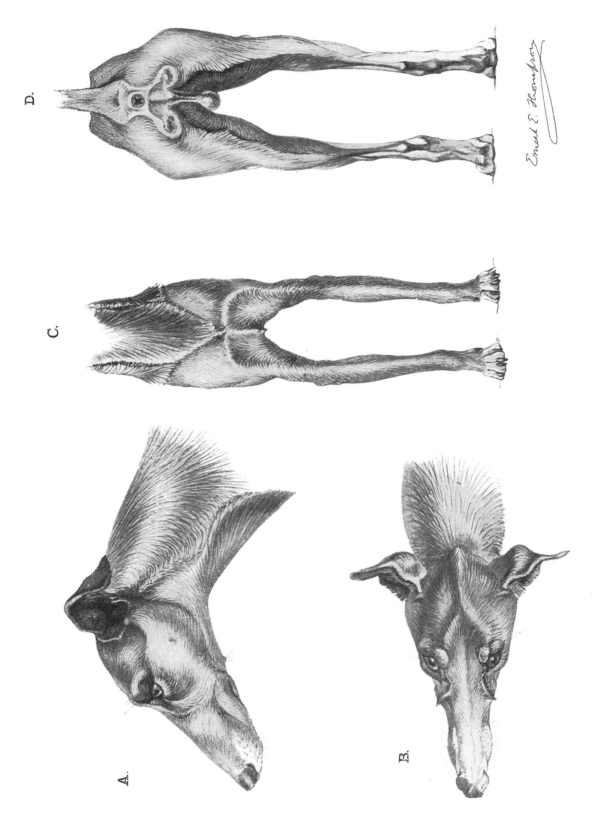

Ernest E. Thompson

PLATE III.—THE ARRANGEMENT OF HAIR ON THE GREYHOUND.

To show the prevailing general plan, especially the various "Structural Scars" and the Ridge caused by the radiating Hair around the Eyes meeting the Hair on the Nose.
(See Chapter II.)

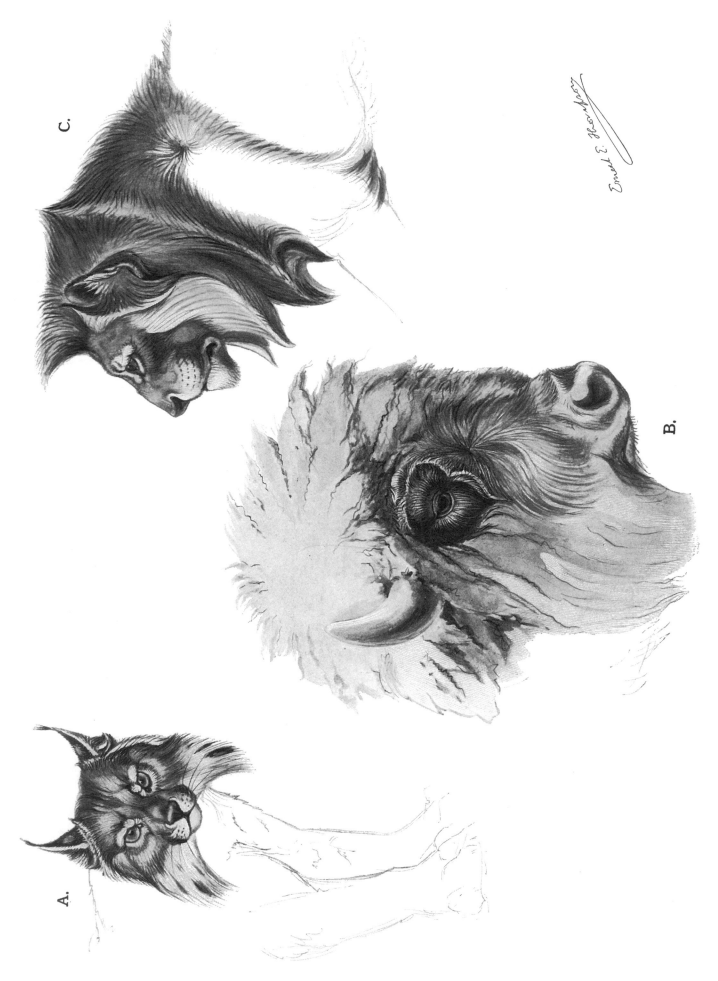

PLATE IV.—HEADS OF LYNX, AMERICAN BUFFALO, AND LION.

A. Head of Canada Lynx, to show the development of the Cheek Ruff and the partial development of the Ear Ruff.
B. Head of American Buffalo, to show the divergent Hair about the Eyes. C. Head of Lion, to show both Ruffs at full development, also the arrangement of the Mane. (*See* Chapter II.)

75. Sagittal Crest or Ridge
87. Zygoma
85. Supermaxilla
86. Premaxilla
77. Submaxilla
78. Ascending Ramus of Jaw
79. Angle of Jaw
80. Atlas
81. Axis
82. Scapula
83. Spine of Scapula
14. Acromion
15. Coracoid Process
16. Head of Humerus
17. Grt. Tuberosity „ „ or Trochiter
18. Deltoid Ridge „ „
19. Body „ „
20. Epicondyloid Ridge of Humerus or Spine
21. Outer Epicondyle „ „
22. Outer Condyle „ „
23. Head of Radius
24. Tuberosity „ „
25. Body „ „
26. Ulna
27. Styloid Process of Ulna
28. Carpus
29. Metacarpus
30. Phalanges

76. Occipital Tuberosity
84. Lambdoid Ridge
42. Neck or Cervical Vertebrae
44. Neural Spine of a Vertebra
43. Thoracic or Dorsal Vertebrae
46. Lumbar Vertebrae
45. Sacrum 3 or 4 vertebrae solidified
47. Coccyx, Tail or Caudal Vertebrae (20 to 22)
50. Transverse Processes
51. Great Trochanter
52. Patella
53. In. Condyle of Femur
54. In. Epicondyle of Femur
55. In. Tuberosity of Tibia
56. Crest of Tibia
57. Tibia
58. Inner Malleolus
59. Astragalus

41. Sternum
40. Olecranon
39. In. Epicondyle
38. In. Condyle
37. Ulna
36. Radius
35. Styloid Process of Radius
34. Inner Malleolus
33. Pisiform
32. Scapho-lunar
31. Pyramidal
60. Head of 2nd. Metatarsal

48. Acetabulum or Socket of Femur
49. Os Innominatum or Pelvic Bone {62. Ilium or Hip, 63. Ischium, 64. Pubis}
65. Lesser Trochanter
66. Linea Aspera
67. Femur or Thigh Bone
68. Outer Epicondyle of „
69. „ Condyle „ „
70. Head of Fibula
71. Fibula
72. Tarsus
73. Metatarsus
74. Phalanges
61. Calcaneum
Cuboid
Outer Malleolus
Outer Tuberosity of Tibia

PLATE V.—THE ANATOMY OF THE GREYHOUND. THE SKELETON.

For the sake of simplicity, the Ribs and Shoulder-Bones of the farther side are omitted.

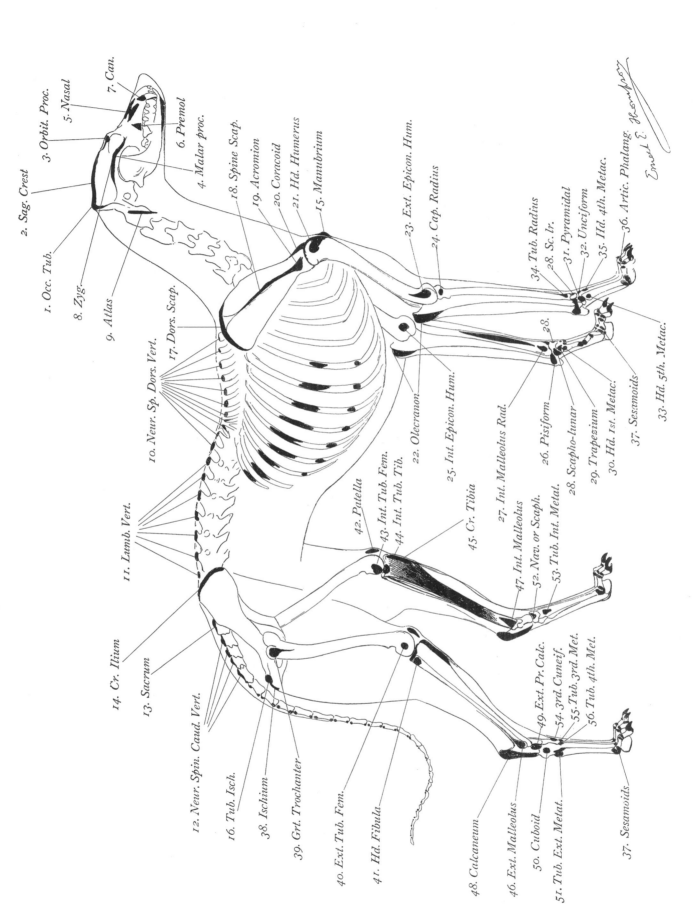

2. Sag. Crest
3. Orbit. Proc.
5. Nasal
7. Can.
6. Premol
4. Malar proc.
18. Spine Scap.
19. Acromion
20. Coracoid
21. Hd. Humerus
15. Manubrium
23. Ext. Epicon. Hum.
24. Cap. Radius
34. Tub. Radius
28. Sc. lr.
31. Pyramidal
32. Unciform
35. Hd. 4th. Metac.
36. Artic. Phalang.

1. Occ. Tub.
8. Zyg.
9. Atlas
17. Dors. Scap.
10. Neur. Sp. Dors. Vert.
22. Olecranon.
25. Int. Epicon. Hum.
27. Int. Malleolus Rad.
26. Pisiform
28. Scapho-lunar
29. Trapezium
30. Hd. 1st. Metac.
37. Sesamoids.
33. Hd. 5th. Metac.
28.

11. Lumb. Vert.
42. Patella
43. Int. Tub. Fem.
44. Int. Tub. Tib.
45. Cr. Tibia
47. Int. Malleolus
52. Nav. or Scaph.
53. Tub. Int. Metat.

14. Cr. Ilium
13. Sacrum
12. Neur. Spin. Caud. Vert.
16. Tub. Isch.
38. Ischium
39. Grt. Trochanter
40. Ext. Tub. Fem.
41. Hd. Fibula
48. Culcaneum
46. Ext. Malleolus
50. Cuboid
51. Tub. Ext. Metat.
49. Ext. Pr. Calc.
54. 3rd. Cuneif.
55. Tub. 3rd. Met.
56. Tub. 4th. Met.
37. Sesamoids.

Ernest E. Thompson

PLATE VI.—THE ANATOMY OF THE GREYHOUND. THE BONE POINTS.

The black places show where the Bones come to the surface nearly enough to make visible points or bosses, supplying fixed points for definite measurements. (*See* Chapter VIII.)

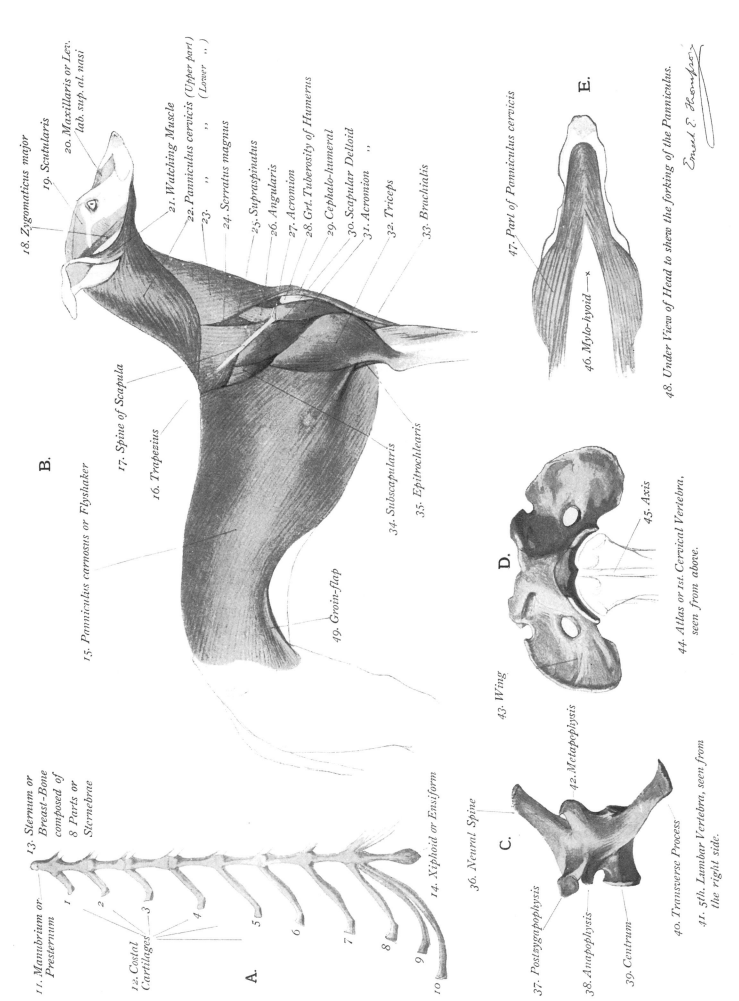

11. *Manubrium or Presternum*

12. *Costal Cartilages*

13. *Sternum or Breast-Bone composed of 8 Parts or Sternebrae*

14. *Xiphoid or Ensiform*

A.

15. *Panniculus carnosus or Flyshaker*

16. *Trapezius*

17. *Spine of Scapula*

18. *Zygomaticus major*

19. *Scutularis*

20. *Maxillaris or Lev. lab. sup. al. nasi*

21. *Watching Muscle*

22. *Panniculus cervicis (Upper part)*

23. ,, ,, *(Lower ,,)*

24. *Serratus magnus*

25. *Supraspinatus*

26. *Angularis*

27. *Acromion*

28. *Grt. Tuberosity of Humerus*

29. *Cephalo-humeral*

30. *Scapular Delloid*

31. *Acromion ,,*

32. *Triceps*

33. *Brachialis*

34. *Subscapularis*

35. *Epitrochlearis*

B.

49. *Groin-flap*

36. *Neural Spine*

37. *Postzygapophysis*

38. *Anapophysis*

39. *Centrum*

40. *Transverse Process*

41. *5th. Lumbar Vertebra, seen from the right side.*

42. *Metapophysis*

C.

43. *Wing*

44. *Atlas or 1st. Cervical Vertebra, seen from above.*

45. *Axis*

D.

46. *Mylo-hyoid* ——×

47. *Part of Panniculus cervicis*

48. *Under View of Head to shew the forking of the Panniculus.*

E.

Ernest E. Thompson

PLATE VII.—THE ANATOMY OF THE GREYHOUND. SOME DETAILS OF THE BONES AND THE FIRST LAYER OF MUSCLES.

A. Sternum seen from below, showing the manner of attachment of the Costal Cartilages.
B. Trunk, with Skin only removed, showing the superficial layer of Muscles.
C. Fifth Lumbar Vertebra.
D. Atlas or First Cervical Vertebra, with outline of the Axis or Second to show their relations.
E. Under view of Head, to show the forking of the Panniculus.

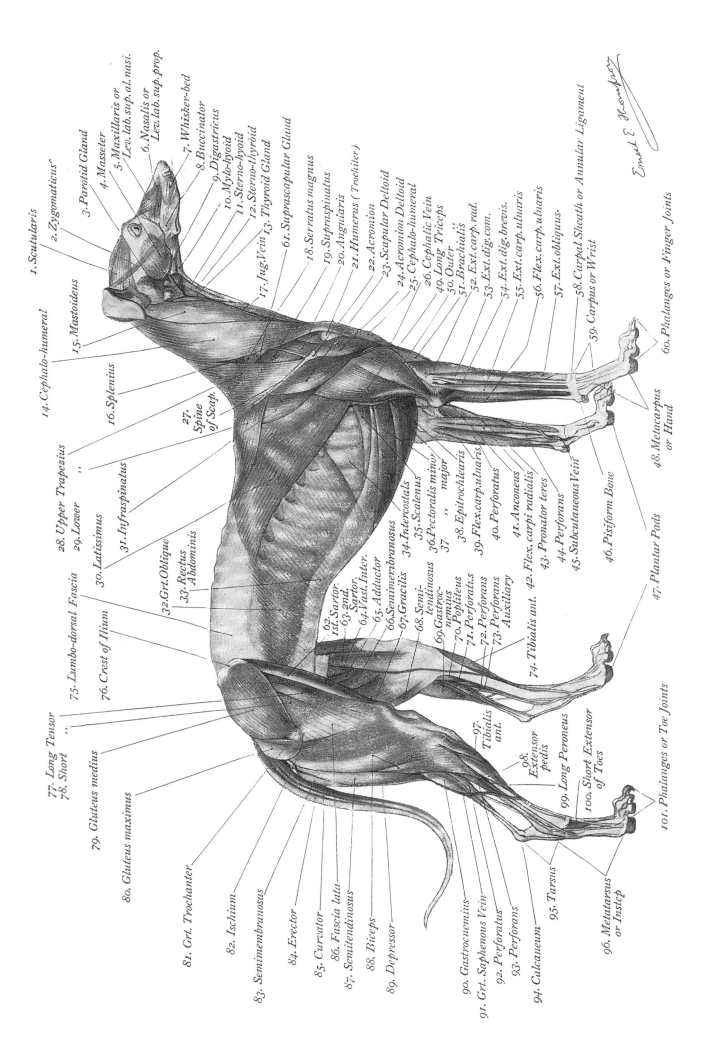

1. Scutularis
2. Zygomaticus
3. Parotid Gland
4. Masseter
5. Maxillaris or Lev. lab. sup. al. nasi.
6. Nasalis or Lev. lab. sup. prop.
7. Whisker-bed
8. Buccinator
9. Digastricus
10. Mylo-hyoid
11. Sterno-hyoid
12. Sterno-thyroid
13. Thyroid Gland
14. Cephalo-humeral
15. Mastoideus
16. Splenius
17. Jug. Vein.
18. Serratus magnus
19. Supraspinatus
20. Anguriaris
21. Humerus (Trochiter).
22. Acromion
23. Scapular Deltoid
24. Acromion Deltoid
25. Cephalo-humeral
26. Cephalic Vein
27. Spine of Scap.
28. Upper Trapezius
29. Lower "
30. Latissimus
31. Infraspinatus
32. Grt. Oblique
33. Rectus Abdominis
34. Intercostals
35. Scalenus
36. Pectoralis minor
37. " major
38. Epitrochlearis
39. Flex. carp. ulnaris
40. Perforatus
41. Anconeus
42. Flex. curpi rudialis
43. Pronator teres
44. Perforans
45. Subcutaneous Vein
46. Pisiform Bone
47. Plantar Pads
48. Metacarpus or Hand
49. Long Triceps
50. Outer "
51. Brachialis
52. Ext. carp. rad.
53. Ext. dig. com.
54. Ext. dig. brevis.
55. Ext. carp. ulnaris
56. Flex. carp. ulnaris
57. Ext. obliquus
58. Carpal Sheath or Annular Ligament
59. Carpus or Wrist
60. Phalanges or Finger Joints
61. Suprascapular Gland
62. 1st. Sartor.
63. 2nd. Sartor.
64. Vast. Inter.
65. Adductor
66. Semimembranosus
67. Gracilis
68. Semi-tendinosus
69. Gastroc-nemius
70. Popliteus
71. Perforatus
72. Perforans
73. Perforans Auxiliary
74. Tibialis ant.
75. Lumbo-dorsal Fascia
76. Crest of Ilium
77. Long Tensor
78. Short "
79. Gluteus medius
80. Gluteus maximus
81. Grt. Trochanter
82. Ischium
83. Semimembranosus
84. Erector
85. Curvator
86. Fascia lata
87. Semitendinosus
88. Biceps
89. Depressor
90. Gastrocnemius
91. Grt. Saphenous Vein
92. Perforatus
93. Perforans
94. Calcaneum
95. Tarsus
96. Metatarsus or Instep
97. Tibialis ant.
98. Extensor pedis
99. Long Peroneus
100. Short Extensor of Toes
101. Phalanges or Toe Joints

PLATE VIII.—THE ANATOMY OF THE GREYHOUND. THE IMPORTANT MUSCLES. This plate more than any other is explanatory of the Visible Form.

The Skin and the Skin Muscles or Panniculi are removed, to expose the second or most important layer of Muscles.

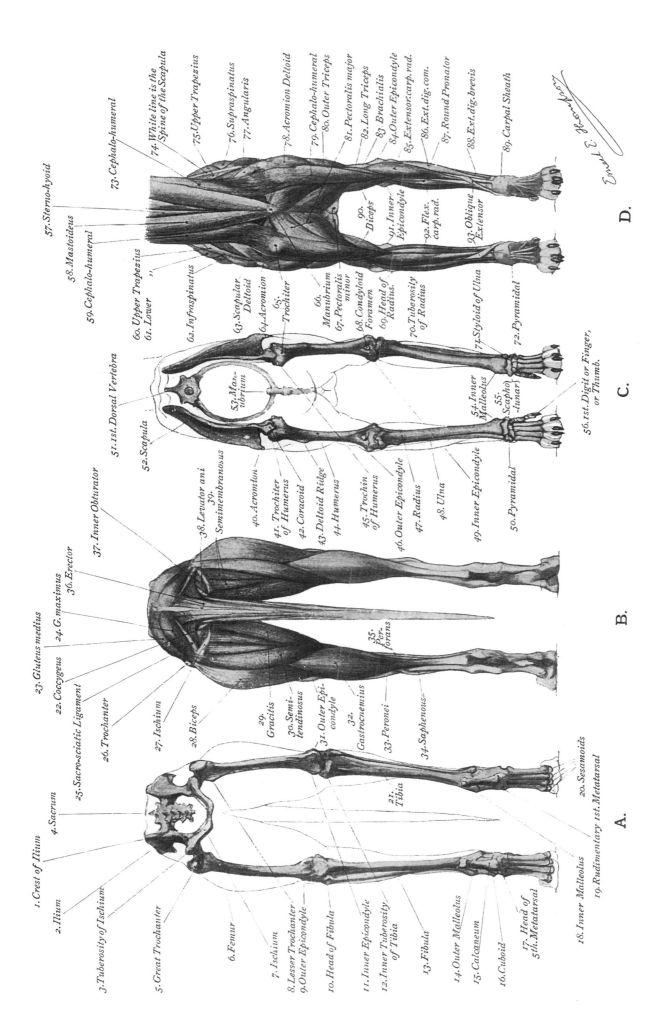

PLATE IX.—THE ANATOMY OF THE GREYHOUND. BACK AND FRONT VIEWS OF THE SKELETON AND THE IMPORTANT MUSCLES.

A. The Skeleton seen from behind. C. The Skeleton seen from in front.
B. The first layer of Muscles on the same region. D. The first layer of important Muscles ot the same region.
This Plate corresponds with Plate VIII.

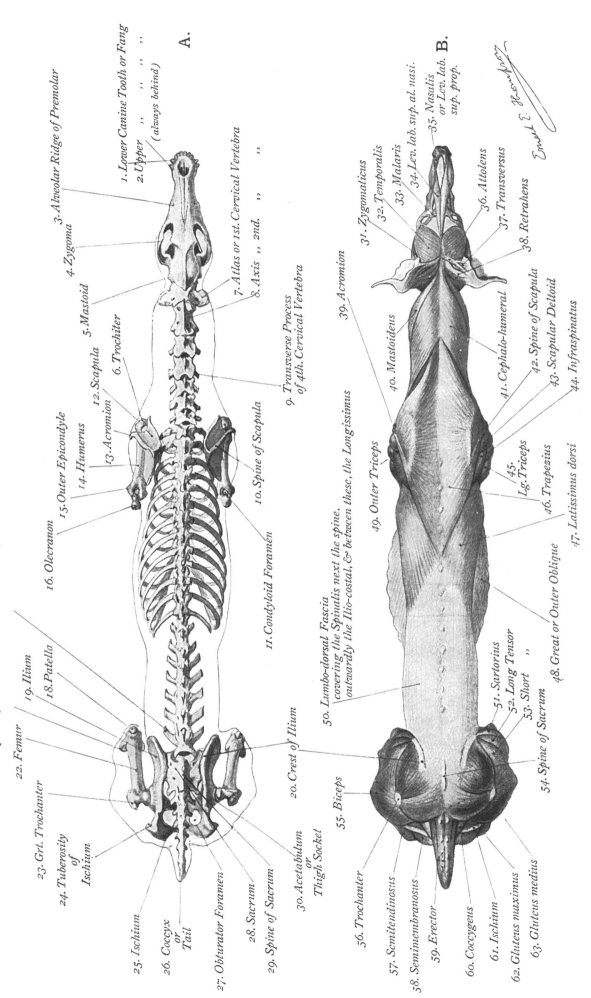

1. Lower Canine Tooth or Fang
2. Upper „ „ „ „
 (always behind)
3. Alveolar Ridge of Premolar
4. Zygoma
5. Mastoid
6. Trochiter
7. Atlas or 1st. Cervical Vertebra
8. Axis „ 2nd. „ „
9. Transverse Process
 of 4th. Cervical Vertebra
10. Spine of Scapula
11. Condyloid Foramen
12. Scapula
13. Acromion
14. Humerus
15. Outer Epicondyle
16. Olecranon
17. Transverse Process of 7th. Lumbar Vertebra
18. Patella
19. Ilium
20. Crest of Ilium
21. Outer Epicondyle
22. Femur
23. Grt. Trochanter
24. Tuberosity
 of
 Ischium
25. Ischium
26. Coccyx
 or
 Tail
27. Obturator Foramen
28. Sacrum
29. Spine of Sacrum
30. Acetabulum
 or
 Thigh Socket

A.

B.

31. Zygomaticus
32. Temporalis
33. Malaris
34. Lev. lab. sup. al. nasi.
35. Nasalis
 or Lev. lab.
 sup. prop.
36. Attolens
37. Transversus
38. Retrahens
39. Acromion
40. Mastoideus
41. Cephalo-humeral
42. Spine of Scapula
43. Scapular Deltoid
44. Infraspinatus
45. Lg. Triceps
46. Trapezius
47. Latissimus dorsi
48. Great or Outer Oblique
49. Outer Triceps
50. Lumbo-dorsal Fascia
 covering the Spinalis next the spine.
 outwardly the Ilio-costal, & between these, the Longissimus
51. Sartorius
52. Long Tensor
53. Short „
54. Spine of Sacrum
55. Biceps
56. Trochanter
57. Semitendinosus
58. Seminembranosus
59. Erector
60. Coccygeus
61. Ischium
62. Gluteus maximus
63. Gluteus medius

PLATE X.—THE ANATOMY OF THE GREYHOUND. THE SKELETON AND IMPORTANT MUSCLES SEEN FROM ABOVE.

A. SKELETON. The lower part of each Limb is omitted for the sake of simplicity. B. MUSCLES. The Panniculi and the superficial Muscles of the Cranium are removed.

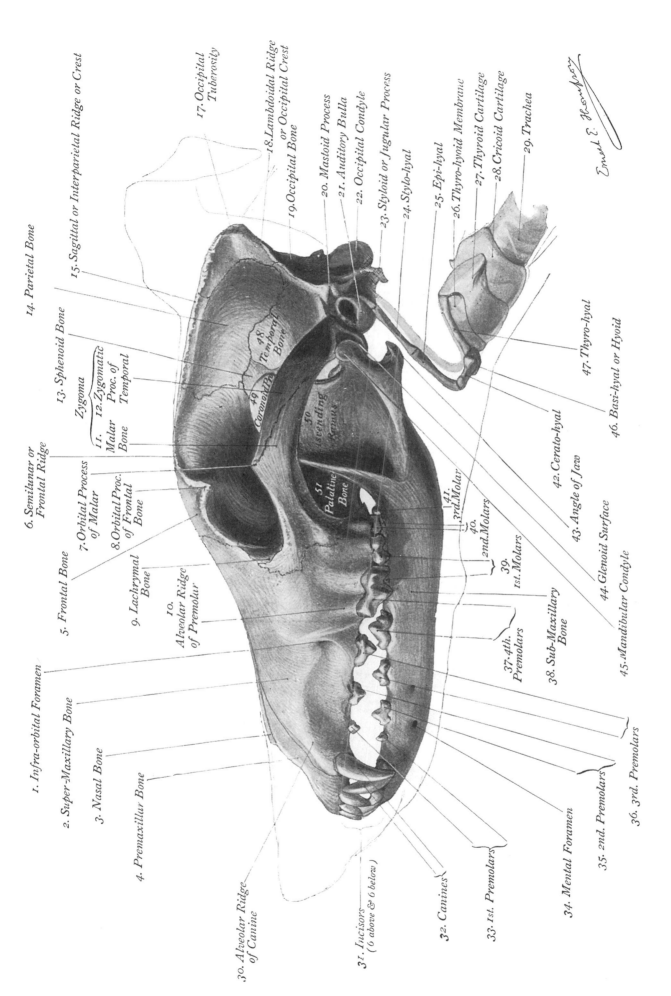

14. *Parietal Bone*

15. *Sagittal or Interparietal Ridge or Crest*

17. *Occipital Tuberosity*

18. *Lambdoidal Ridge or Occipital Crest*

19. *Occipital Bone*

20. *Mastoid Process*

21. *Auditory Bulla*

22. *Occipital Condyle*

23. *Styloid or Jugular Process*

24. *Stylo-hyal*

25. *Epi-hyal*

26. *Thyro-hyoid Membrane*

27. *Thyroid Cartilage*

28. *Cricoid Cartilage*

29. *Trachea*

Ernest E. Hornblower

6. *Semilunar or Frontal Ridge*

13. *Sphenoid Bone*

Zygoma
{ 12. *Zygomatic Proc. of Temporal*
11. *Malar Bone*

48 *Temporal Bone*

49 *Coronoid*

50 *Ascending Ramus*

51 *Palatine Bone*

7. *Orbital Process of Malar*

8. *Orbital Proc. of Frontal Bone*

5. *Frontal Bone*

47. *Thyro-hyal*

46. *Basi-hyal or Hyoid*

42. *Cerato-hyal*

43. *Angle of Jaw*

41. *3rd. Molar*

40. *2nd. Molars*

39. *1st. Molars*

9. *Lachrymal Bone*

10. *Alveolar Ridge of Premolar*

44. *Glenoid Surface*

45. *Mandibular Condyle*

37. *4th. Premolars*

38. *Sub-Maxillary Bone*

1. *Infra-orbital Foramen*

2. *Super-Maxillary Bone*

3. *Nasal Bone*

4. *Premaxillar Bone*

30. *Alveolar Ridge of Canine*

31. *Incisors* (6 above & 6 below)

32. *Canines*

33. *1st. Premolars*

34. *Mental Foramen*

35. *2nd. Premolars*

36. *3rd. Premolars*

PLATE XI. — THE ANATOMY OF THE GREYHOUND. THE SKULL, SHOWING ALSO THE HYOID BONES AND THE LARYNX.

For the sake of clearness, the far side of the under Mandible is omitted.

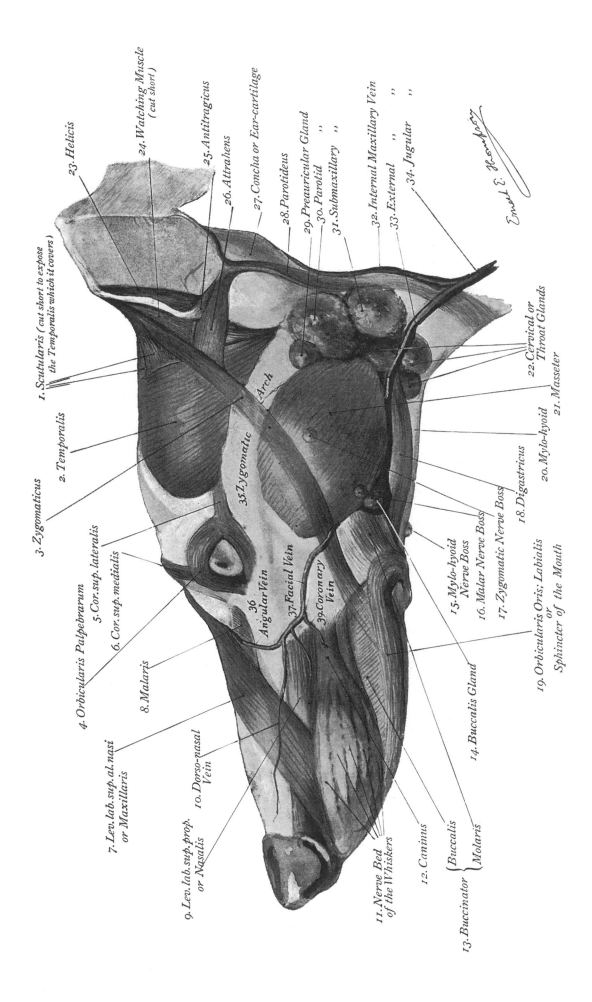

1. *Scutularis* (cut short to expose the *Temporalis which it covers*)
2. *Temporalis*
3. *Zygomaticus*
4. *Orbicularis Palpebrarum*
5. *Cor. sup. lateralis*
6. *Cor. sup. medialis*
7. *Lev. lab. sup. al. nasi or Maxillaris*
8. *Malaris*
9. *Lev. lab. sup. prop. or Nasalis*
10. *Dorso-nasal Vein*
11. *Nerve Bed of the Whiskers*
12. *Caninus*
13. *Buccinator* { *Buccalis* / *Molaris* }
14. *Buccalis Gland*
15. *Mylo-hyoid Nerve Boss*
16. *Malar Nerve Boss*
17. *Zygomatic Nerve Boss*
18. *Digastricus*
19. *Orbicularis Oris; Labialis or Sphincter of the Mouth*
20. *Mylo-hyoid*
21. *Masseter*
22. *Cervical or Throat Glands*
23. *Helicis*
24. *Watching Muscle* (*cut short*)
25. *Antitragicus*
26. *Attrahens*
27. *Concha or Ear-cartilage*
28. *Parotideus*
29. *Preauricular Gland*
30. *Parotid* "
31. *Submaxillary* "
32. *Internal Maxillary Vein*
33. *External* " "
34. *Jugular* " "
35. *Zygomatic*
36. *Angular Vein*
37. *Facial Vein*
39. *Coronary Vein*

PLATE XII.—THE ANATOMY OF THE GREYHOUND. THE MUSCLES, &c., OF THE HEAD.

The Panniculi have been removed.

37. Longissimus

31. Splenius
38. Infraspinatus
32. Rhomboid of Neck
33. Ribbon of ,, ,,
34. Dorsal Rhomboid
35. Spinalis
36. Serratus anticus

1. Occiput
2. Lambdoid Ridge
3. Meatus or Opening of Ear
4. Angle of Jaw
5. Styloid Process
6. Scalenus
7. Longus capitis or Rectus cap. ant. maj.
8. Serratus magnus
9. Supraspinatus
10. Spine of Scapula
11. Acromion
12. Trochiter
13. Teres minor
14. ,, major
15. Long Triceps
16. Outer ,,
17. Anconeus
18. Ext. carpi radialis
19. Short Supinator
20. Oblique Extensor

21. Pisiform Bone

41. Loin or Lumbo-dorsal Fascia
42. Ilium
40. Ilio-costal
39. Serratus posticus

46. Erector
47. Curvator
48. 2 parts of Depressor
49. Gemellus
50. Tendon of Obturator internus crossing the Gemellus
51. Tuberosity of Ischium
52. Quadratus femoris
53. Semimembranosus
54. Great Trochanter
55. Gracilis
56. Semitendinosus
57. Grt. Saphenous Vein
58. Gastrocnemius
59. Perforatus

45. Sacro-sciatic Ligament
43. Gluteus minimus
44. Pyriform

60. Os Calcis or Calcaneum Bone
61. Lower Annular Ligament

62. Short Peroneus
63. Perforans
64. 3rd. Peroneus
65. Extensor pedis
66. Tibialis anticus
67. Long Peroneus
68. Tendo Patellae
69. Patella
70. Semimembranosus
71. Adductor
72. Vastus externus
73. Rectus femoris
74. Sartorius (Post.)
75. Lesser Oblique
76. Ventral Fascia

28. Serratus magnus
27. Scalenus
26. Intern. Intercostals
25. Sternalis
24. Pectoralis minor
23. Pectoralis major
22. Flex. carpi ulnaris

29. Rectus Abdominis
30. Exter. Intercostals

PLATE XIII.—THE ANATOMY OF THE GREYHOUND. THE MUSCLES OF THE THIRD LAYER.

Or the Muscles exposed after removing from the subject as seen in Plate VIII. the Mastoideus, Cephalo-humeral, Sterno-thyroid, Sterno-hyoid, Trapezius, Deltoid, Latissimus, Epitrochlear, Brachialis, Great Oblique, Ext. dig. brevis, Ext. carpi ulnaris, Gluteus maximus, G. medius, First Sartorius, Tensor Vaginæ, Biceps Femoris, Long Peroneus and Inner Adductor of Tail. The Head, Feet, Further Limbs, Trachea, Glands of Throat and Neck, and the Muscles of the Anus, are omitted for the sake of simplicity.

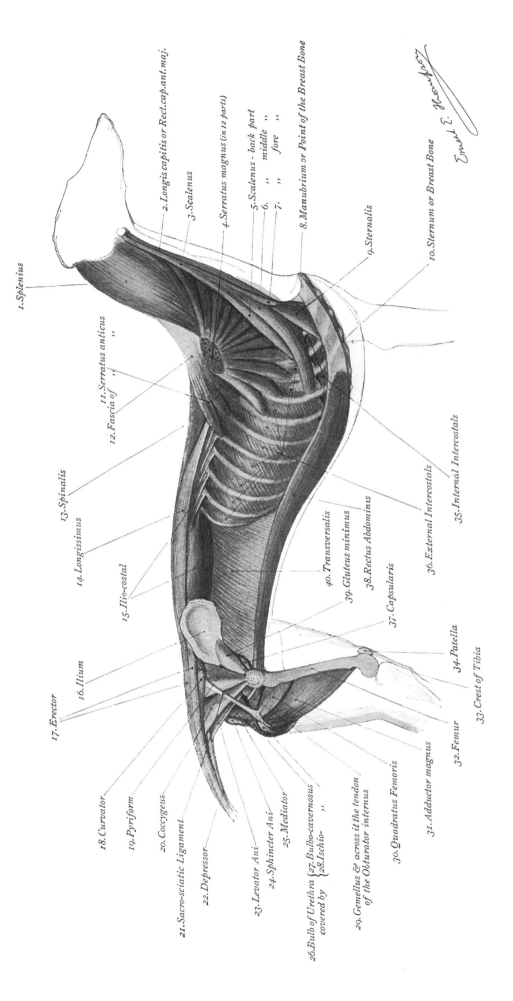

1. Splenius
2. Longis capitis or Rect.cap.ant.maj.
3. Scalenus
4. Serratus magnus (in 12 parts)
5. Scalenus - back part
6. ,, middle ,,
7. ,, fore ,,
8. Manubrium or Point of the Breast Bone
9. Sternalis
10. Sternum or Breast Bone
11. Serratus anticus
12. Fascia of ,, ,,
13. Spinalis
14. Longissinus
15. Ilio-costal
16. Ilium
17. Erector
18. Curvator
19. Pyriform
20. Coccygeus
21. Sacro-sciatic Ligament
22. Depressor
23. Levator Ani
24. Sphincter Ani
25. Mediator
26. Bulb of Urethra { 27. Bulbo-cavernosus
 covered by { 28. Ischio- ,,
29. Gemellus & across it the tendon
 of the Obturator internus
30. Quadratus Femoris
31. Adductor magnus
32. Femur
33. Crest of Tibia
34. Patella
35. Internal Intercostals
36. External Intercostals
37. Capsularis
38. Rectus Abdominus
39. Gluteus minimus
40. Transversalis

PLATE XIV.—THE ANATOMY OF THE GREYHOUND. THE DEEPER MUSCLES OF THE TRUNK AND THIGH.

The subject is here shown yet farther denuded than in Plate XIII., the following being removed : the whole of the Fore-limb, the Rhomboid, Pectorals, Internal Oblique, the Sartorius, Quadriceps, Semitendinosus, Semimembranosus, Biceps Femoris, Gracilis, and the Muscles of the Lower Leg. In this, however, are shown the Muscles of the Anal region, which were omitted in Plate XIII., in order to simplify that diagram.

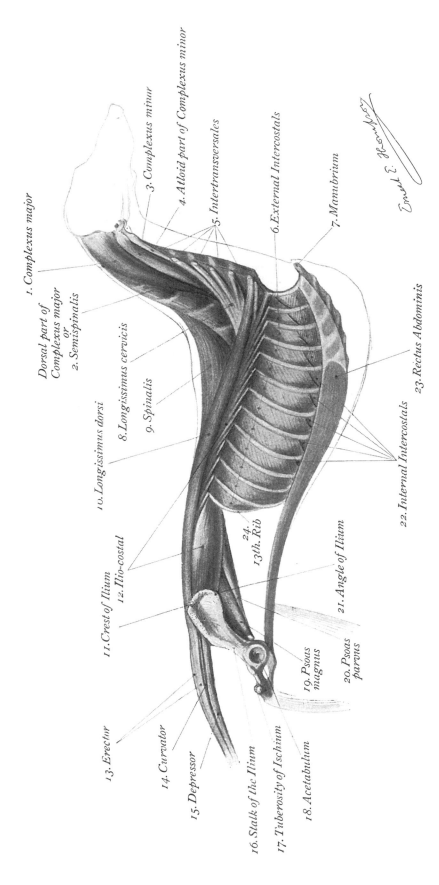

1. Complexus major
Dorsal part of
Complexus major
or
2. Semispinalis
3. Complexus minor
4. Atloid part of Complexus minor
5. Intertransversales
6. External Intercostals
7. Manubrium
8. Longissimus cervicis
9. Spinalis
10. Longissimus dorsi
11. Crest of Ilium
12. Ilio-costal
13. Erector
14. Curvator
15. Depressor
16. Stalk of the Ilium
17. Tuberosity of Ischium
18. Acetabulum
19. Psoas magnus
20. Psoas parvus
21. Angle of Ilium
22. Internal Intercostals
23. Rectus Abdominis
24. 13th. Rib

PLATE XV.—THE ANATOMY OF THE GREYHOUND. THE DEEPEST MUSCLES OF THE TRUNK.

The subject of Plate XIV., further dissected by the removal of the Splenius, Three Serrati, Scalenus, Rectus cap. ant. maj., Sternalis, Transversalis, Pyriform, Gluteus minimus, Capsularis, Coccygeus, Quadratus Femoris, Adductor magnus, Pectineus, Gemellus, the Two Obturators, the Sacro-sciatic Ligaments, the Anal Muscles, and the Femur.

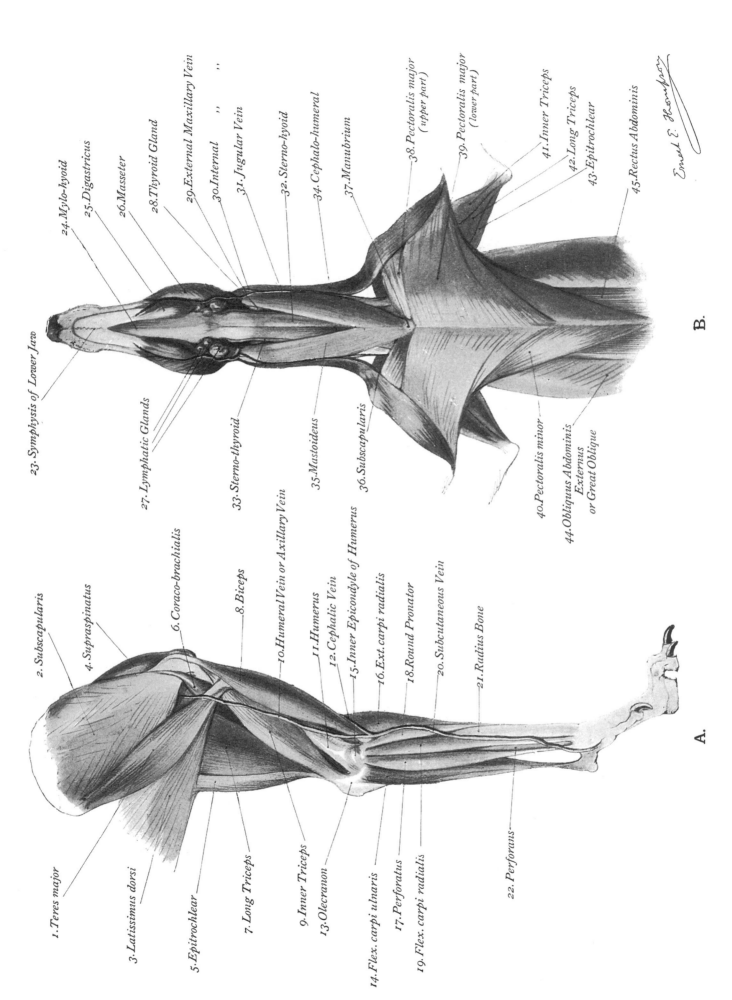

1. *Teres major*
2. *Subscapularis*
3. *Latissimus dorsi*
4. *Supraspinatus*
5. *Epitrochlear*
6. *Coraco-brachialis*
7. *Long Triceps*
8. *Biceps*
9. *Inner Triceps*
10. *Humeral Vein or Axillary Vein*
11. *Humerus*
12. *Cephalic Vein*
13. *Olecranon*
14. *Flex. carpi ulnaris*
15. *Inner Epicondyle of Humerus*
16. *Ext. carpi radialis*
17. *Perforatus*
18. *Round Pronator*
19. *Flex. carpi radialis*
20. *Subcutaneous Vein*
21. *Radius Bone*
22. *Perforans*
23. *Symphysis of Lower Jaw*
24. *Mylo-hyoid*
25. *Digastricus*
26. *Masseter*
27. *Lymphatic Glands*
28. *Thyroid Gland*
29. *External Maxillary Vein*
30. *Internal ,, ,,*
31. *Jugular Vein*
32. *Sterno-hyoid*
33. *Sterno-thyroid*
34. *Cephalo-humeral*
35. *Mastoideus*
36. *Subscapularis*
37. *Manubrium*
38. *Pectoralis major (upper part)*
39. *Pectoralis major (lower part)*
40. *Pectoralis minor*
41. *Inner Triceps*
42. *Long Triceps*
43. *Epitrochlear*
44. *Obliquus Abdominis Externus or Great Oblique*
45. *Rectus Abdominis*

A.

B.

PLATE XVI.—THE ANATOMY OF THE GREYHOUND. INNER SIDE OF FORE-LIMB AND UNDER SIDE OF CHEST.

A. Inner view of left Fore-leg and Shoulder— nothing removed except Skin and Tissue.
B. Under view of Neck and Chest, after removing the Panniculus.

B.

27. Anconeus
28. Head of Radius
29. Tuberosity of Radius
30. Short Supinator
31. Ulna
32. Radius
33. Tendon of Ext. carpi radialis
34. Oblique Extensor

Flex. carpi ulnaris

A.

11. Cephalo-humeral
12. Epitrochlear
13. Outer Triceps
14. Brachialis
15. Epicondyloid Crest
16. Epicondyle
17. Ext. carpi radialis
18. Ext. dig. communis
19. Ext. dig. brevis
20. Ext. carpi ulnaris
21. Perforatus
22. Ext. pol. long. et ind. prop.
23. Radius
24. Carpal Sheath or Annular Ligament
25. Tendons of Perforatus and Perforans
26. 5th. or Outer Toe or Finger

1. Olecranon
2. Anconeus
3. Outer part of Flex. carpi ulnaris
4. Inner " " " "
5. Ulna
6. Oblique Extensor
7. Pisiform
8. Tendon of Ext. carpi ulnaris
9. Plantar Flexors
10. Plantar Pad

PLATE XVII.—THE ANATOMY OF THE GREYHOUND. EXTERIOR OF FORE-LIMB.

A. Outer side of right Fore-leg—nothing removed excepting the Skin and the investing Fascia.
B. Outer side of right Fore-leg, after removing Ext. dig. com., Ext. dig. brevis, Ext. carpi ulnaris.

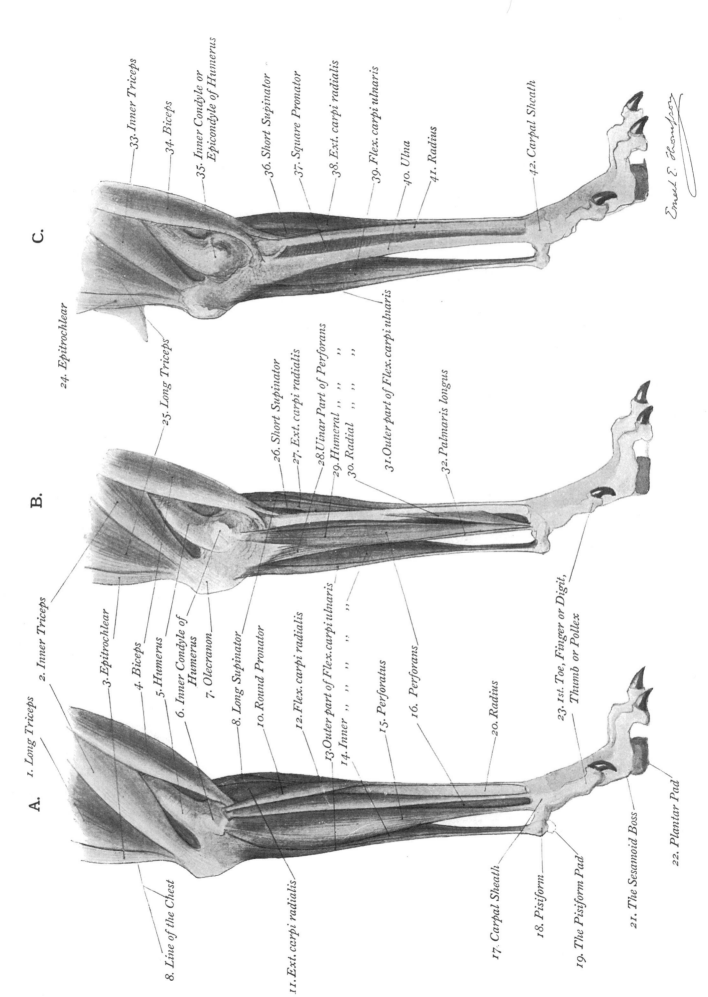

A.

B.

C.

1. Long Triceps
2. Inner Triceps
3. Epitrochlear
4. Biceps
5. Humerus
6. Inner Condyle of Humerus
7. Olecranon
8. Long Supinator
10. Round Pronator
12. Flex. carpi radialis
13. Outer part of Flex. carpi ulnaris
14. Inner ,, ,, ,, ,,
15. Perforatus
16. Perforans
20. Radius
23. 1st. Toe, Finger or Digit, Thumb or Pollex

8. Line of the Chest
11. Ext. carpi radialis
17. Carpal Sheath
18. Pisiform
19. The Pisiform Pad
21. The Sesamoid Boss
22. Plantar Pad

24. Epitrochlear
25. Long Triceps
26. Short Supinator
27. Ext. carpi radialis
28. Ulnar Part of Perforans
29. Humeral ,, ,, ,,
30. Radial ,, ,, ,,
31. Outer part of Flex. carpi ulnaris
32. Palmaris longus

33. Inner Triceps
34. Biceps
35. Inner Condyle or Epicondyle of Humerus
36. Short Supinator
37. Square Pronator
38. Ext. carpi radialis
39. Flex. carpi ulnaris
40. Ulna
41. Radius
42. Carpal Sheath

Ernest E. Thompson

PLATE XVIII.—THE ANATOMY OF THE GREYHOUND. INNER SIDE OF LEFT FORE-LIMB.

A. The Limb with Skin, Fascia, and External Blood-vessels removed. B. The same after removing also the Perforatus, the Flexor carpi radialis, and the Round Pronator. C. The same after also removing the Perforans and the Long Supinator.

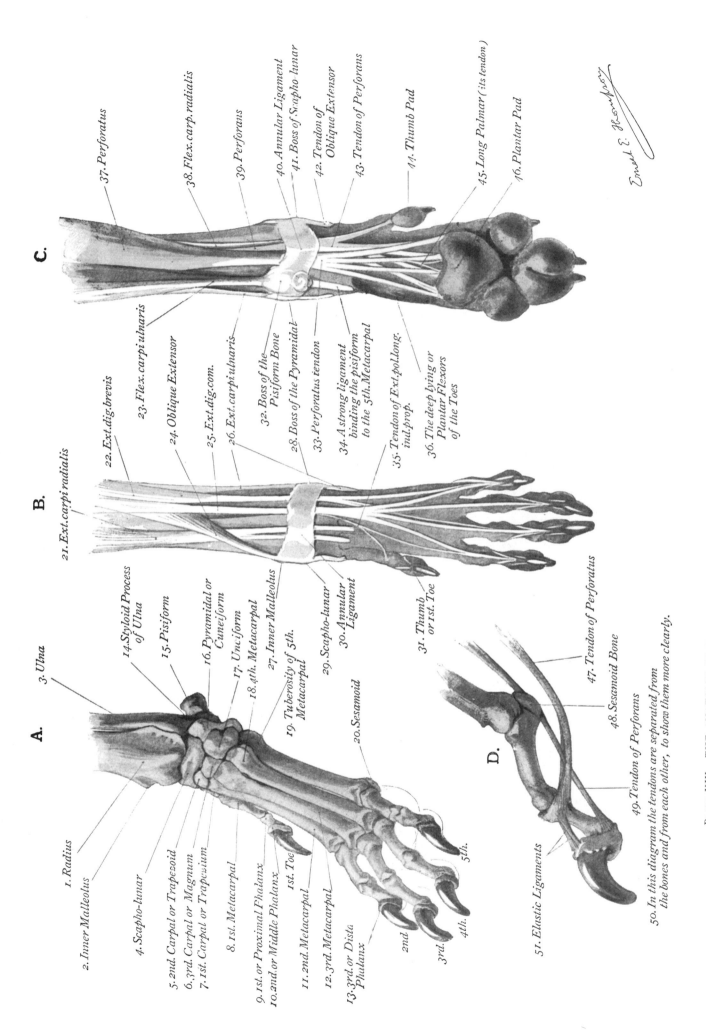

C.

A.

B.

D.

37. *Perforatus*
38. *Flex. carp. radialis*
39. *Perforans*
40. *Annular Ligament*
41. *Boss of Scapho lunar*
42. *Tendon of Oblique Extensor*
43. *Tendon of Perforans*
44. *Thumb Pad*
45. *Long Palmar (its tendon)*
46. *Plantar Pad*

22. *Ext. dig. brevis*
23. *Flex. carpi ulnaris*
24. *Oblique Extensor*
25. *Ext. dig. com.*
26. *Ext. carpi ulnaris*
32. *Boss of the Pisiform Bone*
28. *Boss of the Pyramidal*
33. *Perforatus tendon*
34. *A strong ligament binding the pisiform to the 5th. Metacarpal*
35. *Tendon of Ext. pol. long. indi. prop.*
36. *The deep lying or Plantar Flexors of the Toes*

21. *Ext. carpi radialis*

14. *Styloid Process of Ulna*
15. *Pisiform*
16. *Pyramidal or Cuneiform*
17. *Unciform*
18. *4th. Metacarpal*
27. *Inner Malleolus*
29. *Scapho-lunar*
30. *Annular Ligament*
19. *Tuberosity of 5th. Metacarpal*
20. *Sesamoid*
31. *Thumb or 1st. Toe*

3. *Ulna*

1. *Radius*
2. *Inner Malleolus*
4. *Scapho-lunar*
5. *2nd. Carpal or Trapesoid*
6. *3rd. Carpal or Magnum*
7. *1st. Carpal or Trapesium*
8. *1st. Metacarpal*
9. *1st. or Proximal Phalanx*
10. *2nd. or Middle Phalanx*
11. *2nd. Metacarpal*
12. *3rd. Metacarpal*
13. *3rd. or Distal Phalanx*

1st. Toe
2nd
3rd.
4th.
5th.

47. *Tendon of Perforatus*
48. *Sesamoid Bone*
49. *Tendon of Perforans*
51. *Elastic Ligaments*

Ernest E. Thompson

PLATE XIX.—THE ANATOMY OF THE GREYHOUND. THE BONES AND MUSCLES OF THE LEFT FORE-FOOT.

A. The Bones of the Paw seen from the outer side in front.
B. The Paw seen from above, with Skin and Fascia only removed.
C. The same from behind or below.
D. The Bones and mechanism of a toe, showing the reasons for the names Perforatus (or perforated) and Perforans (or perforating).

50. In this diagram the tendons are separated from the bones and from each other, to show them more clearly.

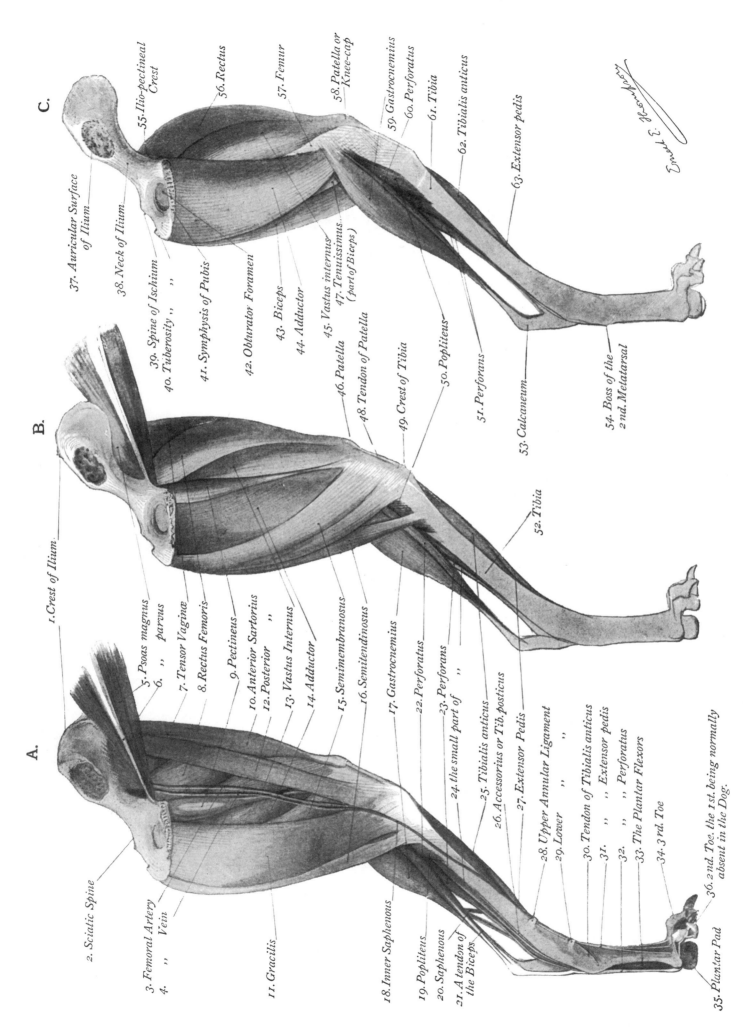

C.

55. Ilio-pectineal Crest
56. Rectus
57. Femur
58. Patella or Knee-cap
59. Gastrocnemius
60. Perforatus
61. Tibia
62. Tibialis anticus
63. Extensor pedis

37. Auricular Surface of Ilium
38. Neck of Ilium
39. Spine of Ischium
40. Tuberosity ,, ,,
41. Symphysis of Pubis
42. Obturator Foramen
43. Biceps
44. Adductor
45. Vastus internus
47. Tenuissimus (part of Biceps)
46. Patella
48. Tendon of Patella
49. Crest of Tibia
50. Popliteus
51. Perforans
53. Calcaneum
52. Tibia
54. Boss of the 2nd Metatarsal

B.

1. Crest of Ilium

5. Psoas magnus
6. ,, parvus
7. Tensor Vagine
8. Rectus Femoris
9. Pectineus
10. Anterior Sartorius
12. Posterior ,,
13. Vastus Internus
14. Adductor
15. Semimembranosus
16. Semitendinosus
17. Gastrocnemius
22. Perforatus
23. Perforans
24. the small part of ,,
25. Tibialis anticus
26. Accessorius or Tib. posticus
27. Extensor Pedis
28. Upper Annular Ligament
29. Lower ,, ,,
30. Tendon of Tibialis anticus
31. ,, ,, Extensor pedis
32. ,, ,, Perforatus
33. The Plantar Flexors
34. 3rd. Toe
36. 2nd. Toe. the 1st being normally absent in the Dog.

2. Sciatic Spine
3. Femoral Artery
4. ,, Vein
11. Gracilis
18. Inner Saphenous
19. Popliteus
20. Saphenous
21. A tendon of the Biceps
35. Plantar Pad

A.

PLATE XX.—THE ANATOMY OF THE GREYHOUND. INNER SIDE OF LEFT HIND-LEG.

A. The Limb with Skin and Fascia only removed.
B. The same after removing also the external Blood-vessels, the Gracilis, the Tibialis posterior, and the Sartorii.
C. The same after removing also the Psoas magnus, Psoas parvus, Tensor Vaginae, Semitendinosus, Semimembranosus, and Pectineus.

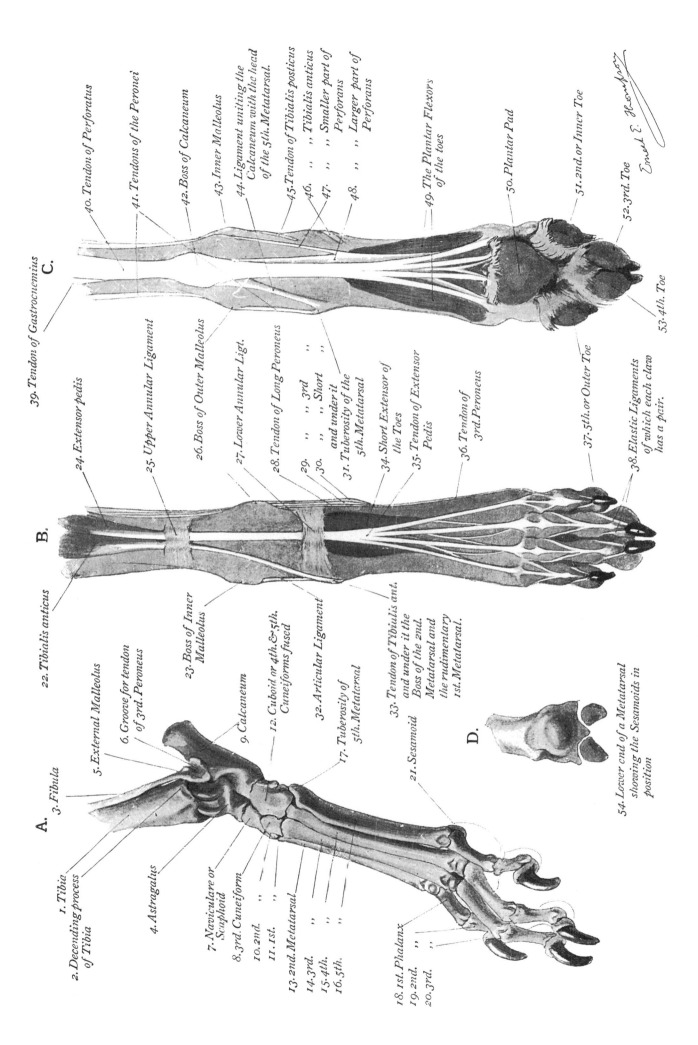

40. Tendon of Perforatus
41. Tendons of the Peronei
42. Boss of Calcaneum
43. Inner Malleolus
44. Ligament uniting the Calcaneum with the head of the 5th. Metatarsal.
45. Tendon of Tibialis posticus
46. ,, ,, Tibialis anticus
47. ,, ,, Smaller part of Perforans
48. ,, ,, Larger part of Perforans
49. The Plantar Flexors of the toes
50. Plantar Pad
51. 2nd. or Inner Toe
52. 3rd. Toe
53. 4th. Toe

39. Tendon of Gastrocnemius

C.

24. Extensor pedis
25. Upper Annular Ligament
26. Boss of Outer Malleolus
27. Lower Annular Ligt.
28. Tendon of Long Peroneus
29. ,, ,, 3rd ,,
30. ,, ,, Short ,, and under it
31. Tuberosity of the 5th. Metatarsal
34. Short Extensor of the Toes
35. Tendon of Extensor Pedis
36. Tendon of 3rd. Peroneus
37. 5th. or Outer Toe
38. Elastic Ligaments of which each claw has a pair.

B.

22. Tibialis anticus

1. Tibia
2. Descending process of Tibia
3. Fibula
5. External Malleolus
6. Groove for tendon of 3rd. Peroneus
9. Calcaneum
12. Cuboid or 4th. & 5th. Cuneiforms fused
32. Articular Ligament
17. Tuberosity of 5th. Metatarsal
23. Boss of Inner Malleolus
33. Tendon of Tibialis ant. and under it the Boss of the 2nd. Metatarsal and the rudimentary 1st. Metatarsal.
21. Sesamoid

A.
4. Astragalus
7. Navicular or Scaphoid
8. 3rd. Cuneiform
10. 2nd. ,,
11. 1st. ,,
13. 2nd. Metatarsal
14. 3rd. ,,
15. 4th. ,,
16. 5th. ,,
18. 1st. Phalanx
19. 2nd. ,,
20. 3rd. ,,

D.

54. Lower end of a Metatarsal showing the Sesamoids in position

PLATE XXI. THE ANATOMY OF THE GREYHOUND. THE BONES AND MUSCLES OF THE LEFT HIND-FOOT.

A. The Bones of the Foot seen from the outer side in front.
B. The Foot seen from above, with Skin and Fascia only removed.
C. The same from behind or below.
D. A pair of Sesamoids, showing how they form the groove for the Tendons under each Metatarsal.

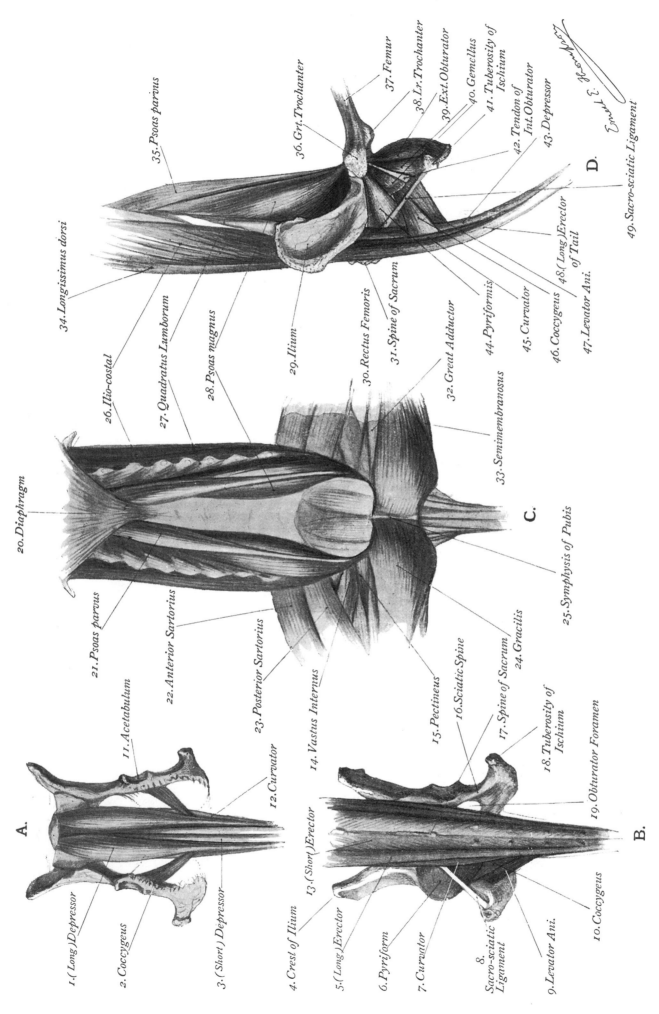

35. *Psoas parvus*
34. *Longissimus dorsi*
26. *Ilio-costal*
27. *Quadratus Lumborum*
28. *Psoas magnus*
29. *Ilium*
30. *Rectus Femoris*
31. *Spine of Sacrum*
32. *Great Adductor*
33. *Semimembranosus*

36. *Grt. Trochanter*
37. *Femur*
38. *Lr. Trochanter*
39. *Ext. Obturator*
40. *Gemellus*
41. *Tuberosity of Ischium*
42. *Tendon of Int. Obturator*
43. *Depressor*
44. *Pyriformis*
45. *Curvator*
46. *Coccygeus*
47. *Levator Ani.*
48. *(Long) Erector of Tail*
49. *Sacro-sciatic Ligament*

D.

20. *Diaphragm*
21. *Psoas parvus*
22. *Anterior Sartorius*
23. *Posterior Sartorius*
24. *Gracilis*
25. *Symphysis of Pubis*
15. *Pectineus*
16. *Sciatic Spine*
17. *Spine of Sacrum*
18. *Tuberosity of Ischium*
19. *Obturator Foramen*
14. *Vastus Internus*

C.

A.

1. *(Long) Depressor*
2. *Coccygeus*
3. *(Short) Depressor*
4. *Crest of Ilium*
5. *(Long) Erector*
6. *Pyriform*
7. *Curvator*
8. *Sacro-sciatic Ligament*
9. *Levator Ani.*
10. *Coccygeus*
11. *Acetabulum*
12. *Curvator*
13. *(Short) Erector*

B.

PLATE XXII.—THE ANATOMY OF THE GREYHOUND. THE BONES AND MUSCLES OF THE PELVIS AND TAIL.

A. Under view of Pelvis, with Pubic Bones cut away to show the attachment of the Muscles of the under side of the Tail.
B. Pelvis seen from above, with the Gluteal Muscles, &c., removed.
C. Under view of Pelvic region, with Abdominal Walls and Muscles removed.
D. Side view of Pelvic region, with Abdominal Walls and Gluteal Muscles removed.

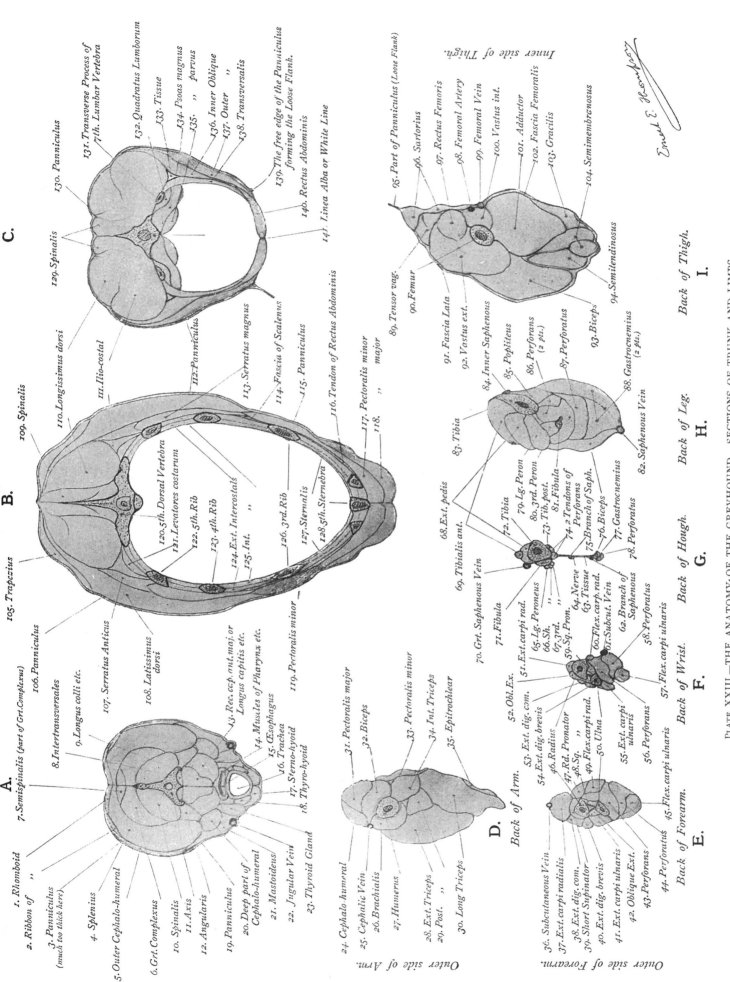

C.

130. Panniculus
129. Spinalis
131. Transverse Process of 7th. Lumbar Vertebra
132. Quadratus Lumborum
133. Tissue
134. Psoas magnus
135. „ parvus
136. Inner Oblique
137. Outer „
138. Transversalis
139. The free edge of the Panniculus forming the Loose Flank.
140. Rectus Abdominis
141. Linea Alba or White Line

B.

109. Spinalis
105. Trapezius
106. Panniculus
110. Longissimus dorsi
111. Ilio-costal
112. Panniculus
113. Serratus magnus
114. Fascia of Scalenus
115. Panniculus
116. Tendon of Rectus Abdominis
117. Pectoralis minor
118. „ major
119. Pectoralis minor
120. 5th. Dorsal Vertebra
121. Levatores costarum
122. 5th. Rib
123. 4th. Rib
124. Ext. Intercostals
125. Int. „
126. 3rd. Rib
127. Sternalis
128. 5th. Sternebra

A.

1. Rhomboid
2. Ribbon of „
3. Panniculus (much too thick here)
4. Splenius
5. Outer Cephalo-humeral
6. Grt. Complexus
7. Semispinalis (part of Grt.Complexus)
8. Intertransversales
9. Longus colli etc.
10. Spinalis
11. Axis
12. Angularis
13. Rec. acp. ant. maj. or Longus capitis etc.
14. Muscles of Pharynx etc.
15. Œsophagus
16. Trachea
17. Sterno-hyoid
18. Thyro-hyoid
19. Panniculus
20. Deep part of Cephalo-humeral
21. Mastoideus
22. Jugular Vein
23. Thyroid Gland
107. Serratus Anticus
108. Latissimus dorsi

D.

24. Cephalo-humeral
25. Cephalic Vein
26. Brachialis
27. Humerus
28. Ext. Triceps
29. Post. „
30. Long Triceps
31. Pectoralis major
32. Biceps
33. Pectoralis minor
34. Int. Triceps
35. Epitrochlear

Outer side of Arm.
Back of Arm.

E.

36. Subcutaneous Vein
37. Ext. carpi radialis
38. Ext. dig. com.
39. Short Supinator
40. Ext. dig. brevis
41. Ext. carpi ulnaris
42. Oblique Ext.
43. Perforans
44. Perforatus
45. Flex. carpi ulnaris
46. Radius
47. Rd. Pronator
48. Sq. „
49. Flex. carpi rad.
50. Ulna
51. Ext. carpi rad.
52. Obl. Ex.
53. Ext. dig. com.
54. Ext. dig. brevis
55. Ext. carpi ulnaris
56. Perforans
57. Flex. carpi ulnaris

Outer side of Forearm.
Back of Forearm.

F.

58. Perforatus
59. Sq. Pron.
60. Flex. carpi rad.
61. Subcut. Vein
62. Branch of Saphenous
63. Tissue
64. Nerve
65. Lg. Peroneus
66. Sh. „
67. 3rd. „
68. Ext. pedis
69. Tibialis ant.
70. Grt. Saphenous Vein
71. Fibula
72. Tibia
73. Tib. post.
74. 2 Tendons of Perforans
75. Branch of Saph.
76. Biceps
77. Perforatus
78. Perforatus

Back of Wrist.
Back of Hough.

G.

79. Lg. Peron
80. 3rd. Peron
81. Fibula
82. Saphenous Vein
83. Tibia
84. Inner Saphenous
85. Popliteus
86. Perforans (2 pts.)
87. Perforatus
88. Gastrocnemius (2 pts.)
93. Biceps
94. Semitendinosus

Back of Leg.

H.

80. Tensor vag.
90. Femur
91. Fascia Lata
92. Vastus ext.
95. Part of Panniculus (Loose Flank)
96. Sartorius
97. Rectus Femoris
98. Femoral Artery
99. Femoral Vein
100. Vastus int.
101. Adductor
102. Fascia Femoralis
103. Gracilis
104. Semimembranosus

Inner side of Thigh.
Back of Thigh.

I.

[Signature: Ernest E. ...]

PLATE XXIII.—THE ANATOMY OF THE GREYHOUND. SECTIONS OF TRUNK AND LIMBS.

The sections here shown were made by sawing up a hard-frozen Greyhound. In each case the natural front and the natural top are shown uppermost, and in the case of the Leg sections the outer side is always at the left of the diagram. The sections are all on exactly the same scale, that is one-third of life size, and are made at right angles to the principal Bone. In all cases the Skin is omitted and in many the name of a Muscle is written when of course its Sinew is understood.

A. Through the Axis or Second Cervical Vertebra. B. Through the deepest part of the Chest, at the Fifth Dorsal Vertebra.
C. Through the Loins, just before the Hip Bone, i.e. through the Sixth Lumbar Vertebra. D. Through the middle of the Humerus. E. Through the Fore-arm, just below the uppermost quarter.
F. Through the lower Fore-arm or Wrist, just above the lowest quarter. G. Through the Hind-leg, just above the lowest quarter of the Tibia, i.e. across the Hough
H. Through the Hind-leg, just below the highest quarter of the Tibia. I. Through the middle of the Femur.

PLATE XXIV.—PROPORTIONS OF A TYPICAL DOG AND WOLF.

The Body goes in a square whose side is 3 heads, the square being defined by the head of the Humerus, top of Shoulder, crest of Ilium, Ischiatic tuberosity, and ground. The Knee and Elbow Joints F and E are at half the height of this square. In addition to the measurements indicated are the following: the widest part of the animal is through the Triceps of the Thigh at N; it is there 1 head; the width of the Chest at its widest part O is ¾ head; the width through the Shoulders at the Acromions K is ¾ head. They resemble those of the Dog, but the Breast and Neck are 1¼ times the size.

This plate serves also to illustrate the proportions of the Wolf.

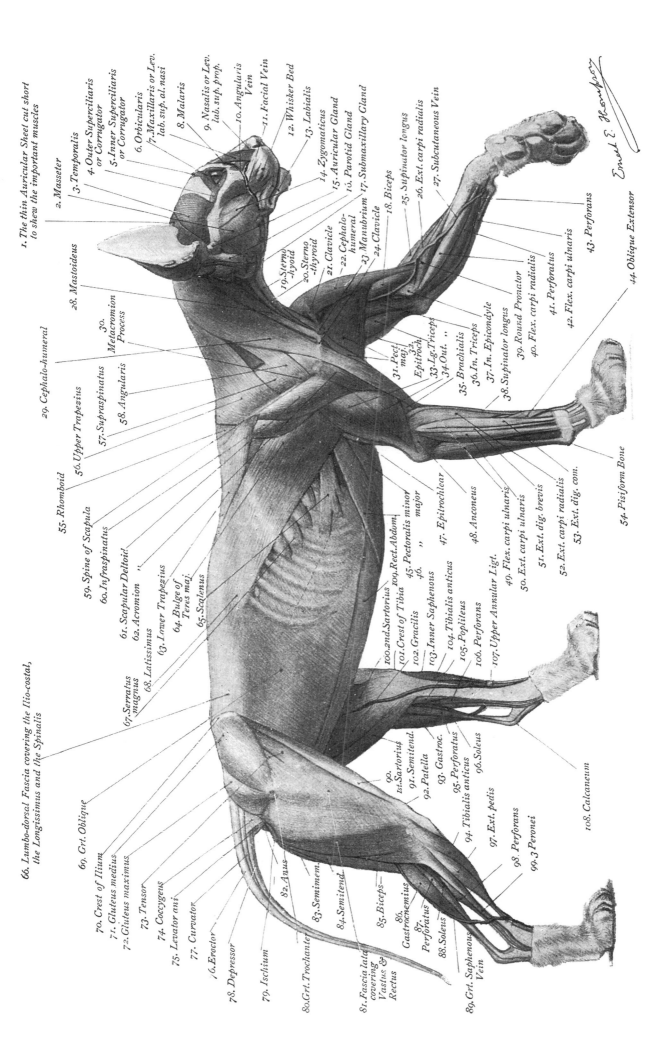

1. The thin Auricular Sheet cut short to shew the important muscles
2. Masseter
3. Temporalis
4. Outer Superciliaris or Corrugator
5. Inner Superciliaris or Corrugator
6. Orbicularis
7. Maxillaris or Lev. lab. sup. al. nasi
8. Malaris
9. Nasalis or Lev. lab. sup. prof.
10. Angularis Vein
11. Facial Vein
12. Whisker Bed
13. Labialis
14. Zygomaticus
15. Auricular Gland
16. Parotid Gland
17. Submaxillary Gland
18. Biceps
19. Sterno-hyoid
20. Sterno-thyroid
21. Clavicle
22. Cephalo-humeral
23. Manubrium
24. Clavicle
25. Supinator longus
26. Ext. carpi radialis
27. Subcutaneous Vein
28. Mastoideus
29. Cephalo-humeral
30. Metacromion Process
31. Pect. maj.
32. Epitroch.
33. Lg. Triceps
34. Out. ,,
35. Brachialis
36. In. Triceps
37. In. Epicondyle
38. Supinator longus
39. Round Pronator
40. Flex. carpi radialis
41. Perforatus
42. Flex. carpi ulnaris
43. Perforans
44. Oblique Extensor
45. Pectoralis minor
46. ,, major
47. Epitrochlear
48. Anconeus
49. Flex. carpi ulnaris
50. Ext. carpi ulnaris
51. Ext. dig. brevis
52. Ext. carpi radialis
53. Ext. dig. con.
54. Pisiform Bone
55. Rhomboid
56. Upper Trapezius
57. Supraspinatus
58. Angularis
59. Spine of Scapula
60. Infraspinatus
61. Scapular Deltoid
62. Acromion ,,
63. Lower Trapezius
64. Bulge of Teres maj.
65. Scalenus
66. Lumbo-dorsal Fascia covering the Ilio-costal, the Longissimus and the Spinalis
67. Serratus magnus
68. Latissimus
69. Grt. Oblique
70. Crest of Ilium
71. Gluteus medius
72. Gluteus maximus
73. Tensor
74. Coccygeus
75. Levator ani
76. Erector
77. Curvator
78. Depressor
79. Ischium
80. Grt. Trochanter
81. Fascia lata covering Vastus & Rectus
82. Anus
83. Semimem.
84. Semitend.
85. Biceps
86. Gastrocnemius
87. Perforatus
88. Soleus
89. Grt. Saphenous Vein
90.
91. Semitend.
92. Patella
93. Gastroc.
94. Tibialis anticus
95. Perforatus
96. Soleus
97. Ext. pedis
98. Perforans
99. 3 Peronei
100. 2nd Sartorius
101. Crest of Tibia
102. Gracilis
103. Inner Saphenous
104. Tibialis anticus
105. Popliteus
106. Perforans
107. Upper Annular Ligt.
108. Calcaneum
1st. Sartorius

PLATE XXV.—THE ANATOMY OF THE CAT. (Also of Lion, Tiger, Panther, &c.)

This represents the important layer of Muscles, and corresponds with Plate VIII. The Latissimus dorsi is here shown of less extent than usual; it commonly descends as far as the dotted line and covers the Serrati and Scaleni. For the nomenclature of parts not herein named, see the corresponding plates of the Dog.

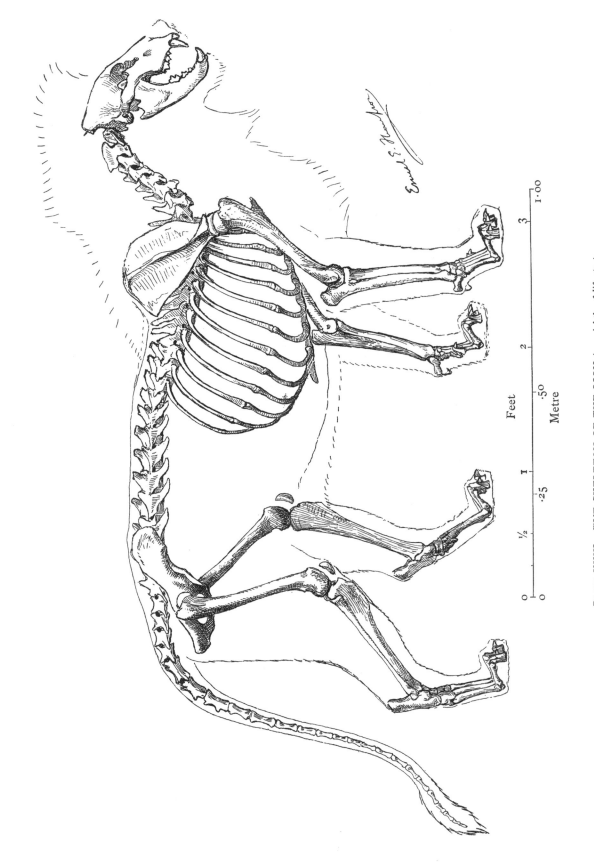

PLATE XXVI.—THE SKELETON OF THE LION (one-eighth of life-size).

The Jaws, the Ribs, and the Scapula of the far side are omitted for the sake of simplicity. For the names of parts see the plates of the Dog's Skeleton.

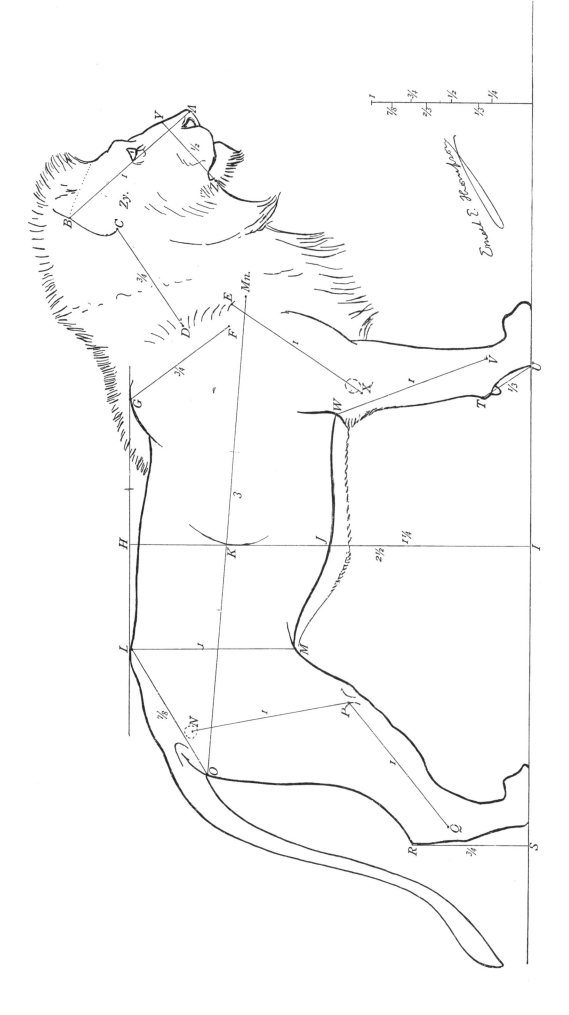

PLATE XXVII.—THE PROPORTIONS OF THE LION.

The Lion is lower and longer than the Dog or Wolf, being 2½ heads high by 3 long. In addition to the proportions indicated on the diagram, the width of the Body through the Acromions = I head. The width of the head at the Zygomatic arches, Zy = ⅔ head. The width through the Great Trochanters = ⅘ head. The greatest width through the crests of the Ilia = ½ head. The length of Tail = the height at Shoulder. The Ribs end at K exactly in the middle of the line O, Mn. The height at the Shoulder is more than half the total length from Nose to Ischium. The Loose Skin on the Belly as indicated is very variable.

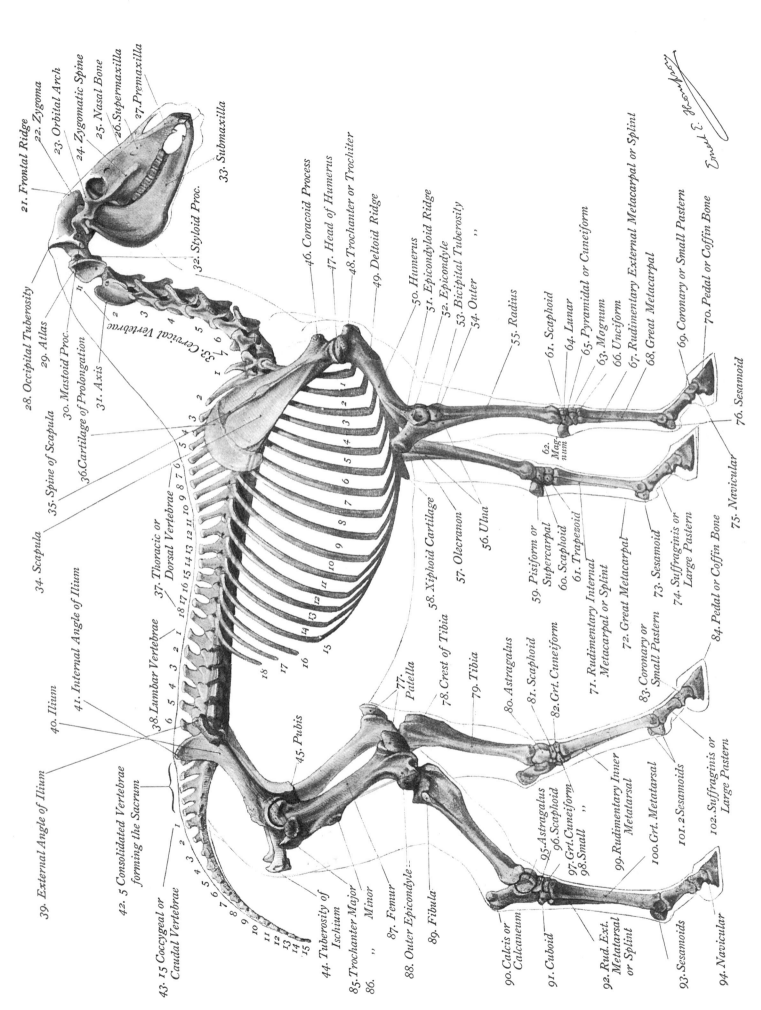

21. Frontal Ridge
22. Zygoma
23. Orbital Arch
24. Zygomatic Spine
25. Nasal Bone
26. Supermaxilla
27. Premaxilla
28. Occipital Tuberosity
29. Atlas
30. Mastoid Proc.
31. Axis
32. Styloid Proc.
33. Submaxilla
34. Scapula
35. Spine of Scapula
36. Cartilage of Prolongation
37. Thoracic or Dorsal Vertebrae
38. Lumbar Vertebrae
39. External Angle of Ilium
40. Ilium
41. Internal Angle of Ilium
42. 5 Consolidated Vertebrae forming the Sacrum
43. 15 Coccygeal or Caudal Vertebrae
44. Tuberosity of Ischium
45. Pubis
46. Coracoid Process
47. Head of Humerus
48. Trochanter or Trochiter
49. Deltoid Ridge
50. Humerus
51. Epicondyloid Ridge
52. Epicondyle
53. Bicipital Tuberosity
54. Outer ,,
55. Radius
56. Ulna
57. Olecranon
58. Xiphoid Cartilage
59. Pisiform or Supercarpal
60. Scaphoid
61. Trapezoid
61. Scaphoid
62. Magnum
63. Magnum
64. Lunar
65. Pyramidal or Cuneiform
66. Unciform
67. Rudimentary External Metacarpal or Splint
68. Great Metacarpal
69. Coronary or Small Pastern
70. Pedal or Coffin Bone
71. Rudimentary Internal Metacarpal or Splint
72. Great Metacarpal
73. Sesamoid
74. Suffraginis or Large Pastern
75. Navicular
76. Sesamoid
77. Patella
78. Crest of Tibia
79. Tibia
80. Astragalus
81. Scaphoid
82. Grt. Cuneiform
83. Coronary or Small Pastern
84. Pedal or Coffin Bone
85. Trochanter Major
86. ,, Minor
87. Femur
88. Outer Epicondyle
89. Fibula
90. Calcis or Calcaneum
91. Cuboid
92. Rud. Ext. Metatarsal or Splint
93. Sesamoids
94. Navicular
95. Astragalus
96. Scaphoid
97. Grt. Cuneiform
98. Small ,,
99. Rudimentary Inner Metatarsal
100. Grt. Metatarsal
101. 2 Sesamoids
102. Suffraginis or Large Pastern

PLATE XXVIII.—THE ANATOMY OF THE HORSE. THE SKELETON.

For the nomenclature of parts not herein named see the corresponding plates of the Dog.

The Jaws, Ribs, and Scapula of the far side are omitted for the sake of simplicity.

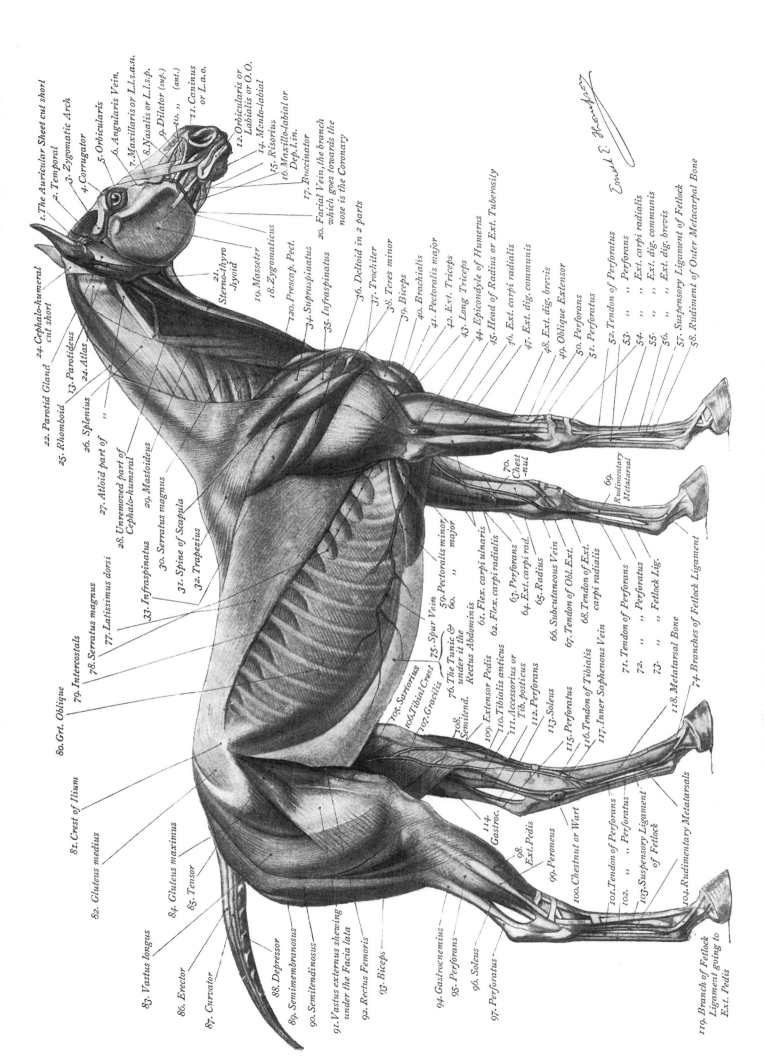

1. The Auricular Sheet cut short
2. Temporal
3. Zygomatic Arch
4. Corrugator
5. Orbicularis
6. Angularis Vein.
7. Maxillaris or L.l.s.a.n.
8. Nasalis or L.l.s.p.
9. Dilator (sup.)
10. " (ant.)
11. Caninus or L.a.o.
12. Orbicularis or Labialis or O.O.
14. Mento-labial
15. Risorius
16. Maxillo-labial or Dep.l.in.
17. Buccinator
20. Facial Vein, the branch which goes towards the nose is the Coronary
21. Sterno-thyro hyoid
19. Masseter
18. Zygomaticus
120. Prescap. Pect.
34. Supraspinatus
35. Infraspinatus
36. Deltoid in 2 parts
37. Trochiter
38. Teres minor
39. Biceps
40. Brachialis
41. Pectoralis major
42. Ext. Triceps
43. Long Triceps
44. Epicondyle of Humerus
45. Head of Radius or Ext. Tuberosity
46. Ext. carpi radialis
47. Ext. dig. communis
48. Ext. dig. brevis
49. Oblique Extensor
50. Perforans
51. Perforatus
52. Tendon of Perforatus
53. " Perforans
54. " Ext. carpi radialis
55. " Ext. dig. communis
56. " Ext. dig. brevis
57. Suspensory Ligament of Fetlock
58. Rudiment of Outer Metacarpal Bone

22. Parotid Gland
24. Cephalo-humeral cut short
25. Rhomboid
13. Parotideus
26. Splenius
24. Atlas
27. Atloid part of "
28. Unremoved part of Cephalo-humeral
29. Mastoideus
30. Serratus magnus
31. Spine of Scapula
32. Trapezius
33. Infraspinatus
77. Latissimus dorsi
78. Serratus magnus
79. Intercostals
80. Grt. Oblique
81. Crest of Ilium
82. Gluteus medius
84. Gluteus maximus
85. Tensor
86. Erector
87. Curvator
83. Vastus longus

70. Chest-nut
69. Rudimentary Metatarsal

59. Pectoralis minor
60. " major
61. Flex. carpi ulnaris
62. Flex. carpi radialis
63. Perforans
64. Ext. carpi rad.
65. Radius
66. Subcutaneous Vein
67. Tendon of Obl.Ext.
68. Tendon of Ext. carpi radialis
71. Tendon of Perforans
72. " Perforatus
73. " Fetlock Lig.
74. Branches of Fetlock Ligament
118. Metatarsal Bone
117. Inner Saphenous Vein
116. Tendon of Tibialis
115. Perforatus
112. Perforans
113. Soleus
114. Gastroc.
111. Accessorius or Tib. posticus
110. Tibialis anticus
109. Extensor Pedis
108. Semitendi- nosus
76. The Tunic & under it the Rectus Abdominis
75. Spur Vein
107. Gracilis
106. Tibial Crest
105. Surtorius
88. Depressor
89. Semimembranosus
90. Semitendinosus
91. Vastus externus shewing under the Facia lata
92. Rectus Femoris
93. Biceps
94. Gastrocnemius
95. Perforans
96. Soleus
97. Perforatus
98. Ext. Pedis
99. Peroneus
100. Chestnut or Wart
101. Tendon of Perforans
102. " Perforatus
103. Suspensory Ligament of Fetlock
104. Rudimentary Metatarsals
119. Branch of Fetlock Ligament going to Ext. Pedis

PLATE XXIX.—THE ANATOMY OF THE HORSE. THE IMPORTANT MUSCLES.

The back part of the Parotid Gland, the Panniculi, the Auricular Sheet, and the superficial part of the Cephalo-humeral are removed to expose the more important Muscles.
The Facial Vein varies greatly with the individual ; in this the simplest form is represented.

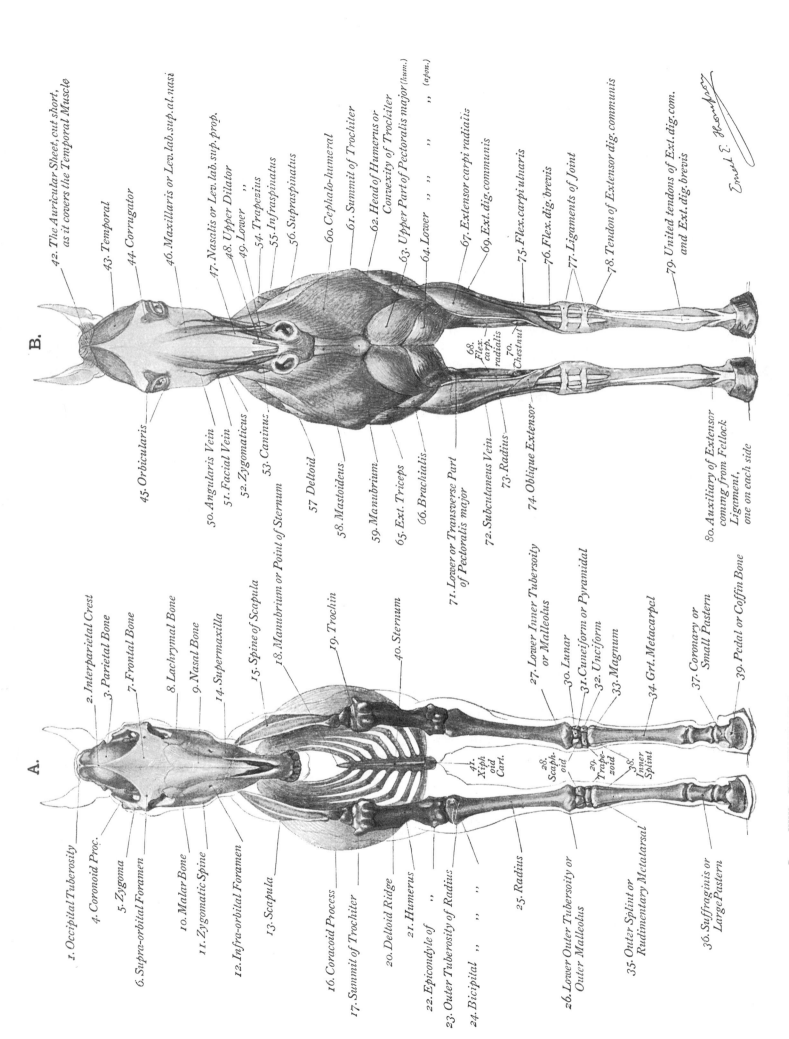

B.

42. *The Auricular Sheet, cut short, as it covers the Temporal Muscle*
43. *Temporal*
44. *Corrugator*
46. *Maxillaris or Lev. lab. sup. al. nasi*
47. *Nasalis or Lev. lab. sup. prop.*
48. *Upper Dilator*
49. *Lower* ,,
54. *Trapezius*
55. *Infraspinatus*
56. *Supraspinatus*
60. *Cephalo-humeral*
61. *Summit of Trochiter*
62. *Head of Humerus or Convexity of Trochiter*
63. *Upper Part of Pectoralis major* (hum.)
64. *Lower* ,, ,, ,, ,, (apon.)
67. *Extensor carpi radialis*
69. *Ext. dig. communis*
75. *Flex. carpi ulnaris*
76. *Flex. dig. brevis*
77. *Ligaments of Joint*
78. *Tendon of Extensor dig. communis*
79. *United tendons of Ext. dig. com. and Ext. dig. brevis*

68. *Flex. carp. radialis*
70. *Chestnut*

45. *Orbicularis*
50. *Angularis Vein*
51. *Facial Vein*
52. *Zygomaticus*
53. *Caninus*
57. *Deltoid*
58. *Mastoideus*
59. *Manubrium*
65. *Ext. Triceps*
66. *Brachialis*
71. *Lower or Transverse Part of Pectoralis major*
72. *Subcutaneus Vein*
73. *Radius*
74. *Oblique Extensor*
80. *Auxiliary of Extensor coming from Fetlock Ligament, one on each side*

A.

2. *Interparietal Crest*
3. *Parietal Bone*
7. *Frontal Bone*
8. *Lachrymal Bone*
9. *Nasal Bone*
14. *Supermaxilla*
15. *Spine of Scapula*
18. *Manubrium or Point of Sternum*
19. *Trochin*
40. *Sternum*
27. *Lower Inner Tubersoity or Malleolus*
30. *Lunar*
31. *Cuneiform or Pyramidal*
32. *Unciform*
33. *Magnum*
34. *Grt. Metacarpel*
37. *Coronary or Small Pastern*
39. *Pedal or Coffin Bone*

41. *Xiph oid Cart.*
28. *Scaph- oid*
29. *Trape- zoid*
38. *Inner Splint*

1. *Occipital Tuberosity*
4. *Coronoid Proc.*
5. *Zygoma*
6. *Supra-orbital Foramen*
10. *Malar Bone*
11. *Zygomatic Spine*
12. *Infra-orbital Foramen*
13. *Scapula*
16. *Coracoid Process*
17. *Summit of Trochiter*
20. *Deltoid Ridge*
21. *Humerus*
22. *Epicondyle of* ,,
23. *Outer Tuberosity of Radius*
24. *Bicipital* ,, ,,
25. *Radius*
26. *Lower Outer Tuberosity or Outer Malleolus*
35. *Outer Splint or Rudimentary Metatarsal*
36. *Suffraginis or Large Pastern*

Ernest E. Thompson

PLATE XXX.—THE ANATOMY OF THE HORSE. FRONT VIEW OF THE SKELETON AND THE IMPORTANT MUSCLES.

The Auricular Sheet and the Panniculi are removed.

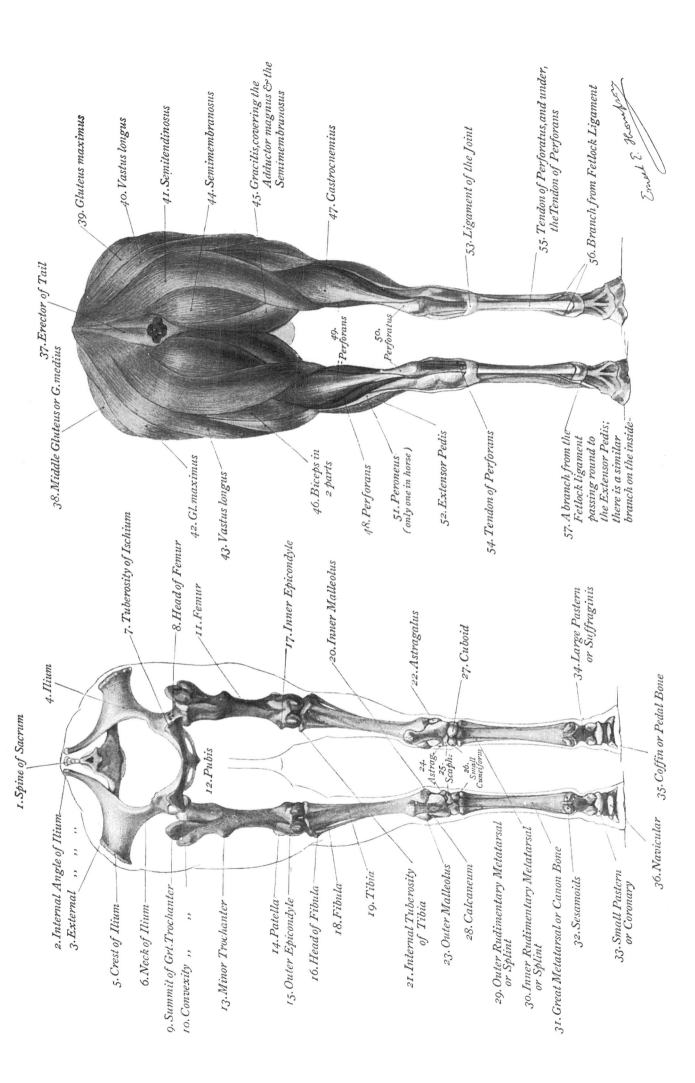

1. Spine of Sacrum
2. Internal Angle of Ilium
3. External „ „ „
4. Ilium
5. Crest of Ilium
6. Neck of Ilium
7. Tuberosity of Ischium
8. Head of Femur
9. Summit of Grt. Trochanter
10. Convexity „ „
11. Femur
12. Pubis
13. Minor Trochanter
14. Patella
15. Outer Epicondyle
16. Head of Fibula
17. Inner Epicondyle
18. Fibula
19. Tibia
20. Inner Malleolus
21. Internal Tuberosity of Tibia
22. Astragalus
23. Outer Malleolus
24. Astrag.
25. Scaph.
26. Small Cuneiform.
27. Cuboid
28. Calcaneum
29. Outer Rudimentary Metatarsal or Splint
30. Inner Rudimentary Metatarsal or Splint
31. Great Metatarsal or Canon Bone
32. Sesamoids
33. Small Pastern or Coronary
34. Large Pastern or Suffraginis
35. Coffin or Pedal Bone
36. Navicular
37. Erector of Tail
38. Middle Gluteus or G. medius
39. Gluteus maximus
40. Vastus longus
41. Semitendinosus
42. Gl. maximus
43. Vastus longus
44. Semimembranosus
45. Gracilis, covering the Adductor magnus & the Semimembranosus
46. Biceps in 2 parts
47. Gastrocnemius
48. Perforans
49. Perforans
50. Perforatus
51. Peroneus (only one in horse)
52. Extensor Pedis
53. Ligament of the Joint
54. Tendon of Perforans
55. Tendon of Perforatus, and under, the Tendon of Perforans
56. Branch from Fetlock Ligament
57. A branch from the Fetlock ligament passing round to the Extensor Pedis; there is a similar branch on the inside-

Ernest E. Thompson

PLATE XXXI.—THE ANATOMY OF THE HORSE. BACK VIEW OF THE SKELETON AND THE IMPORTANT MUSCLES.

The Tail is cut off at the base.

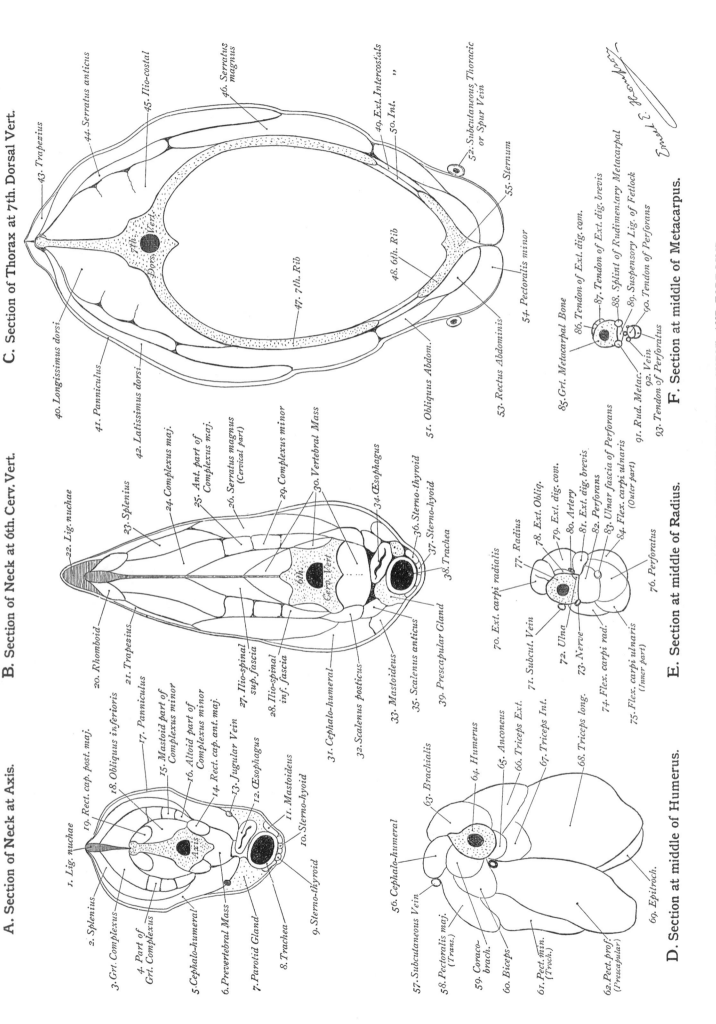

A. Section of Neck at Axis.

B. Section of Neck at 6th. Cerv. Vert.

C. Section of Thorax at 7th. Dorsal Vert.

D. Section at middle of Humerus.

E. Section at middle of Radius.

F. Section at middle of Metacarpus.

1. Lig. nuchae
2. Splenius.
3. Grt. Complexus.
4. Part of Grt. Complexus
5. Cephalo-humeral
6. Prevertebral Mass
7. Parotid Gland
8. Trachea
9. Sterno-thyroid
10. Sterno-hyoid
11. Mastoideus
12. Œsophagus
13. Jugular Vein
14. Rect. cap. ant. maj.
15. Mastoid part of Complexus minor
16. Altoid part of Complexus minor
17. Panniculus
18. Obliquus inferioris
19. Rect. cap. post. maj.
20. Rhomboid
21. Trapezius.
22. Lig. nuchae
23. Splenius.
24. Complexus maj.
25. Ant. part of Complexus maj.
26. Serratus magnus (Cervical part)
27. Ilio-spinal sup.fascia
28. Ilio-spinal inf. fascia
29. Complexus minor
30. Vertebral Mass
31. Cephalo-humeral
32. Scalenus posticus
33. Mastoideus
34. Œsophagus
35. Scalenus anticus
36. Sterno-thyroid
37. Sterno-hyoid
38. Trachea
39. Prescapular Gland
40. Longissimus dorsi
41. Panniculus
42. Latissimus dorsi
43. Trapezius
44. Serratus anticus
45. Ilio-costal
46. Serratus magnus
47. 7th. Rib
48. 6th. Rib
49. Ext. Intercostals
50. Int.
52. Subcutaneous Thoracic or Spur Vein
53. Rectus Abdominis
54. Pectoralis minor
55. Sternum
56. Cephalo-humeral
57. Subcutaneous Vein
58. Pectoralis maj. (Trans.)
59. Coraco-brach.
60. Biceps
61. Pect. min. (Troch.)
62. Pect. prof. (Prescapular)
63. Brachialis
64. Humerus
65. Anconeus
66. Triceps Ext.
67. Triceps Int.
68. Triceps long.
69. Epitroch.
70. Ext. carpi radialis
71. Subcut. Vein
72. Ulna
73. Nerve
74. Flex. carpi rad.
75. Flex. carpi ulnaris (Inner part)
76. Perforatus
77. Radius
78. Ext. Obliq.
79. Ext. dig. con.
80. Artery
81. Ext. dig. brevis
82. Perforans
83. Ulnar fascia of Perforans
84. Flex. carpi ulnaris (Outer part)
85. Grt. Metacarpal Bone
86. Tendon of Ext. dig. com.
87. Tendon of Ext. dig. brevis
88. Splint of Rudimentary Metacarpal
89. Suspensory Lig. of Fetlock
90. Tendon of Perforans
91. Rud. Metac.
92. Vein
93. Tendon of Perforatus

PLATE XXXII.—THE ANATOMY OF THE HORSE. SECTION OF THE NECK, CHEST, AND FORE-LIMB.

The sections are one-fifth of natural size, are at right angles to the long axis of the part cut, and are divested of Skin and all but the very important Fascia. The upper side is always towards the top of the plate, and the right side to the right. In the case of the Limbs, the right Limb is taken, and is shown with the outer side to the right and the fore-side upwards. The lower face of the section is the one drawn.

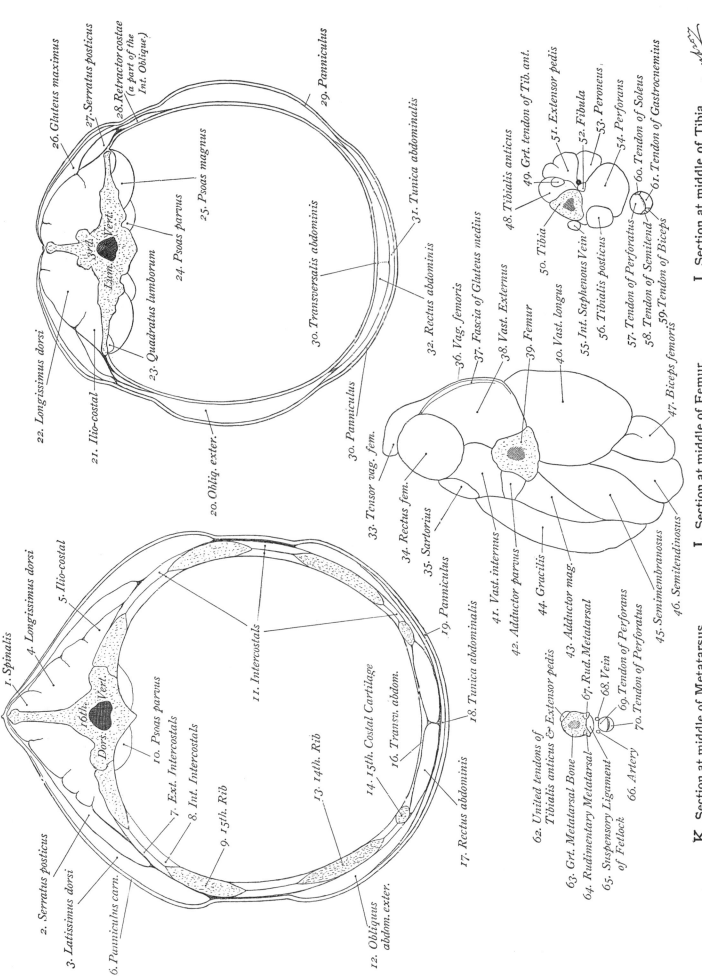

G. Section of the Body at the 16th. Dorsal Vertebra, i.e. the deepest part of the belly.

1. Spinalis
2. Serratus posticus
3. Latissimus dorsi
4. Longissimus dorsi
5. Ilio-costal
6. Panniculus carn.
7. Ext. Intercostals
8. Int. Intercostals
9. 15th. Rib
10. Psoas parvus
11. Intercostals
12. Obliquus abdom. exter.
13. 14th. Rib
14. 15th. Costal Cartilage
16. Transv. abdom.
17. Rectus abdominis
18. Tunica abdominalis
19. Panniculus
16th. Dors. Vert.

H. Section of the Trunk at the 3rd. Lumbar Vertebra.

20. Obliq. exter.
21. Ilio-costal
22. Longissimus dorsi
23. Quadratus lumborum
24. Psoas parvus
25. Psoas magnus
26. Gluteus maximus
27. Serratus posticus
28. Retractor costae (a part of the Int. Oblique.)
29. Panniculus
30. Transversalis abdominis
30. Panniculus
31. Tunica abdominalis
32. Rectus abdominis
3rd. Lumb. Vert.

I. Section at middle of Femur.

33. Tensor vag. fem.
34. Rectus fem.
35. Sartorius
36. Vag. femoris
37. Fascia of Gluteus medius
38. Vast. Externus
39. Femur
40. Vast. longus
41. Vast. internus
42. Adductor parvus
43. Adductor mag.
44. Gracilis
45. Semimembranosus
46. Semitendinosus
47. Biceps femoris

J. Section at middle of Tibia.

48. Tibialis anticus
49. Grt. tendon of Tib. ant.
50. Tibia
51. Extensor pedis
52. Fibula
53. Peroneus
54. Perforans
55. Int. Saphenous Vein
56. Tibialis posticus
57. Tendon of Perforatus
58. Tendon of Semitend
59. Tendon of Biceps
60. Tendon of Soleus
61. Tendon of Gastrocnemius

K. Section at middle of Metatarsus.

62. United tendons of Tibialis anticus & Extensor pedis
63. Grt. Metatarsal Bone
64. Rudimentary Metatarsal
65. Suspensory Ligament of Fetlock
66. Artery
67. Rud. Metatarsal
68. Vein
69. Tendon of Perforans
70. Tendon of Perforatus

PLATE XXXIII.—THE ANATOMY OF THE HORSE. SECTIONS OF THE TRUNK AND HIND-LIMB.

The same scale, &c., as in the preceding plate.

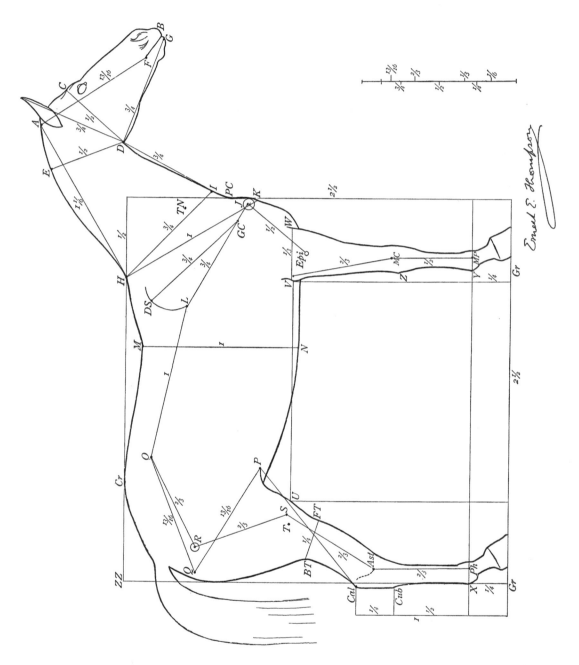

PLATE XXXIV.—THE PROPORTIONS OF A TYPICAL HORSE.

Measured in heads. In addition to the proportions indicated on the plate, the width of the Body just below O, *i.e.* the crest of the Ilium = 1 head; the greatest width of the Chest, about the middle of the line MN = 1 head; the greatest width of the Hind Quarters, *i.e.* about the middle of the line RS = 1 head, each Thigh being there ⅜ head thick; the greatest width at the Shoulders, *i.e.* at GC, the Humeral head = ⅔ head. The widest part of the Head is at the Orbit, where it is rather more than ⅜ head; the Neck at its widest place TN is ⅓ head.

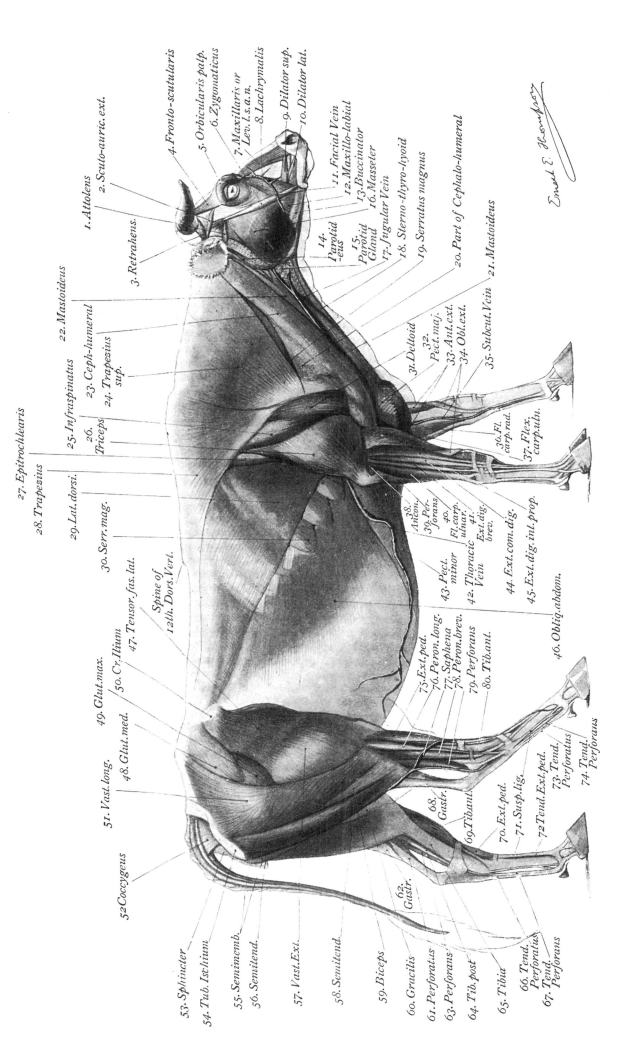

1. Attolens
2. Scuto-auric. ext.
3. Retrahens.
4. Fronto-scutularis
5. Orbicularis palp.
6. Zygomaticus
7. Maxillaris or Lev. l. s. a. n.
8. Lachrymalis
9. Dilator sup.
10. Dilator lat.
11. Facial Vein
12. Maxillo-labial
13. Buccinator
14. Parotid-eus
15. Parotid Gland
16. Masseter
17. Jugular Vein
18. Sterno-thyro-hyoid
19. Serratus magnus
20. Part of Cephalo-humeral
21. Mastoideus
22. Mastoideus
23. Ceph-humeral
24. Trapezius sup.
25. Infraspinatus
26. Triceps
27. Epitrochlearis
28. Trapezius
29. Lat. dorsi.
30. Serr. mag.
31. Deltoid
32. Pect. maj.
33. Ant. cxt.
34. Obl. ext.
35. Subcut. Vein
36. Fl. carp. rad.
37. Flex. carp. uln.
38. Anticon.
39. Per-forans
40. Fl. carp. ulnar.
41. Ext. dig. brev.
42. Thoracic Vein
43. Pect. minor
44. Ext. com. dig.
45. Ext. dig. int. prop.
46. Obliq. abdom.
47. Tensor. fus. lat.
48. Glut. med.
49. Glut. max.
50. Cr. Ilium
51. Vast. long.
52. Coccygeus
53. Sphincter
54. Tub. Ischium
55. Semimemb.
56. Semitend.
57. Vast. Ext.
58. Semitend.
59. Biceps
60. Gracilis
61. Perforatus
62. Gastr.
63. Perforans
64. Tib. post
65. Tibia
66. Tend. Perforatus
67. Tend. Perforans
68. Gastr.
69. Tibiant.
70. Ext. ped.
71. Susp. lig.
72. Tend. Ext. ped.
73. Tend. Perforatus
74. Tend. Perforans
75. Ext. ped.
76. Peron. long.
77. Saphena
78. Peron. brev.
79. Perforans
80. Tib. ant.

Spine of 12th. Dors. Vert.

Ernest E. Thornhast

PLATE XXXV.—THE ANATOMY OF THE OX.

The Panniculi and Thinner Fascia are removed.

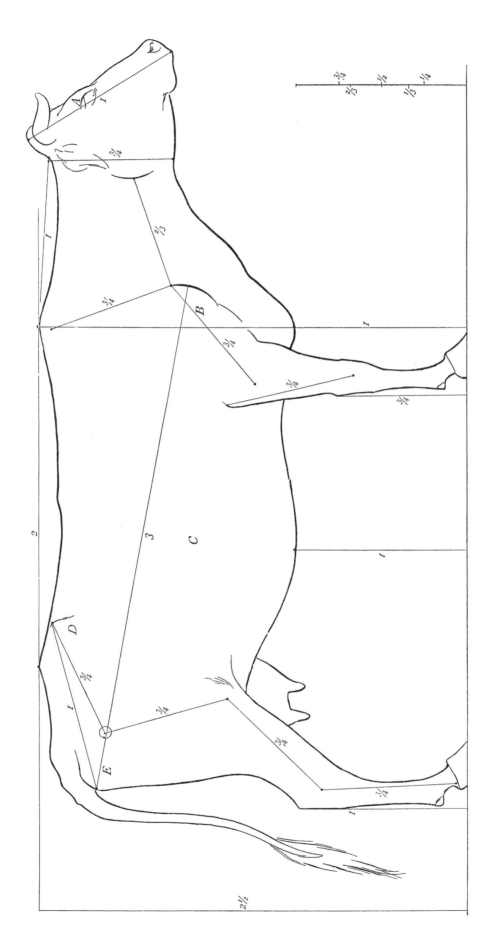

PLATE XXXVI.—THE PROPORTIONS OF THE OX.

In addition to the measurements indicated, the length of the Ear is $\frac{5}{11}$ of a head, so is the width of the Head at the widest part A, *i.e.* through from side to side at the Upper Eyelids ; through the Shoulders from Trochiter to Trochiter B = $\frac{3}{4}$ of a head ; through the thickest part of the Belly C = $1\frac{1}{2}$ heads ; through the extreme outer point of the Iliac crests D = 1 head ; through the extreme outer point of the Ischium E = $\frac{2}{3}$ of a head.

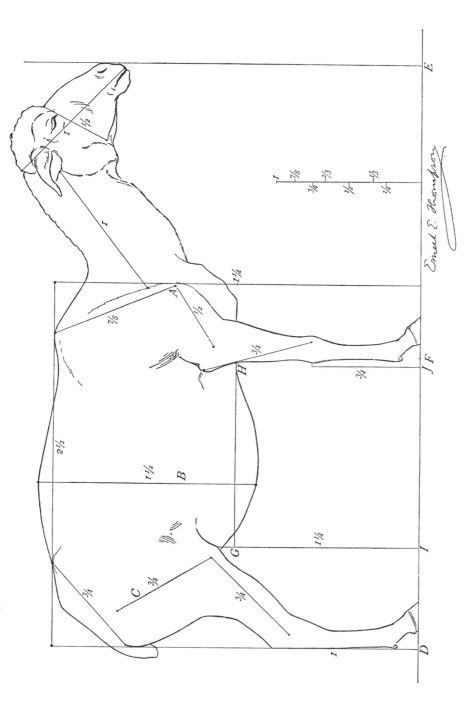

Ernest E. Thompson

PLATE XXXVII.—THE PROPORTIONS OF THE SHEEP.

The Sheep goes in a square of 2½ heads, but the Back rises above the square, as it does in many of the smaller Deer; the Neck, as perhaps in all grazing Animals, is 1 head long; on the line D E, extending from the level of the Nose to the end of the Body, the central point F is on the level of the back of the Arm; the Breast is at half the height of the Shoulder; the square G H J I is drawn to show the tendency to repeat under the Belly, in the scale of half, the figure which encloses the whole body. In addition to the measurements indicated on the plate, the width through the Acromion A is 1 head; the width through the thickest part of the Thigh C is 1 head; the width through the external angles of the crests of the Ilia is ⅞ head; the width of the Belly at its widest point B is 1⅓ heads; its depth at this level is 1½ heads. Usually the body is nearly circular here, and both of the measurements are very variable. The individual illustrated is a very full-bodied animal. These proportions will be found in nearly all of the Sheep tribes, including the Bighorns, &c.

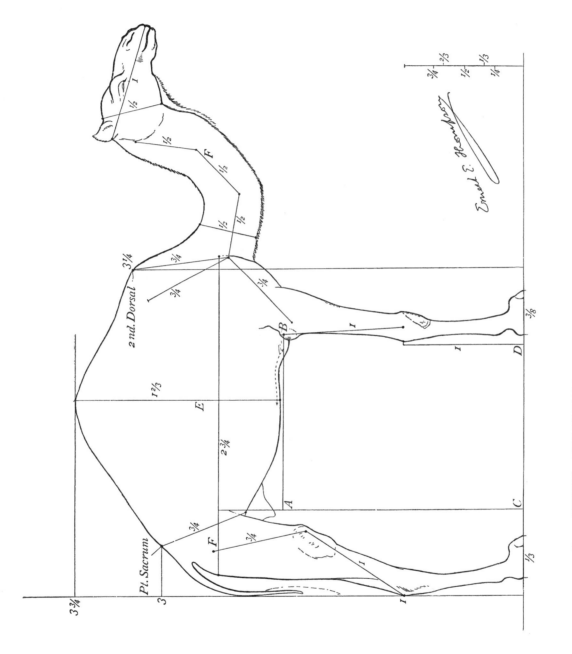

PLATE XXXVIII.—THE PROPORTIONS OF THE DROMEDARY AND THE CAMEL.

The plate represents the Dromedary, but where the proportion is not one of thickness it applies also to the Camel, which is simply a more heavily-built or heavy-draught Dromedary. It will be seen that this animal is higher than long, being 3¾ heads high at the Hump, and 2¾ long in the Body from Shoulder to Ischium. In addition to the proportions indicated, the width through the orbits of the Eyes is ⅔ head ; the width through the middle of the Neck F ⅓ head (the Neck varies but little in width) ; the width through the Shoulders is ⅚ head ; through the Belly at the widest point E is 1 head ; through the Thighs at F is 1⅓ heads ; the length of the Tail is 1 head ; of the Ear ⅔ of a head ; the front corner of the Eye is in the middle of the length of the Head. If the Hind-leg were advanced to A so that the front line of the Thigh would be straight, then the figure included by the points A B C D would be of exactly the same proportion as the figure of the animal's body.

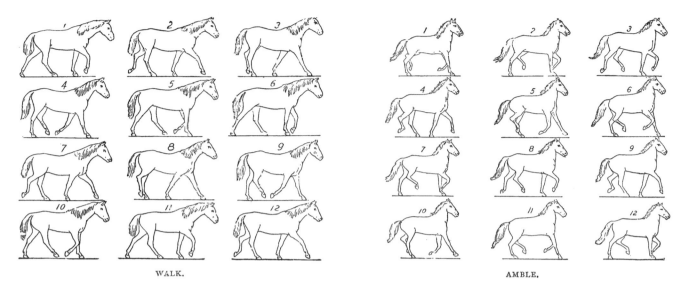

WALK.

AMBLE.

PLATE XXXIX.—THE HORSE IN MOTION—THE WALK AND THE AMBLE.
From Muybridge photographs.

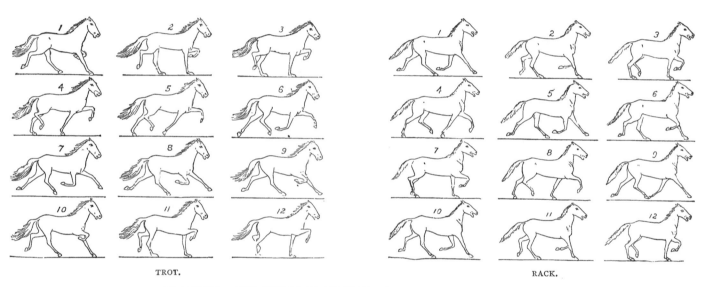

TROT.

RACK.

PLATE XL.—THE HORSE IN MOTION—THE TROT AND THE RACK.
From Muybridge photographs.

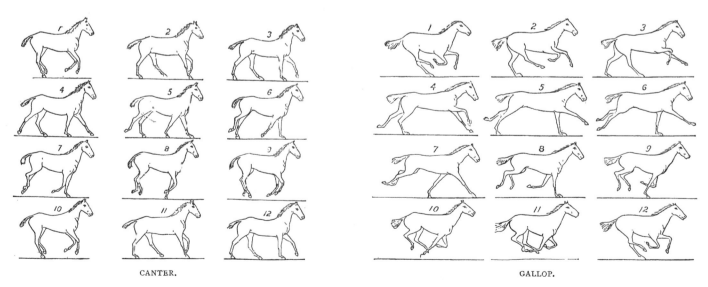

CANTER.

GALLOP.

PLATE XLI.—THE HORSE IN MOTION—THE CANTER AND THE GALLOP.
From Muybridge photographs.

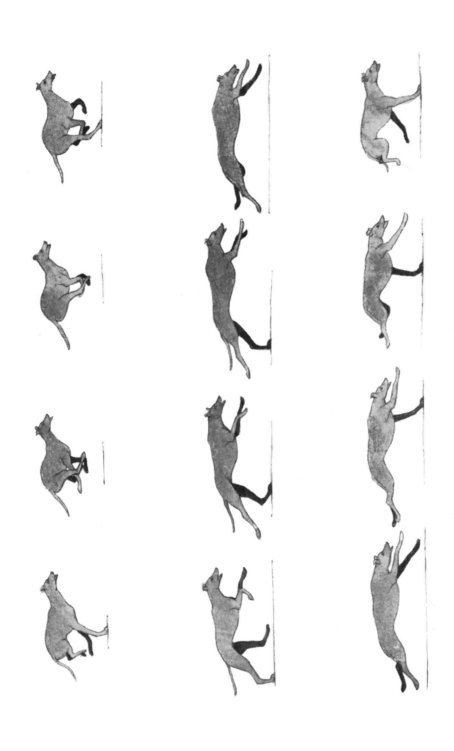

PLATE XLII.—ATTITUDES OF A HOUND RUNNING.

From instantaneous photographs by Muybridge.

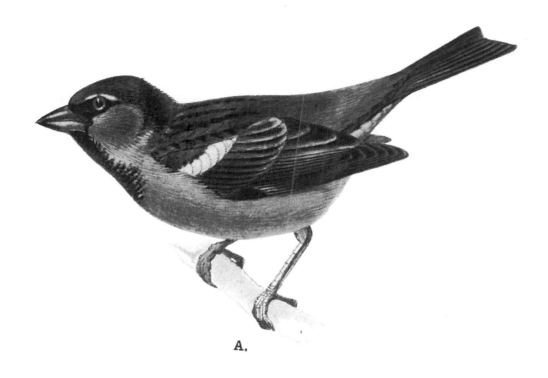

A.

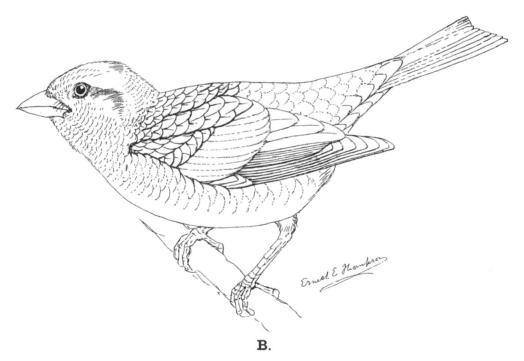

B.

PLATE XLIII.—THE COMMON HOUSE OR EUROPEAN SPARROW. (*Passer domesticus.*)

A. The living Bird in good Feather, to show the Pattern.
B. The Anatomy or Arrangement of the Feathering.

This plate will illustrate the Feather arrangement of all the Singing Birds or Passeres. The plate is life-size.

A.

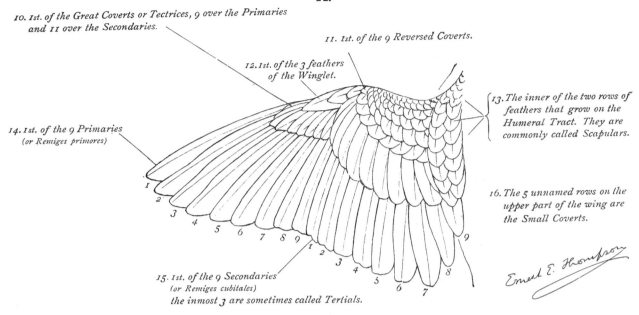

10. 1st. of the Great Coverts or Tectrices, 9 over the Primaries and 11 over the Secondaries.

11. 1st. of the 9 Reversed Coverts.

12. 1st. of the 3 feathers of the Winglet.

13. The inner of the two rows of feathers that grow on the Humeral Tract. They are commonly called Scapulars.

14. 1st. of the 9 Primaries (or Remiges primores)

16. The 5 unnamed rows on the upper part of the wing are the Small Coverts.

1
2
3
4 5 6 7 8 9
1 2 3 4 5 6 7 8 9

15. 1st. of the 9 Secondaries (or Remiges cubitales) the inmost 3 are sometimes called Tertials.

Ernest E. Thompson

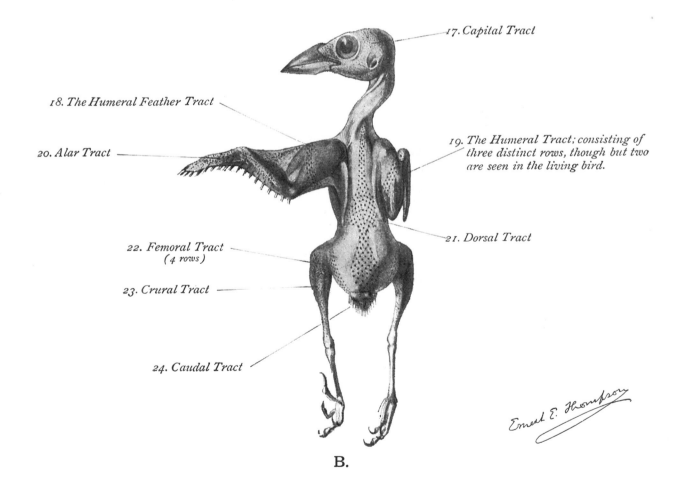

17. Capital Tract

18. The Humeral Feather Tract

19. The Humeral Tract; consisting of three distinct rows, though but two are seen in the living bird.

20. Alar Tract

22. Femoral Tract (4 rows)

21. Dorsal Tract

23. Crural Tract

24. Caudal Tract

Ernest E. Thompson

B.

PLATE XLIV.—THE ANATOMY OF THE COMMON OR HOUSE SPARROW.

A. The upper surface of the left Wing, to show the Feather arrangement.
B. The naked Body, to show the Feather tracts and Naked tracts.

This plate also will illustrate the general features of Feathering in all the Passeres or Singing Birds. This plate is life-size.

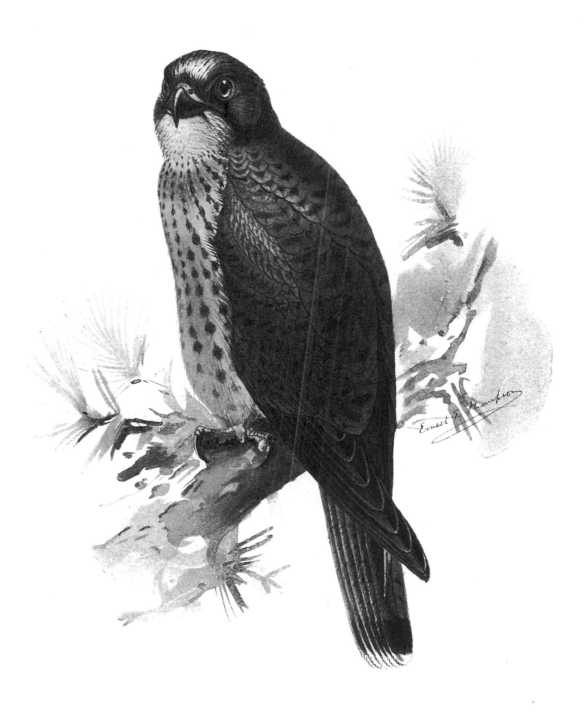

PLATE XLV.—THE EUROPEAN KESTREL. (*Falco alaudarius.*)—Female.

To illustrate the Form and Feather arrangement of the Falcons. The plate is half life-size.

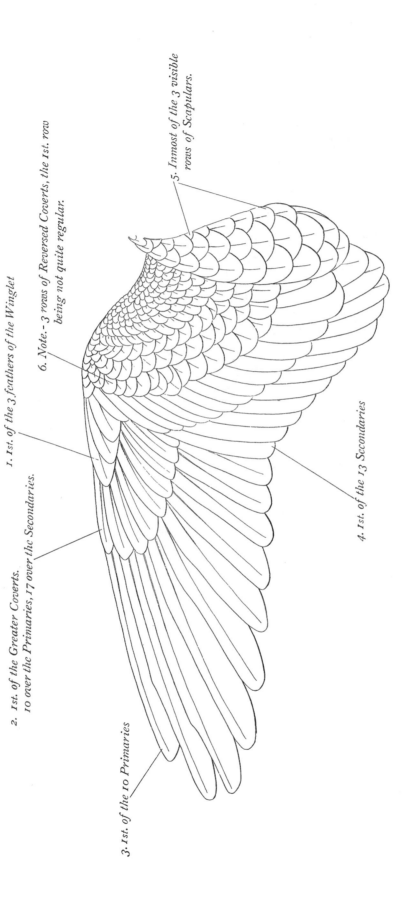

1. 1st. of the 3 feathers of the Winglet

2. 1st. of the Greater Coverts.
10 over the Primaries, 17 over the Secondaries.

3. 1st. of the 10 Primaries

4. 1st. of the 13 Secondaries

5. Inmost of the 3 visible rows of Scapulars.

6. Note. - 3 rows of Reversed Coverts, the 1st. row being not quite regular.

PLATE XLVI.—UPPER SURFACE OF LEFT WING OF EUROPEAN KESTREL.

The plate is half life-size.

A.

B.

C.

PLATE XLVII.—THE ANATOMY OF THE COMMON QUAIL OF EUROPE. (*Coturnix communis.*)

A. The living Quail, to show the Pattern produced by the markings when each Feather is perfect and in proper position. B. The abstract Form.
C. The Feathering, to show the various Series.

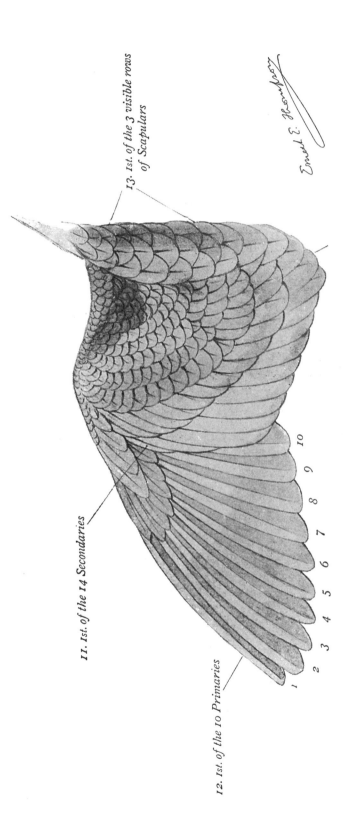

14. *Note: 3 half rows and 6 whole rows of Reversed Coverts*

13. *1st. of the 3 visible rows of Scapulars*

11. *1st. of the 14 Secondaries*

12. *1st. of the 10 Primaries*

Ernest E. Thompson

PLATE XLVIII.—UPPER SURFACE OF LEFT WING OF COMMON QUAIL OF EUROPE.

The plate is life-size.

PLATE XLIX. THE PLAN OF A PEACOCK'S TRAIN.

To show the Arrangement when each Feather is present in perfect condition. The plate is $\frac{1}{9}$ of life size.